ART AS HISTORY

Art as History

Episodes in the Culture and Politics of Nineteenth-Century Germany

PETER PARET

PRINCETON UNIVERSITY PRESS
PRINCETON, NEW JERSEY

Copyright © 1988 by Princeton University Press

Published by Princeton University Press, 41 William Street,
Princeton, New Jersey 08540

In the United Kingdom: Princeton University Press, Guildford, Surrey

This book has been composed in Linotron Sabon type

Clothbound editions of Princeton University Press books are printed
on acid-free paper, and binding materials are chosen for
strength and durability. Paperbacks, although satisfactory
for personal collections, are not usually suitable
for library rebinding

Printed in the United States of America by Princeton
University Press, Princeton, New Jersey

Library of Congress Cataloging-in-Publication Data
Paret, Peter.
Art as history : episodes in the culture and politics
of nineteenth-century Germany / Peter Paret.
p. cm.
Bibliography: p.
Includes index.
ISBN 0-691-05541-6
1. Arts, German. 2. Arts, Modern—19th century—Germany.
3. History in art. 4. Politics in art. 5. Art and
history—Germany. 6. Arts—Political aspects—Germany.
7. Germany—History—1789-1900. I. Title.
NX550.A1P36 1988
700'.43—dc19 88-22623

If we are to create historical art
it is not enough to look back on history;
we must be able to live history,
to take part in public life.

Jacob Burckhardt
"Bericht über die Kunstausstellung
zu Berlin im Herbste 1842"

Contents

Acknowledgments

THIS STUDY draws on a number of documents in the papers of Anton von Werner in the Central State Archives of the German Democratic Republic in Merseburg, which I first explored some years ago when engaged in other research. I should again like to thank the staff of the Merseburg archives for the help they gave me at the time. I am greatly indebted to Dale R. Roylance, Curator of Graphic Arts in the Firestone Library of Princeton University, for permitting me to reproduce Menzel's wood engravings from the Library's copy of the first edition of Kugler's and Menzel's *Geschichte Friedrichs des Grossen*; to the editors of the *Journal of Interdisciplinary History* for permission to incorporate material in the third chapter that first appeared in different form in their journal; to the Theodor-Fontane-Archiv in Potsdam and the Museum Administration of the city of Hanau in Hesse for help in locating and identifying a number of originals for the illustrations; to the Institute for Advanced Study for help in defraying the cost of the illustrations; and to the following institutions for making available to me photographs of works in their collections: Kunstmuseum Düsseldorf; Hamburger Kunsthalle; Staatliche Museen Preussischer Kulturbesitz, Nationalgalerie, Berlin (West); Bismarck-Museum, Friedrichsruh; and Archiv für Kunst und Geschichte, Berlin (West).

It is a pleasure to express my gratitude to Professor Daniel Moran of the University of Northern Colorado for bibliographical assistance, and to Joanna Hitchcock, Susan Bishop, and Eric Van Tassel of the Princeton University Press for the care with which they turned the manuscript into a book.

ART AS HISTORY

Introduction

THE TITLE of this study refers to more than one kind of interaction between the arts and history. A painter of a subject drawn from Antiquity or the author of a novel set in the Middle Ages may use the past as a decorative device or may seek to explore it seriously. Scholars may study images, fiction, or verse that treat contemporary incidents or conditions as documents of the times in which they originated. A painting with a contemporary theme becomes a historical source, whether or not the artist intended it as such. Similar transformations occur when works of the imagination re-create or comment on an earlier period rather than the present. Elements of their own age appear in their treatment of the past; they, too, document the times in which they originated, and potentially are sources for the historical understanding of later generations. Their interpretation of the past may retain sufficient force to influence our own view of their historical subject; it cannot fail to offer us clues to the interpreter and to the interpreter's environment.

The following pages discuss a number of episodes in German history from a point of view that joins interpretations of past events with aesthetic responses to contemporary conditions, and sees both as indications of social and political as well as cultural characteristics of their own period. "Episode" is used in an expansive sense to include not only the painting of a picture or the writing of a novel or poem, but also aspects of the work's immediate and more remote background, and of its impact and implications. None is treated exhaustively, as no work of art can be; but aspects of each work are traced across aesthetics, politics, and the life of the artist, and some of the connections between episodes are outlined, which make each a nodal point in a vast network of human experience and interpretation. The first episode goes back to the late 1830s and to changes in the political attitudes and expectations of segments of Prussian society. The last extends from the 1860s to the Franco-Prussian War and beyond.

These are dates that span highly significant events in modern German history. After faltering in the years before and during the Revolution of 1848, Prussian foreign policy recovered and the state's dominance in German affairs became irreversible. The influence of Austria and France was eliminated, and the unification of Germany achieved. During the same years the character of Prussia's internal politics became fixed along lines that were to remain basically unchanged until 1918 and the collapse of the empire. That is not to say, however, that the episodes in themselves—although far from trivial in the history of German culture—are of particular consequence to the general history of the times. Any number of parallel or comparable incidents might have been chosen in their place. If they do have a larger meaning, it is mainly because so many others would have conveyed a similar message. The value they possess rests in their representative, illustrative character.

5

Each episode concerns specific problems and their solutions in art, literature, and scholarship. But distinct though they are, they are linked by aesthetic, social, and political elements, and by individual lives. Taken together, they may suggest something of the innovativeness and seemingly inexhaustible creativity of high bourgeois culture in nineteenth-century Germany as well as some of its weaknesses. The episodes also mark a political process that ultimately negated aspirations widely held in this culture and that was to have implications far beyond Germany: the rise of political liberalism in Restoration Prussia, its apparent victory and eventual check during and after the Revolutions of 1848, and its disintegration under the second empire.

Today interpretations of the past in art and literature can rarely be characterized as history. But it remains difficult to draw an absolute dividing line between scholarship and the many extraneous elements that gather around it, aesthetics among them. History, when it passes from research to interpretation, becomes more than scholarship. Interpretations of the past not only reflect concerns of the present, which may or may not add to their precision and power; each interpretation is conveyed in language whose vocabulary, syntax, imagery, and structure express the qualities of a particular individual. The historian's language tends to affect his analysis and, if he has talent, often achieves aesthetic value. To a degree, history then becomes art, and art and scholarship combine to interpret the past in ways that neither could alone.

In Germany this synthesis was strongest in the early and middle decades of the nineteenth century, when history was becoming scientific. The new scholarship was the product of a generation with pronounced aesthetic needs and the ability to satisfy them, even as the values of high culture were beginning to be called into question by new economic and social forces. For a time, methodological innovation and the highest aesthetic culture existed side by side. Ranke's early work demonstrates how illuminating their integration could be. His study "Cardinal Consalvi and his Administration of the Papal State under the Pontificate of Pius VII," first published in 1832, opens with a chapter that could—were some lines of dialogue added—easily be imagined as part of *The Charterhouse of Parma* or *The Red and the Black*. A poem by the fifteen-year-old Consalvi, then a seminarian, introduces the basic theme of ambition and intense work, a theme Ranke develops in accounts of the young man's ancestors, his first appointments in the Papal service, his imprisonment by Roman republicans in Castel Sant'Angelo in 1799, and his maneuvers as secretary of the conclave of cardinals, leading to the election of Chiaramonti, his future patron, as pope the following year. The social, political, and psychological analysis of these first pages, presented in prose that seems capable of the utmost specificity without ever losing its ease and clarity, prepares the reader for the main body of the work and provides its key. The novelistic aspects of much of Ranke's work are strengthened by his practice of adding descriptions of a protagonist's gesture or facial expression to his accounts of political or intellectual developments. These shifts in focus not only create a sense of immediacy and underscore nuances of meaning, but also convey Ranke's vision of history as an undivided amalgam

6

of general forces and the individual. Sometimes he makes use of a metaphor in his treatment of diplomatic negotiations, institutional change, or similar topics and offers the reader a sudden new insight. Book II of his *History of the Popes*, which discusses Catholic reforms after Luther, ends with a brief paragraph that follows immediately on his analysis of the failure of efforts at reconciliation between Catholics and Protestants: "Thus two springs well up in close proximity high in the mountains; as soon as they have made their way down slopes and vales into the plain they separate into great rivers, never to join again."[1]

For Ranke, especially in his early years, history and literature were indivisible, though history was the dominant element. Twenty or thirty years before he began to write, the emphasis in the relationship could still be the reverse. Historical interpretations could then be so fully subsumed in the work of art that art became history. On the eve of the French Revolution it was still possible for a poet and dramatist to be appointed professor of history at a German university. Schiller's *History of the Revolt of the Netherlands*, which helped convince the Jena authorities of his qualifications for the post, represented no original research; nor do its structure and certain inconsistencies in the motivations he attributes to some of the political and religious leaders about whom he writes make it entirely satisfactory as literature. But it was written in prose that few German writers of the time could equal, and no one approached the psychological intuition and mastery of dramatic effect with which Schiller described such events as the initial conspiracy of the Dutch nobles, the drafting and presentation of their "Compromise"—the petition to remove the Inquisition—or the Protestant mob's destruction of statues and images in churches across the land.

It was in his plays that Schiller gave the richest aesthetic expression to his understanding of human behavior and of political conflict, and the vehicle of his analysis is almost always a historical theme. The men and women in *Don Carlos*, the *Wallenstein* trilogy, or *William Tell*, who struggle within themselves or against others to achieve emotional and political freedom, who strive to carry an ideal to triumph, do so as agents of great historical forces. Schiller saw the individual historically. In his dramas history is infinitely more than a scenic backdrop; the author's psychological interpretations are enveloped in his view of the past. Goethe's account of the writing of *William Tell* suggests the force with which the evidence and context of historical acts worked on Schiller's imagination: "He began by covering the walls of his room with as many maps of Switzerland as he could find. Then he read travel books on Switzerland, until he knew in detail the roads and tracks of the area where the Swiss uprising had taken place. At the same time he studied Swiss history, and after he had gathered all this material he sat down to work . . ."[2] Within a specific setting in time and place, however, the conflicts in the Netherlands or the Swiss mountains, at the court of Philip II, or in Wallenstein's camp and headquarters express universal themes. "The repression of the Dutch people [became] a cause of all peoples who were conscious of their rights," Schiller wrote in the introduction to the *Revolt of the Netherlands*.[3] The appeal of freedom, but also

other general elements in history—the attractions of political power, its social necessity and ethical ambiguity, or, on the other hand, the impact on events of the psychological strengths and weaknesses of individuals—are the subjects of Schiller's historical dramas.

In their author's fascination with the past, which did not preclude his ruthless reshaping of the evidence, Schiller's dramas are precursors of much historical art in nineteenth-century Germany: plays, novels, and poems on historical themes or in historical settings, and paintings and graphics on historical subjects. Generations acquired their sense of earlier times—learned to think historically—in part from such historical art and literature as Schiller's plays. Inevitably, and often intentionally, these works also reflected some concerns of the times in which they were created. Usually they did so more directly than could works of historical scholarship addressed to an academic audience, which may approach the present only through the screen of the past. Schiller's great success with the German public owed much to the fact that his assertion of the autonomy of the individual as an absolute conformed to the dissatisfaction that many of his readers felt with aspects of their social condition. In the 1790s their frustration on the whole still lacked political content and direction, but irritation with the real and symbolic barriers of a corporative, hierarchical social system was already widespread. The idea of freedom—the basic theme, according to Goethe, of everything Schiller wrote—might have various meanings; but the political relevance of his dramas and histories seemed sufficiently apparent in the Paris of 1792 for the Convention to associate Schiller with George Washington, Alexander Hamilton, and Thomas Paine when these and other representatives of the idea and cause of liberty were proclaimed honorary citizens of the new republic.

During the French Revolution no German painter approached such dramatists as Schiller or Kleist in the intensity of their historical interest. None painted pictures that were even remotely comparable to the work of the pre-1789 David of the *Oath of the Horatii*, let alone of the David of *Marat*. It was not until the last years of the Napoleonic era that historical painting in Germany began to loosen the ties that bound it to biblical themes on the one hand and to allegorical celebrations of the majesty and grace of temporal princes on the other. But potentially the fine arts contained the same interactions and affinities between past and present that were expressed in the works of German dramatists. When, in 1819, Schopenhauer in *The World as Will and Idea* asserted the universality and topicality of historical painting he gave voice to concepts that were already current, if not yet unopposed. "Besides beauty and grace," he wrote, "a major subject of historical painting is character, which means the depiction of the will at the highest level of reality . . . This, its infinite task, historical painting fulfills by showing us scenes from life, whether of greater or lesser significance. No individual, no action can be without meaning, and in all and through all the idea of humanity unfolds more and more. On that account no occurrence of human existence should be excluded from painting."[4]

8

To repeat: Works of art and literature, whether they address the past or not, reflect facets of the times in which they originate. Their references to the present may be central or marginal, deliberate or unconscious and indirect. In time, these works are transformed into historical sources. If they are not merely reflective but influence people's thought and behavior, they become document and historical force in one. Much may be said about the remoteness of this kind of material from conditions in the wider society, about distortions of its evidence by the aesthetic and intellectual values that are central to it, about its many ambiguities. Some historians, nevertheless, will feel a strong inducement to overcome these difficulties. Art and literature are among society's most determined efforts to understand itself, and through their insights, errors, and obfuscations we hear the clear voice of the past.

Art as History; History as Politics: *The History of Frederick the Great* by Kugler and Menzel

I. LIBERALISM AND THE FREDERICIAN TRADITION

A NEW INTEREST in the person and reign of Frederick the Great became apparent among educated Germans in the later years of the Restoration. Together with Luther, Blücher, and Queen Louise—whose early death in the years when Prussia was little more than a Napoleonic dependency made her a martyr in the popular imagination—Frederick had never ceased to figure in the historical consciousness of the mass of the people, especially in Prussia's central and eastern provinces. Recollections of old people, reinforced by sparse history lessons in the primary schools and by cheap woodcut and lithographed broadsheets, spread the message of a heroic, demanding, paternalistic ruler throughout the country. Among the bureaucracy and in professional and business circles, Frederick's image was more ambiguous. His death had generally been seen as clearing away an obstacle to progress. After Prussia's collapse in 1806 he came to symbolize in many minds the old system that had failed before the French Revolution and Napoleon. Such a deeply committed associate of the reform party as the publicist Ernst Moritz Arndt expressed disgust at the great king's aping of French ways, at his cynicism, his atheism, and his contempt for the traditions of the German empire. Frederick also had defenders—Goethe among them—and the memoirs of some of his soldiers and administrators showed him in a favorable light. But they could scarcely make up for the criticism, and for a time they were overshadowed by the accusations of his sister Wilhelmine, whose memoirs caused a sensation when they were published in 1811. Now, some fifteen years after the battle of Waterloo, the king's reputation began to revive.

The greater role that the past was beginning to play in German thought may have contributed to the change. More specific reasons were dynastic considerations of the Prussian royal family on the one hand, and the political condition of Germany on the other. The diplomatic settlements at the end of the Napoleonic era had created a federation of thirty-six autonomous German states, one of which comprised the western territories of the multinational Austrian empire. In the decades that followed, the governments of the confederation failed, to a greater or lesser degree, to come to terms with forces that were beginning to change the economic and social conditions of their peoples, and with new ideas about the political character appropriate to the separate states and to Germany as a whole. Constitutional government had gained a foothold in a few of the states, primarily in the south; but efforts to make it more meaningful or to introduce a constitution where it did not yet exist, as in Prussia, were strongly resisted, as were moves toward greater national unity, which would have reduced the autonomy of the individual states. In Austria, the most powerful member of the confederation, the

authority of the pre-industrial elites remained substantially intact; in Prussia, the traditional elites now shared authority with a strong, increasingly professional bureaucracy, but managed to maintain the status quo by open and covert social controls and by such policies as press censorship and limitations on the right of assembly. These bonds were not appreciably loosened by the Revolutions of 1830, which Germany experienced only as faint echoes of the storms that forced the abdication of Charles X in France, gained Belgium her independence from the Netherlands, and led to a nationalist uprising in Poland. Except for a few flagrant cases of misgovernment and corruption, Germany still lacked the motives for revolution. But an increasingly important element of the population—the middle levels of society—faced legal and political restraints that with every passing year were less attuned to the dynamics of demography, economic growth, and cultural change.

Historians use the terms "middle class" or "bourgeoisie" when they refer to these groups, but they know that the unitary implications of the terms are misleading, especially when applied to the first half of the nineteenth century. The variety, not least in background, status, and interests, among those who were considered and who considered themselves to belong to the bourgeoisie or *Bürgertum* was very great. The groups included descendants of the old elites of seventeenth- and eighteenth-century corporative society, the mercantile and financial patriciate that ruled such cities as Hamburg and Frankfurt; sons of well-to-do members of the former craft guilds, who carried on the work of their fathers in an economically less restricted environment; educated bureaucratic elites and their close associates, professors and parsons, who helped shape the character of the capitals of the larger states, above all Berlin, and in more traditional form the residences and university towns of central and southern Germany; members of the free professions—lawyers, physicians, writers; merchants and entrepreneurs, who in such centers of early industrialization as the Rhineland, Saxony, and Württemberg were developing a new and distinct outlook; and the growing numbers of engineers, technicians, bookkeepers, and other specialists their enterprises required. In Hans-Ulrich Wehler's characterization, the *Bürgertum* before 1848 "retained its hybrid features—facing both a disappearing past and an emerging future."[1]

Many members of these fragmented social groupings derived a measure of cohesion from certain shared views and interests that had come to be characterized as "liberal." But liberalism, too, which became more assertive with the Revolutions of 1830 but did not subside with them, was far from uniform. In the 1830s, and well into the 1840s, it stood for a complex of diverse, often very generalized opinions and attitudes: a wish for greater national unity, the replacement of bureaucratic absolutism by political systems that allowed the educated and economically respectable to take part in public affairs, the abolition of traditional institutions that inhibited a free social and economic life, the lifting of press censorship, the partial or total separation of church and state, an independent judiciary, and improvements in public education. Except on the local level in some German states, these ideals had not yet become encapsulated in political structures. Until political parties developed in the second half of the 1840s, lib-

eralism referred to beliefs rather than programs. Historians, following some contemporaries, speak of the "liberal movement" of the *Vormärz*—the period before the revolutions in March 1848—but the term "movement" is accurate only if it is taken to mean affinity rather than organization.

These affinities were prevalent throughout the middle classes and could be found in upper-class circles as well. Their limits were set on the left by the still small number of democrats, on the right by those who continued to believe in the superiority of noble or patrician birth and—more significantly—by the many who thought a country's social health and its international presence could be assured only by a powerful centralized government, whose authority ultimately was absolute. In Prussia the elevation of the state, coupled with strict monarchic loyalties attached less to the person of the king than to the institution of kingship, formed the basis for the conservative counterpoise to liberalism. It attracted not only members of the old elites but also many people of middle-class origin and way of life, Ranke among them.

Prussian liberals, far from minimizing the value of the state, regarded it as an essential instrument of progress. Like their predecessors of the reform era, they believed in the state's dual function of guarding and nurturing society and representing its interests in the community of nations, while enabling the individual to fulfill his potential. But they wanted government, which after Napoleon's fall had subsided into a newly efficient bureaucratic absolutism, to recover its true, progressive nature, and in their relationship to the reformed state they sought their own transformation from subject to citizen—*Staatsbürger*, as the combined noun put it in German. "From the beginning of modern political life in Germany," a student of liberalism has written, "it had been the state which had created the foundation for citizenship by weakening the restraints imposed by traditional society, breaking down the power of regional loyalties and institutions, creating laws which linked the individual to the central polity. Liberalism's main problem was how to build upon these achievements of the *Staat* and at the same time to fulfill the promise implied by the word *Bürger*, the promise of a participant public willing and able to define its own destiny."[2] In Frederick the Great a growing number of German liberals, not only in Prussia, found a valuable symbol of enlightened, vigorous statecraft with which to confront the conservatism and orthodoxy of the governments under which they lived.

The revival of Frederick's reputation was advanced by the publication of a number of scholarly reinterpretations and editions of documents. Ranke devoted a few glowing pages to Frederick in his essay on "The Great Powers." Much new material was made known in the first serious biography of the king, which appeared in four volumes of text and five of documents between 1832 and 1834. Some years later, its author, J.D.E. Preuss, began work on a comprehensive critical edition of Frederick's writings, which eventually reached a total of thirty volumes. The renewal of interest in the king was further stimulated by the approaching hundredth anniversary in 1840 of his accession to the throne. Among the many publishers planning to mark and exploit the centennial was the Leipzig firm of J. J. Weber, a pioneer in illustrated publications in Germany,

which decided to commission a life of Frederick, modelled on another work it was about to publish—the translation from the French of a history of Napoleon.

The *Histoire de l'Empereur Napoléon* by the French historian and politician Paul-Mathieu Laurent de l'Ardèche first appeared in Paris in 1838 and was reprinted the following year and again in 1840, the year Napoleon's body was returned to France.[3] The text was a superficial if smoothly written narrative, similar to any number of other biographies of Napoleon by authors to the left of the unforgiving ultra-royalist camp. Laurent, who after the collapse of the July Monarchy in 1848 was to represent the far left in the Constituent and Legislative Assemblies, regarded Napoleon as the fitting successor to the Jacobin dictatorship. In his eyes both stood for democracy—to be sure, of a highly guided kind. But his political views were only rarely emphasized in the text, which instead met the requirements for commercial success by offering an undemanding account of the great man battling an entire world. What set the book apart from competing works were the number and quality of its illustrations. The 794 pages of text were accompanied by 457 wood-engravings—a proportion that almost enabled the images to carry the story by themselves. The artist was Horace Vernet, one of the leading historical painters in France, a specialist both in contemporary battle scenes and in the Napoleonic era. Vernet enjoyed a European reputation: when Prussia added a section for arts and science to the Order *Pour le mérite* in 1842, Vernet was among the first group of foreigners elected knights of the order. Some of his paintings, which also served as the basis for illustrations in the book—for example, *Napoleon's Farewell to the Guard*—are the source of the pictorial associations that many people still attach to certain episodes in the emperor's life. The broad appeal of the Napoleonic legend as conveyed through the close integration of text and image opened markets for the book beyond France. Within a year of the first edition, it was being translated not only into German, but into English and Spanish as well; by the 1860s the American edition had been reprinted six times.

Early in 1839, Weber offered the project of writing Frederick's biography on this model to a young academic in Berlin, Franz Kugler, who accepted the commission and suggested Adolph Menzel as the illustrator.[4] This was the beginning of a close and rich collaboration. It resulted in a book that became both a monument of a new kind of history and a political statement, and proved an important point of departure in each man's further development. In his person and work, Kugler combined many elements of German scholarship and aesthetic and literary culture of the middle decades of the century. The diversity of his interests was itself characteristic of his generation, but the range of his achievements, great and small, was exceptional. Kugler, who was born in 1808 the son of a well-to-do Pomeranian merchant, studied surveying, architecture, and philology, and at the age of twenty-three received the doctorate for a dissertation on a minor medieval poet. Two years later he began to lecture on the history of art at the University of Berlin and at the Royal Academy of Arts, where he was promoted to professor in 1835. His approach to the study of art, about which something will be said further on, constitutes his most original and lasting achievement and made him one of

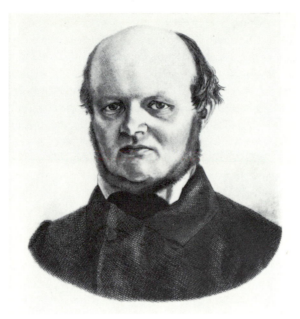

1. Eduard Mandel after Adolph Menzel:
Franz Kugler, 1854 or 1855.

the great figures in the development of art history as a modern scholarly discipline. His friend Theodor Fontane seems, nevertheless, to have exaggerated only a little when he wrote in his recollections that Kugler would have gladly traded his scholarly reputation for a resounding success in the arts.[5] He sketched and painted—his impression of Hegel at the lectern is a familiar document of the period—set verse to music, and published poems and novels; three of his historical dramas reached the stage. But of all these works only one, a song made up of a plotless sequence of romantic images on the banks of a German river, "An der Saale hellem Strande," achieved lasting popularity. It can still be found in modern collections of folk songs and Lieder, and in student songbooks. As editor and commentator he fared better. With his friend the painter-poet Robert Reinick he published the *Songbook for German Artists* in 1833, which was well received. The same year he founded a periodical for the fine arts, and from then until his death—he died of a stroke in 1858—edited or regularly contributed to art journals, and quickly became an influential critic of contemporary art in Germany. In the last years of his life, he and Fontane jointly edited the yearbook *Argo*, among the most forward-looking collections of literature, scholarship, and comment of the time.

Kugler's art-historical publications, his literary writings, and his extensive cultural journalism did not keep him from still other tasks. His work on the biography of Frederick, which went beyond writing the text to closely collaborating with Menzel on the subject and character of the illustrations, led to a second project on a related theme—a history of Brandenburg-Prussia from 1660 to 1789, some eight hundred pages in length.

17

These historical and patriotic works further recommended the energetic scholar to the government, and in 1843 he entered the Prussian Ministry of Ecclesiastical Affairs, Education, and Medicine—the so-called Kultusministerium—where he was soon given responsibility for matters pertaining to art and the theater. His promotion to the senior ranks of the bureaucracy was rapid, and had he lived he would have been a likely candidate to head the ministry. Kugler's memoranda and proposals, redefining the government's role as patron and guarantor of the fine arts, their subjects ranging from the inventory and preservation of historically significant works of art to the training of artists, constitute an important phase in the process by which Wilhelm von Humboldt's neo-humanistic vision at the beginning of the century of the bond between the free individual and the state was turned into the institutionalized *Kulturstaat* of the age of industrialization, the rise of mass societies, and nationalism.

II. THE NEW TASKS OF HISTORICAL ART

WHEN KUGLER began to lecture on the history of art in 1833, it was a discipline in transition. Winckelmann's great achievement in the preceding century, in replacing the art historian's traditional enumeration of artists and their works with a comprehensive view based on periodization and the concept of a dominant style, had been slow in bringing about further theoretical advances. Art history was still characterized by masses of specialized studies, while many periods, areas, and artists were ignored. Philosophic systems, teleological convictions, and the Romantics' search for the essence of art in the folk soul and in idealized Christianity continued to fragment the field. The relationship between art history and history remained uncertain. The great changes that now began were caused in part by developments within the discipline, in part by changes in the study of history in general.

The new way of writing history that emerged in Germany in the 1820s and 1830s—sometimes called scientific history—and its subsequent development, historicism, gave less attention to general phenomena and turned toward the particular, the specific and unique. These were to be revealed by intensified archival research and by the historian's effort to place himself intellectually and emotionally in the situation of the individuals and societies he studied. Reliance on philosophic systems, on one or the other form of the concept of progress, and on the practice of passing judgment on the past lost some of their intellectual luster and scholarly acceptability. History was becoming a modern discipline, and at the same time its sub-fields began to define themselves more clearly. Coincident with the professionalization of history was its more pronounced impact on the literate public. History became a mainstay of *Gymnasium* and university education, a development that had not only intellectual and cultural but also political implications. If more people now wrote and read history, it was in part because to many of them history carried an ideological, possibly even a specifically political, message or, more generally, turned the past into a source of inspiration for the

present. Political and cultural sympathies helped determine the period that was thought to be particularly meaningful to the present. For some it might be the French Revolution or the Enlightenment, for others the Middle Ages, which Germans living under thirty-six different governments could interpret as offering the promise, across centuries, of renewed German unity and power.

In his art-historical as in his historical writings, Kugler sought to emulate Ranke's rejection of generalities for greater specificity and a fuller exploitation of the documents. Kugler's conception of the history of art was as unteleological as was possible for a man of his time and education. He was an early realist, whose analyses concentrated on the work of art and minimized the explanatory significance of theoretical systems such as Hegel's *Aesthetik*. The specific work, he believed, depended primarily on the individual characteristics of the artist and on prevailing aesthetic and technical conditions, far less on external values and ideals. In 1837, when not yet thirty, Kugler published a *Handbook of the History of Painting* in two volumes, the first general history of a particular branch of the visual arts. In this work, and in his subsequent *Handbook of Art History*, Kugler discarded the traditional division of art into national schools for a more universal historical point of view, which sought similarities and connections between the art of different societies and epochs, including prehistoric and primitive art. His writings deemphasized the broader cultural, social, and political context of art—for example, the *History of Painting* refers the reader who wishes more detailed information on sixteenth- and seventeenth-century Italy to Ranke's *History of the Popes*—and in this manner fostered the autonomy of the discipline. But the narrower approach was imposed by the mass and complexity of the art-historical material: it did not reflect Kugler's overall outlook. Art history, he asserted, was merely a branch of general cultural history, a statement that did not imply a causal connection running from the whole to the part, but their coexistence and mutual ties. Jacob Burckhardt, who studied with Kugler after he moved to Berlin in 1839, and soon turned from student to collaborator and friend, later declared that whatever qualities his work possessed he owed mainly to Kugler, and that Kugler was the first to analyze the history of art as a whole, trace its major lines of development, and survey all of its parts in the context of general history.[6]

Kugler's influence on Burckhardt and his role in the development of modern cultural history, a development that cannot be disassociated from the conception cultural historians have of their own age, has not yet been sufficiently analyzed. But it is apparent that he and Burckhardt derived great intellectual benefits from their friendship and collaboration, which were not limited to shared methods of studying the art and culture of earlier periods. In their commentaries on their own times as in their historical writings, Kugler and Burckhardt were sensitive to the links between art and its social and political environment, and both were receptive to certain aspects of contemporary art. The genre that held a special meaning for them was historical painting.

Kugler closely observed the changes in character that historical painting in Germany had undergone since the Napoleonic era, and did not hesitate to define the goals for its continuing development. From the idealized and the general at the beginning of

the century—official celebrations of ceremonial themes demanded by princely patrons, and treatments of Christian themes, strongly influenced by the neo-medieval and neo-renaissance works of such groups as the Nazarenes, a community or "brotherhood" of German artists which for a time worked in Rome—historical painting gradually became specific and realistic. By the 1830s and 1840s historical painting, like the study of history itself, had assumed a powerful new presence in German culture. The number of works on historical themes increased to such an extent that some contemporaries could claim it now was the most widely practiced genre in painting. Peter Brieger mentions an incident that symbolizes the replacement of former values, of ways of thinking and seeing, by the new historical art. When Friedrich Overbeck, a leading member of the Nazarenes, completed his painting *Triumph of Religion in the Arts*, the work was "indignantly rejected by [the philosopher and critic] Friedrich Theodor Vischer: this kind of religious art was outdated. The new supreme challenge, Vischer declared, was that of 'secular historical' painting. Who interprets the Holy Ghost more appropriately, Vischer asked, the artist who paints a dove over a bundle of rays, or the artist who shows me a noble and great man, a Luther or Hus, aflame with divine enthusiasm? The question, which answered itself, merely expressed an insight that during the previous decades had gradually become accepted truth."[7]

The slow turning away of historical art from the overtly symbolic, in which the idea is given absolute precedence over documented fact, toward attempts at a realistic interpretation of events that had actually occurred, represented a basic change in outlook. The agents of this general process, the artists, needed to master numerous specific tasks, which, although differing in kind and weight, were interdependent: the discovery of new methods of composition and execution, which broke free from styles of the past; the discovery of new themes and of suitable ways of dealing with them, a range of issues that included a problem that was at once superficial and linked to the very core of the process: should the painter depict his figures in accord with the physical types of their culture and times, and wearing clothes appropriate to their historical situation? Gradually, conventionally timeless robes and stylized "medieval" smocks and armor gave way to greater detail and an increasing effort to differentiate periods and social groups.

Relatively early examples of this transition are works painted in the 1830s by two leading exponents of historical painting at the Düsseldorf Academy, Ferdinand Hildebrandt and Carl Friedrich Lessing. With Munich, Düsseldorf had become a center of historical painting in Germany. Its director since 1826 was Wilhelm Schadow, a former Nazarene, who now proclaimed a realism in art that in its gentle, contemplative character was at best a very limited concession to changing tastes. His pupils Hildebrandt and Lessing went beyond their master. The former's *Murder of the Sons of Edward IV*, painted in 1835, caused a sensation with its pathetic description of the two sleeping boys about to be smothered. Collectors soon commissioned the artist to produce two copies. Kugler praised the work and noted its faithful adherence to its literary source (Shakespeare's *Richard the Third*, IV,iii).[8] To us today, everything in the painting is false, from its emotional tenor and the prettily posed figures of the victims and murder-

ers to the drapes, sword-hilt, open bible, and other embellishments that suggest an op-ulently theatrical High Renaissance rather than fifteenth-century London. Lessing's works were more serious, especially his paintings of John Hus and the Hussite Rebel-lion. Lessing immersed himself in the history of the period and studied sources on the correct clothing of his priests, soldiers, and peasants. Above all, he developed a com-pelling if one-sided historical interpretation of his subject. He re-created the Hussite movement as an early phase in the still continuing struggle of free men against Catholic orthodoxy and intolerance, a point of view that lent his paintings a political immediacy that his public had no difficulty in grasping. The painter Philip Veit, a grandson of Moses Mendelssohn, who had become converted to Catholicism, resigned as director of the Städelsche Institut in Frankfurt in protest against the purchase of Lessing's *Hus before the Council of Constance*. Lessing conveyed an unambiguous political message in his paintings, but they failed as works of art. Their composition was conventional, colors and brushwork were impersonal and timid, their historical character rested in their antiquarian details, and although each canvas was based on the confrontation of a leading figure with his supporters or opponents Lessing could manage neither the contrast between individual and mass nor their interaction. The crowds that surround Hus disintegrate into individual portraits, each a study of a particular attitude and emo-tion. The paintings were literary works to be read by the viewer, turning from face to face, from gesture to gesture.[9]

The most powerful historical art associated with Düsseldorf did not appear until the 1840s. Alfred Rethel, who came to the Academy as a boy of thirteen in 1829 and remained until he broke with Schadow in 1836, eventually created murals and paintings that were coherent both as art and as history. Their historical side reflected Rethel's genuine effort to understand the period he was interpreting, but also political and cul-tural forces of his own generation. Schadow profoundly disagreed with the contempo-rary relevance, the harsh monumentality, the energy and violence of Rethel's battle scenes and other historical works, as he disapproved of their search for historical veri-similitude, which Rethel actually pursued far less intensely than did many other artists, being content to let a few details stand for the whole. As late as the 1840s Schadow deplored the transmission of historical research to the canvas as a dilution of the ethical message that alone justified art. By that time the first German encyclopedia of costume had appeared, in response (the editor wrote) to the need of modern artists. By that time, too, the major art academies regularly offered courses in history and the history of costume. Art historians call the artists' use of scholarship in their work, very widespread between the 1830s and the end of the century, "historicism"—*Historismus*—which is not the same as the *Historismus* of Ranke and Meinecke but in its attempts at the intel-lectual and psychological re-creation of aspects of the past is related to it.[10]

What events and figures from the past should the historical painter choose for his work, and how should he interpret them? Despite Schopenhauer's earlier plea that his-torical art not ignore the ordinary, the 1830s still preferred significant individuals and incidents to the commonplace activities of obscure men and women, although in time

such characteristic events—often treated anecdotally—became widely accepted. Many artists and critics, influenced by the writings of Vischer and Kugler among others, came to agree that the most successful historical art—whether murals, easel paintings, graphics, or book illustrations—tended to be art that treated a specific and often crucial moment in a real rather than an imaginary, typical episode. The instant depicted should express the meaning of the entire historical event, which, if possible, the viewer could grasp even without specialized knowledge. In addition, the work should ideally convey a broader, more general message. An example of this approach is a painting, now very familiar, by the German-American artist Emanuel Leutze, who studied at the Düsseldorf Academy in the early 1840s and was strongly influenced by Lessing: *Washington crossing the Delaware*. Leutze took great care to familiarize himself with the superficial features of his subject, the weapons and clothes of the period—he even acquired a uniform coat that George Washington might have owned. His canvas reports on certain specific and crucial events of the early-morning hours of 25 December 1776—the unexpected movement of American troops to the northern bank of the Delaware River as a preliminary to a surprise attack on royal forces stationed in Trenton. But the painting also celebrates the hero who safely leads his cause through hostile elements—though, to be sure, the ice on the Delaware is breaking up and the wintry scene already holds the promise of a new spring. When the work was first exhibited it was widely praised. Leutze's contemporaries did not know—or perhaps found uninteresting—something that is evident and significant to us today: despite his careful historical research he produced a painting totally devoid of any sense of late-eighteenth-century America: his characters are men of the 1840s—students and burghers masquerading as freedom fighters of an earlier period.[11]

Kugler would have approved of Leutze's intention, if not of his manner of carrying it out. But Kugler came to find other kinds of historical subjects even more telling and important. These concerned events, not necessarily extraordinary or dramatic though still rich in symbolism, that were part of everyday social, economic, political, and military activity, which in the aggregate made possible the great turning points in history. In 1837, in a favorable discussion of twelve lithographs on important episodes in the history of Brandenburg-Prussia by the young Adolph Menzel, Kugler distinguished between the ceremonial and overtly symbolic—subjects favored by the conventional historical painter—and incidents that constituted the true historical substance of these events. The elevation of Frederick of Hohenzollern to the Electorate of Brandenburg, he wrote, was "certainly one of the important episodes in the history of Brandenburg, and is indeed suitable for artistic interpretation. However, its historical significance resides by no means in itself, but rather in its sources and consequences." It is these that the historical artist should address. To be sure, in the same article Kugler acknowledged that not only great social and political forces but also the outstanding individual formed a valid theme for historical art. In particular, he referred to what he termed *ethische Momente* in history, those instances when a supremely gifted man or woman recognizes

the general interests of the age, and uses them to achieve a great purpose or is defeated in tragic opposition to them.[12]

Historical art, Kugler wrote elsewhere, has the task of "revealing and making present to us true historical events."[13] "What research has explored must be brought to life by art."[14] "When written history presents us with only a general outline (which, to be sure, is very often the case), the artist must resort to his own imagination . . ."; but his inventions must be based on the serious study of whatever evidence is obtainable on the major forces, conditions, and attitudes of the period depicted, as well as of such external aspects as physiognomic types and costumes.[15] Kugler went so far as to assert that the study of costume was as important as the study of anatomy or perspective, a conscious exaggeration to which he could have resorted only to demonstrate how seriously he took the scholarly task of historical art.[16]

That historical art, as it moved from the ideal and speculative to the real world, might sound a strong political note was widely understood; indeed, this seems to have been a motivation for opposing such a reorientation. But few critics drew the consequences as sharply as did the young Burckhardt. At the end of 1842 Kugler invited him to review the annual art exhibition of the Royal Academy in Berlin for the *Kunstblatt*, a journal that Kugler co-edited with another art historian. Burckhardt did not hesitate to attribute the blandness, as he saw it, of contemporary German painting in part to its political and social environment. "Because the German until now has lacked a public life, which alone is able to create superior historical art, he has concentrated on the singular and individual . . . Because our art, despite its youthful vitality, lacked the breath of drama and history [*dramatisch-historische Athem*], it embraced an unlimited symbolism, which is now displayed before our eyes in a wide spectrum from the most sublime reflection to silly frivolity . . . In his mind's eye the German artist sees the psychological-symbolic problem rather than dramatic action . . . Not a single German painting in this exhibition displays a true historical style." Burckhardt thought, however, that times were changing: "We confidently count on the public life that is awakening so vigorously in these days, which promises the beginning of a new historical era, and we believe that a new historical style will soon reveal itself."[17]

Kugler's co-editor of the *Kunstblatt*, Ernst Förster, denied the validity of Burckhardt's critique, which he took less as an appraisal of general conditions than as an attack on the philosophic and symbolic treatment of biblical and historical themes characteristic of the Nazarenes, and Kugler felt obliged to defend his protégé. In an open letter, in which he shifted the argument from the specifically political to the broader issue of realism, he criticized contemporary German art in words that became famous: "To its aristocratic element our [German] art must add as a necessary counterpart a democratic element . . . Yes, a democratic element in the full, bold sense of that term."[18] Kugler was certainly not a democrat. To the extent that he held any strong political views, they were those of a moderate and, on occasion, rather cautious Prussian liberal. But politics mattered far less to him than did scholarship and art. His call for an art that

was both aristocratic and democratic echoes through German cultural history for the next three generations. Both Burckhardt and later, in the 1890s, another Swiss, Hugo von Tschudi, director of the Berlin National Gallery, adapted it for their own criticisms of German art; but the original statement was not a declaration of political faith. Rather, Kugler meant it as a plea for greater realism in German art, for an art that renounced the idealized treatment of ceremonial and official consecrations of power in favor of a more intense reflection of everyday life in the past as well as in the present. Such an art, to be sure, would also give new value to these commonplace and often unaristocratic, even anti-aristocratic, forces in German life.

When Kugler accepted Weber's invitation to write a biography of Frederick the Great, he welcomed the occasion to demonstrate the high degree of realism and scholarship that historical art could attain—especially illustrations closely coordinated with the text. In Menzel he found a collaborator who to a degree unique in German art of the time combined the two qualities that Kugler proclaimed as essential in modern historical art. Perhaps it would be more accurate to say that Menzel held out the promise of doing so, since at the beginning of 1839 he was still in the early stages of his career. He was born in 1815, in the Silesian town of Breslau. His father, master of a girls' school, later opened a small lithographic studio in Berlin and taught his son the rudiments of lithography and of other graphic techniques before his early death in 1832. At the age of sixteen the young Menzel became the breadwinner for his mother and his two younger siblings. He matured early into a harsh, aloof personality; the burden of his responsibilities made heavier by the psychological isolation created by his exceptionally short height—he never grew beyond four feet seven inches. Although he had the capacity for great affection, he remained throughout life an observer more than a participant in human relationships. Even his first works reveal an unusual combination of characteristics: an intense realism and an almost equally pronounced interest in history, to which he brought the same insistence on unadorned truth that marked his pictures of Berlin in the 1830s. Some graphics on historical subjects, especially his sequence of lithographs on major events in Brandenburg-Prussian history, demonstrated a scholar's care in the use of historical sources. At the same time Menzel was making a small name for himself as an interpreter of contemporary life, notably with illustrations to Chamisso's *Peter Schlemihl* whose matter-of-fact character oddly complements the symbolism of Chamisso's fantastic tale, and with his engravings for Goethe's dramatic poem *Des Künstlers Erdewallen*. It is characteristic of Menzel's fascination with life as it is that in the springtime of the European *Bohème* he refused to romanticize the world of the artist but was attracted to Goethe's bitterly humorous account of a painter's inspiration, his struggle against poverty and lack of understanding, and his posthumous recognition.

The character and extent of Menzel's realism have been frequently discussed in the art-historical literature. In its preoccupation with technical issues, the debate too often minimizes Menzel's stated intentions and his fundamental attitude, that of a passionate

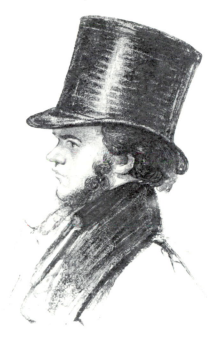

2. Oskar Bargemann after Franz Krüger:
Adolph Menzel, 1837.

eyewitness who understood that (as he wrote when he was twenty-one) "not everything is true to nature that is copied from nature with anxious accuracy."[19] In his paintings and graphics on historical themes the artist's visual control of appearances was supplemented with an intellectual and emotional effort to understand the phenomena of the past, which he re-created in ways he believed to be historically authentic and at the same time realistic in contemporary terms. The individuals he depicts do not strike poses; they could never be taken as representatives of a philosophical system or of the World Spirit. They are men and women moving in an environment that is familiar to them even if not to the viewer.

To Menzel as to Kugler, the biography of Frederick offered the opportunity to test and develop this conception of realism, which stretched unbroken from interpretations of the present to interpretations of the past, although when dealing with historical events the artist's powers of perception required the buttress of research. In connection with another of his many projects, Kugler had compiled an inventory of several thousand sources on the history of Frederick and his times, which he now gave to his collaborator: lists of eighteenth-century paintings and graphics; books, manuscripts, and maps; uniforms, clothes, and flags; buildings and furniture. Menzel made extensive use of this evidence and listed many of the items in an appendix to the book, "Historical Documentation to Aid the Reader in Interpreting some of the Illustrations"—an open

declaration, if any were needed, of the scholarly view the artist took of his task. Kugler and Menzel set to work in the spring of 1839. Both proceeded rapidly, so that the following year chapters of the book began to appear in installments. The whole was published in 1842 as a volume of nearly 650 pages with 376 wood engravings, on average more than one illustration, vignette, or decorated initial for every two pages.[20]

III. MENZEL'S ILLUSTRATIONS FOR *FREDERICK THE GREAT*

THE PROFUSELY illustrated book, its images and decorations closely integrated with the text, printed in large, relatively cheap editions, became an important publishing phenomenon in the 1830s. The best early specimens appeared in France, but the technical development that helped make this new kind of book possible—wood engraving—had been developed over the preceding decades in England, and a Northumbrian, Thomas Bewick, was its first master. In wood engraving, the artist, or more usually a technician working from a sketch, copies or traces the original on a plate of hard wood cut across the grain, using not knives as in a conventional woodcut but a burin and other engraving tools to trace and lift out the areas that are to remain white on the print. The technique permits finer lines and greater detail than are possible in a woodcut, in which the image is cut into a plate of softer wood. Its thin lines and gradations of tone tend to contrast less with modern typefaces than do the heavier blacks of the woodcut; the wood engraving is printed together with the text, and the hard woodblock allows a greater number of good impressions than can usually be produced by a woodcut. The many reprints of Kugler's and Menzel's *History of Frederick the Great* in the nineteenth century used clichés of the first edition for the illustrations, but in 1922 a large reprinting made use of the original blocks, and the impressions, though somewhat darker than those of the first edition, are still of better than acceptable quality.

The new illustrated book, its images a major rather than a subordinate part of the whole, was one of the innovations in publishing in the second quarter of the nineteenth century that created, and catered to, a rapidly expanding reading public. It gave impetus to the popularization of the sciences which began in earnest in the 1830s, and to the popularization of history that was associated with it for a time. The illustrated book also reflected the demand of Romanticism for the interaction of different art forms. The breakdown of barriers between the arts, Charles Rosen and Henri Zerner have written, "found its most natural expression and its greatest success in book illustration."[21] Of course, the former insistence on the separation of the arts notwithstanding, some interaction had always taken place. Not a few late-eighteenth-century operas, for example, had texts of sound literary quality: da Ponte's libretto for *Don Giovanni* was superior to most earlier stage treatments of the Don Juan theme; and Mozart's score and da Ponte's text not only are joined, but fuse the dramatic and tragic with comedy. But while hardly new, simultaneity of the arts and modes responded to the Romantics' strong sense that truth in art was found in commingling.

Probably the most influential early book in which illustrations are not separated on plates but are printed on the same page as the text, with which they form a single expressive unit, was the 1835 edition of Alain Lesage's *Gil Blas*, with several hundred wood engravings by Jean Ginot. The new style joined rather than replaced the earlier manner. For example, when the collected works of Béranger were published in 1836, Grandville's illustrations, perfectly attuned to Béranger's verses, were printed on separate plates distributed throughout the text. But for some years the close integration of word and image became the fashion, which led to some beautifully designed and produced books, but also to much that was mediocre. In 1836 an edition of *Don Quixote*, illustrated by Tony Johannot, was published by Dubochet, the same firm that two years later brought out the biography of Napoleon with Vernet's illustrations. The two books do not compare with such superb examples of integrated design as François Fabre's simple, elegant *Némésis Médicale* with illustrations by Daumier, published in 1840, or Louis Huart's *Muséum Parisien* of the following year, whose only flaw is a lack of stylistic unity among its 350 illustrations, the work of not one but six artists, Daumier and Grandville among them. Nor could Vernet's *Napoléon* match another biography of the emperor with marvelously evocative illustrations by Auguste Raffet, which was published in 1842. Kugler and Menzel patterned their *History of Frederick* on a work that represented the good commercial average of the new style rather than one of its great achievements, but they succeeded in far surpassing their model.

In their general appearance the two books are fairly similar. Both are large quarto volumes—the dimensions of the French work, 25.4 × 16.8 centimeters, a trifle larger than the German. In both, the page is framed with double rectangular lines—the corners often imperfectly joined in the French volume—which enclose page number, text, illustrations, and vignettes. The German volume lacks running heads, which makes for a simpler, stronger page, and its typeface is *Fraktur*, while the French text is set in Bodoni. In both works the placement of the illustrations is irregular—at the head or bottom of the page, or between blocks of text. Occasionally an illustration broaches one or both lines framing the page, which adds variety to the layout and greater immediacy to the image. The differences between the two works—and they are great—rest in the character of the text and of the illustrations, and in their manner of interacting.

Laurent depicts Napoleon as one of the great men in history, who, knowingly or not, advance the cause of humanity. Even actions that seem only to spread misery, such as wars, are instruments of Providence. The emperor is the representative of three centuries of French culture, which his wars carry to the less developed countries of "northern and southern Europe." He is also the champion of the "revolution that in its infancy was called 'the French,' but that had already demonstrated . . . that it was destined to become universal." It is only when Napoleon, from considerations that are understandable but nonetheless mistaken, begins to act like the head of a dynasty rather than the first magistrate of a free society—a transformation said to occur in 1812—that he falters. Laurent's interpretation combines a Romantic concept of the genius who is above

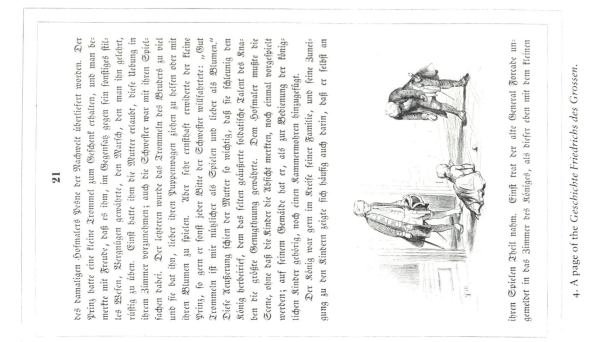

21

des damaligen Hofmalers Pesne der Nachwelt überliefert worden. Der Prinz hatte eine kleine Trommel zum Geschenk erhalten, und man bemerkte mit Freude, daß es ihm, im Gegensaß gegen sein sonstiges stilles Wesen, Vergnügen gewährte, den Marsch, den man ihn gelehrt, rüstig zu üben. Einst hatte ihm die Mutter erlaubt, diese Uebung in ihrem Zimmer vorzunehmen; auch die Schwester war mit ihren Spielsachen dabei. Der leßteren wurde das Trommeln des Bruders zu viel und sie bat ihn, lieber ihren Puppenwagen ziehen zu helfen oder mit ihren Blumen zu spielen. Aber sehr ernsthaft erwiderte der kleine Prinz, so gern er sonst jeder Bitte der Schwester willfahrtete: „Gut Trommeln ist mir nüßlicher als Spielen und lieber als Blumen." Diese Aeußerung schien der Mutter so wichtig, daß sie schleunig den König berdrief, dem das feste geäußerte soldatische Talent des Knaben die größte Genugthuung gewährte. Dem Hofmaler mußte die Scene, ohne daß die Kinder die Absicht merkten, noch einmal vorgespielt werden; auf seinem Gemälde hat er, als zur Bedienung der königlichen Kinder gehörig, noch einen Kammermohren hinzugefügt.

Der König war gern im Kreise seiner Familie, und seine Zuneigung zu den Kindern zeigte sich häufig auch darin, daß er selbst an ihren Spielen Theil nahm. Einst trat der alte General Forcade ungemeldet in das Zimmer des Königes, als dieser eben mit dem kleinen

4. A page of the *Geschichte Friedrichs des Grossen.*

186

HISTOIRE

pour laquelle il avait fait la révolution, l'établissant, au contraire, sur la base indestructible de la justice, sur la rémunération proportionnelle des services et des vertus.

Une lettre de remerciements qu'il reçut à cette époque d'un sergent de grenadiers, nommé Aune, lui fournit l'occasion de faire la réponse suivante : « J'ai reçu votre lettre, mon brave camarade, lui écrivit-il, vous n'aviez pas besoin de me parler de vos actions, je les connais toutes. Vous êtes le plus brave grenadier de l'armée depuis la mort du brave Benezette. Vous avez eu un des cent sabres que j'ai distribués à l'armée; tous les soldats étaient d'accord que c'était vous qui le méritiez davantage.
» Je désire beaucoup vous revoir, le ministre de la guerre vous envoie l'ordre de venir à Paris. »

Quelques vues secrètes que Bonaparte pût cacher sous ses démonstrations de franchise et de familiarité, il vaut mieux encore le voir flatter et récompenser ainsi la bravoure, même par calcul d'ambition, que de le suivre aux fêtes données en l'honneur des hommes qui furent censés

3. A page of *L'Histoire de l'Empereur Napoléon.*

all rules with an intensely patriotic sense of French mission, wrapped up in a general faith in progress. It is couched in a narrative largely devoted to military affairs, which attributes Napoleon's eventual failures on the battlefield to the perfidy of his enemies, to the treachery of his allies, and to occasional misunderstandings or fatigue on the part of his subordinates.[22] For his sources, Laurent drew almost entirely on French materials, notably such staples of the Napoleonic legend as the bulletins of the *Grande Armée*, the *Mémorial* of St. Helena, and Béranger's songs, all of which he treated uncritically.

Kugler's sources were better than Laurent's, and his interpretations, while usually very favorable to their subject, more detached and on specific issues more critical. He combined memoirs and contemporary collections of anecdotes with the most scholarly texts then available, in particular the heavily documented, almost unreadable multi-volume biography by Preuss, who also agreed to review the text for accuracy. Essentially Kugler wrote the life of Frederick as a personal and political *Bildungsroman*, in which the pupil eventually becomes the teacher. In 1839 Preuss was completing a new study of Frederick's youth, and based largely on Preuss' findings Kugler for the first time gave the general reader a detailed account of the young man's conflict with his father, his attempt to flee Prussia, his capture, the execution of the young officer who had helped him, and the gradual reconciliation between father and son. According to Kugler, in this profound psychological crisis Frederick learned to subordinate himself to the demands of his royal position, just as every Prussian was learning to subordinate himself to the authority of the new, centralized Prussian monarchy.

Not unlike Napoleon, Kugler's Frederick is a driven individual and a world-historical force; but he is not destructive of the international order, and his reign does not end in failure. He is also a complex human being, torn by conflicting emotions and interests. In a new introduction to the second edition, Kugler noted that Frederick "was not launched on his course like some miraculous meteor; rather we see him develop step by step."[23] His is an innovative, expansive modern mind; but he cannot completely shed traditional, restrictive attitudes. Kugler deplores the king's personal harshness, which could lead to injustice, but regrets even more some of his policies—the human and economic cost of his wars, and his insistence on maintaining rigid legal divisions between social groups, represent "a point of view that has become alien to us today"[24] Repeatedly Kugler points to the links between the economic and cultural vitality of society and its hierarchic character. Frederick, he writes for instance, was concerned for the well-being of the peasants, "but although he would not tolerate real serfdom in his states, he did not dare release the peasants from the numerous dependent relationships to the noble landlords, since that would have forced him to reduce the prerogatives of the latter. Consequently agriculture could not be brought to the desired flowering."[25] Such shortcomings could not, however, be explained by measuring them against the standards of the 1840s; they must be seen as impediments of the times to which even a genius is subject. In the final analysis they fade to insignificance before the king's constant care to advance the state and to prepare a politically immature society for its subsequent tasks. Then as now, Kugler's interpretation may be summarized, Frederick is a *praecep-*

tor patriae. But in the example he gives of enlightened ideas and energetic government he also was and continues to be a *praeceptor rei publicae.*

What do Menzel's illustrations contribute to this interpretation? Kugler, we know, believed it was the task of historical art to reveal and make present "true historical events" to later generations. But the act of revealing, although in the first place addressed to the viewer's imagination and aesthetic sense, cannot be separated from the act of explaining, and not every aspect of the past lends itself to treatment on canvas or woodblocks. Even illustrations, which are not independent statements but in one way or another work together with a text, might find it difficult to analyze the development of political theory or to inform us of the quality, amount, and profitability of a given economic activity. Art can, however, interpret the impact of political ideas on individuals or societies, or impress on us the human reality of agricultural or industrial labor; and art may be a particularly powerful tool of psychological interpretation and of the elucidation of historical forces by means of symbols. When Menzel began work on his illustrations he may not have been fully aware of the range of possibilities he was facing. He started out with a pronounced political view of his subject. It is the main difference between Frederick and Napoleon, he wrote in his first letter to his publisher, "that Frederick was more of a father to his people, and therefore his memory is sacred above all to the bourgeoisie, among whom the seeds of his institutions continue to thrive more vigorously and effectively [than in other groups]."[26] But as he entered deeply into Frederick's history, his vision of the paternalistic and enlightened monarch was joined by other and often contradictory themes: the development of Frederick from a difficult childhood to a powerful but lonely old age, and his complex relationship with his immediate and wider environment: family, army, society, the Prussian state. He conveyed the drama—and in the course of the book increasingly the tragedy—of a gifted, powerful individual whose achievements were paid for with the efforts, sacrifices, and lives of the many.

As their publisher had expected, Menzel's pictures extended the reach of Kugler's text by attracting a clientele that otherwise might have shown little interest in a history of Frederick the Great. They also enlarged the interpretation by giving the text greater specificity, psychological force, and imaginative appeal. This presupposed a strong affinity in the views that author and artist took of Frederick, an agreement further strengthened by their shared realism. Although Menzel quickly learned to appreciate the power of symbolic interpretations, he rarely chose symbolic, ceremonial occasions as his subject. He preferred to depict events that, in Kugler's terms, lent these occasions their true historical significance, and he placed great value on everyday incidents. By concentrating on fleeting instances of action and behavior he created an effect of immediacy, which Kugler and others likened to the plain truth transmitted by the new medium of photography.[27] An early example is an illustration to an anecdote from Frederick's childhood, in which a general surprises Frederick William I playing ball with his small son. It is one of Menzel's first illustrations, when he had not yet trained his wood engravers to follow his drawings carefully, and when the drawings themselves

were still rather stiff—something that changed in the course of the work. But we can already see Menzel's interest in movement and immediacy (Fig. 4).

If Kugler's text and Menzel's illustrations proceed on fairly parallel courses, not all aspects of the text are reflected in the pictures, and others are brought more sharply into focus than the author may have intended. For example, the illustrations do not refer to Kugler's critical discussion of the hierarchic character of Frederician society—although at least once Menzel comments ironically on military arrogance.[28] On the other hand, Kugler's observations on the high casualties of Frederick's wars and on their social and economic costs were expanded by Menzel into a major theme, which in turn helps shape the fundamental character of his interpretation: the movement back and forth between the king and the mass that does his bidding.

5. Horace Vernet: Execution of the Duc d'Enghien.

Menzel's ability to strike out on his own without coming into serious conflict with the text constitutes one of the great differences between his and Vernet's work. He is an interpreter in his own right; Vernet stays very close to Laurent's panegyric text. Vernet begins each chapter with a large decorated initial, the design of which usually refers to the content of the chapter—a practice Menzel borrowed. Occasionally Vernet illustrates a passage of the text with a symbolic drawing. His treatment of the execution of the Duc d'Enghien, for example (Fig. 5), shows lilies, the badge of the Bourbon dynasty, smashed by musketballs, which pit the wall behind the broken stalks. It is one of the most effective illustrations in the book; but generally Vernet chooses a more literal ap-

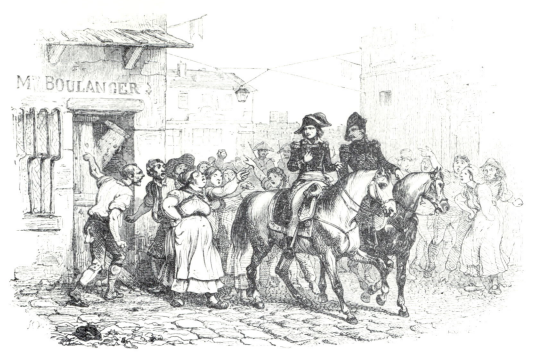

6. Horace Vernet: Napoleon and the Fat Woman.

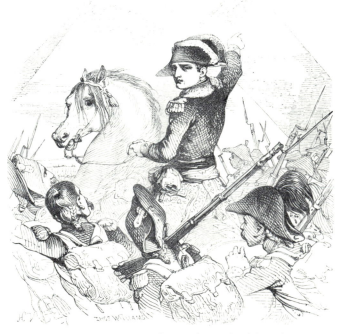

7. Horace Vernet: Napoleon at the Battle of the Nile.

proach. He also prefers smaller scenes, often treated anecdotally, in which the emphasis is placed on a group or a few individuals, or often on Napoleon alone. A characteristic example occurs in the early chapter on the years between Thermidor and the first Italian campaign (Fig. 6). The text (quoting Las Cases) relates that in one of the minor bread riots after Vendemiaire, Napoleon was confronted by a monstrously fat woman who shouted that the well-fed officers on horseback didn't care that the people were starving. Vernet depicts the incident at the critical moment: people are pointing at the bakery and shaking their fists, just as Napoleon is about to reply to the woman, a reply that disarms the crowd by making it laugh. Who, he asks, is fatter: he or she?

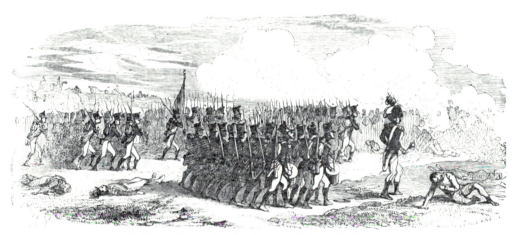

8. Horace Vernet: Attack of the 57th Infantry Regiment.

Vernet follows Laurent in presenting Napleon's life primarily from the perspective of war. But, oddly, he never draws large units of men, let alone entire armies. Even the decisive battles of the most massive wars in history until that time are depicted by isolating a detail from the larger event: a few soldiers or groups of soldiers, the emperor usually at their center, stand for the whole. An instance of Vernet's preference for reducing the scale is his illustration of Napoleon's exhortation to his troops as they are about to engage the Turkish army in Egypt: forty centuries are watching you from the pyramids! (Fig. 7). The picture offers a melodramatic reconstruction, in which a few individually realized soldiers represent the mass being inspired by the charismatic leader. Whatever the circumstances in which Napoleon made his famous appeal to their pride, it could not have been in the midst of a swirling group of infantrymen, whose very panache in closing with the enemy is a reaction to words that are still being uttered. Even in his very rare pictures of larger numbers of soldiers, Vernet tries to individualize. An illustration for the chapter on the War of 1809 (Fig. 8), showing a French regiment

advancing, emphasizes a drum major, two drummers of the unit in the foreground, and a wounded soldier in the classical pose of a Roman gladiator.

Usually, however, Vernet prefers a close focus. Characteristically, his interpretation of the burning of Moscow simply shows the emperor watching the flames from a window in the Kremlin. Truly astounding is the single illustration for the Battle of Waterloo (Fig. 9). Once again the clash of armies is reduced to an anecdotal character study, which combines a Romantic concept of the genius who dares all regardless of consequences with the portraits of a few soldiers, representing the French army, each caught in a different pose: loading, firing, being hit. The details are realistic, but the whole is false. We know that whatever the appearance of the battlefield on 18 June 1815, it wasn't anything like this. But Vernet's theatrical vision suits the basic tenor of the text: the genius who follows his star with blind self-assurance is the main, almost the only, subject. The society in which and with which he fulfills his destiny Vernet, like Laurent tends to ignore. Menzel, by contrast, is fascinated by the conflicting traits of Frederick's personality, by his difficult growth to maturity, and by the social and military forces that Frederick sets in motion and exploits but only in rare moments fully controls.

Only two dozen illustrations after the early scene of the little boy playing with his father, Menzel reaches the high intellectual and technical level that with few exceptions

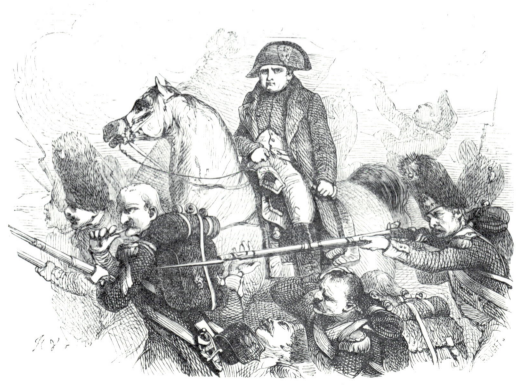

9. Horace Vernet: Napoleon at Waterloo.

10. Adolph Menzel: An Escaping Horse.

he maintains for the rest of the work. A powerful symbolic statement marks the change (Fig. 10): a runaway horse, its bridle torn, is the frontispiece of the chapter on Frederick's attempt at the age of eighteen to escape from his father. The image catches the psychological reality of the escape; it also makes a play on words: *sich im Zaum halten*—to keep oneself in check, to bridle one's emotions—is what the young man was too desperate to do. The drawing's impact on the reader is scarcely diminished by a certain awkwardness in the positioning of the horse's legs—at the time Menzel acknowledged that he found horses difficult to draw. An improvement in the quality of engraving is also apparent. It was executed by Ludwig Unzelmann, the most gifted among the German wood engravers Menzel was training to new standards of faithfulness in copying his drawings.

After the reconciliation with his father, Frederick was given a residence in Rheinsberg, near Berlin, in a chateau that was remodeled according to his wishes. Menzel illustrates this episode with a sketch that combines an emphasis on movement and everyday activity with a deeper meaning (Fig. 11). Masons and painters are working on a scaffold that encompasses the entire scene; in the center the painter Antoine Pesne shows a courtier the fresco he is completing: Apollo in his chariot driving away the night. It was also in Rheinsberg that Frederick wrote his discussion of political principles, the *Anti-Machiavel*. Menzel was dissatisfied with his treatment of the last theoretical statement on politics that Frederick made before ascending the throne—Frederick's hand holding up the tract to a bust of Machiavelli (Fig. 12). For the second and subsequent editions he drew another, more forceful version of the same motif (Fig. 13). He

35

11. Adolph Menzel: Antoine Pesne shows his
Painting of the Rising Sun.

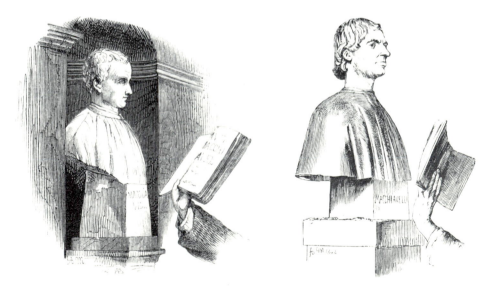

12–13. Adolph Menzel: Frederick's *Anti-Machiavel* (first version left
and second version right).

36

14. Adolph Menzel: Death in the Camp (first version).

made other substitutions as well, the most interesting being that of a vignette accompanying Kugler's description of the eve before a battle: Death as a drummer awakes soldiers asleep in their tents (Fig. 14). In later editions Menzel showed Death running through the camp in a miniature dance of death, the other dancers still unseen in their tents (Fig. 15).

The interactions of symbolic and realistic elements in Menzel's illustrations reach their highest intensity in his treatment of war. He interprets Frederick's campaigns from three perspectives: the strategic genius of the king and his relationship to his troops, a relationship in which the army is not merely a passive instrument but is often unpredictable, with a will of its own; the energy and sacrifice of many thousands of men, which make the wars possible; the very great cost in lives and suffering. Unlike Vernet's Napoleon, Frederick is not constantly in the forefront of the illustrations. Menzel makes a point of Frederick's leadership, but for long stretches his person is submerged beneath the action of armies, individual soldiers, civilians, diplomats—the entire range of society carrying on and experiencing the conflict.

The chapters on the longest and most critical of the wars—the Seven Years War—provide examples of the manner in which Menzel develops these themes. The discussion of the diplomatic antecedents of the war opens with two juxtaposed images (Fig. 16).

15. Adolph Menzel: Death in the Camp (second version).

16. Adolph Menzel: Mars, and the initial *D*.

The first letter, a decorated initial *D*, is drawn as an open window in a half-timbered house, through which we see a family standing before a table (lit by what appears to be a small Christmas tree), father and mother with folded hands. But the peace of these humble folk is threatened by the gigantic figure of Mars approaching, a scourge in one hand, a torch in the other. The chapter ends with the three final lines of Frederick's response to Voltaire of October 1757. Voltaire had urged the king to compromise with his enemies and renounce some of his conquests rather than fight to the death. Frederick

38

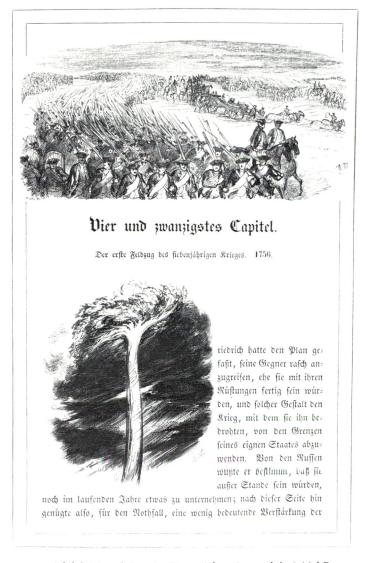

17. Adolph Menzel: Prussian Forces Advancing, and the initial *F*.

replied that a peaceful existence was appropriate for Voltaire, but that "I, threatened by shipwreck / Facing the storm / Must think, live, and die as king"—lines Menzel follows with a vignette of Frederick's arm emerging from an ermine cloak, raising his sword.[29]

Book III of *Frederick the Great* deals with the war itself. Its title page, the heading "Heroism" drawn against a stormy sky, presents the conflict as a fight among eagles. Immediately following is the chapter on the first campaign of the war, which opens with

a large initial *F* formed by a bolt of lightning crossing a storm-whipped tree, while above the chapter-heading seemingly endless columns of Prussian troops sweep into Saxony (Fig. 17).

In the ten illustrations to the events between the beginning of the war and the first Prussian defeat, the Battle of Kolin, Frederick appears only once—as a distant figure, silhouetted against a window through which he observes the advancing enemy. The account of Kolin is illustrated with two engravings of Prussian forces taking heavy casualties.

Other illustrations emphasize the cost of the war even more drastically (Figs. 18–21). In a devastated town, survivors are burying their dead. A Prussian convoy, carrying supplies to the army, is ambushed and its covering force destroyed. The chapter on the end of the war includes a vignette of a dazed and terrified soldier sitting among corpses.

18. Adolph Menzel: Burials in a Destroyed Town.

Menzel used a similar motif with larger focus in a chapter on the Second Silesian War: dead and wounded line the foreground; a sentry stands on the slope of a hill in the middle distance, while a few men carry bodies down the opposite slope; in the far background, troops mass for the next engagement.

Among the war pictures are some remarkable night scenes. Each is based on a documented event, but of course Menzel had many options to choose from. He seems to have decided on these scenes for the technical challenge they presented and in order to heighten and further dramatize the uncertainty, danger, and horror of war. After the book appeared, several reviewers criticized these engravings as too dark and indistinct; one or two even suspected that the printing was faulty. In fact, the night scenes are among the most impressive of Menzel's war images. We have seen the vignettes of Death running through the camp. A more realistic use of darkness occurs in the picture of a march at night (Fig. 22). A lantern carried by a man walking next to the king, who is

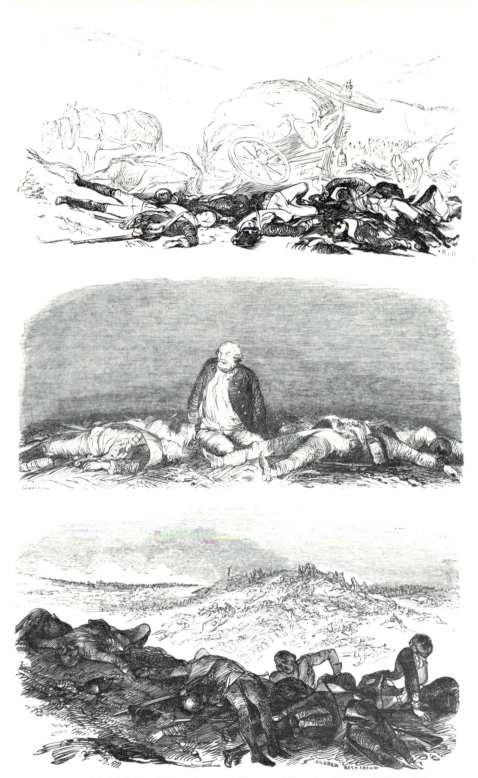

19–21. Adolph Menzel: From the top, A Destroyed Prussian Convoy, A Wounded
Soldier and Corpses, and A Battlefield Covered with Corpses.

22. Adolph Menzel: Frederick on a Night March.

mounted on a white horse, provides the only light. The scene of a night battle is filled
with movement and drama (Fig. 23). In the foreground we can just make out a wounded
officer being carried away. The episode—the Prussian defeat at Hochkirch in 1758—so
interested Menzel that he decided it deserved a further illustration (Fig. 24). Also set at
night, but very different in character, is a scene of Frederick by a campfire, having just
dismissed an officer who reported the approach of the enemy (Fig. 25). This complex
and sophisticated composition once again reveals Menzel's deep interest in movement
and simultaneity, but it also suggests the limits of his type of realism. The king looks
after the officer who rides off to the right, but he is already turning toward his own
horse, which a page leads forward. Officers around the billowing fire are watching and
talking, and in the foreground a grenadier, adjusting his cartridge belt, hurries to join
his unit. Everyone and everything is in motion, and the urgency of the moment and the

23. Adolph Menzel: Field Marshal Keith Mortally Wounded.

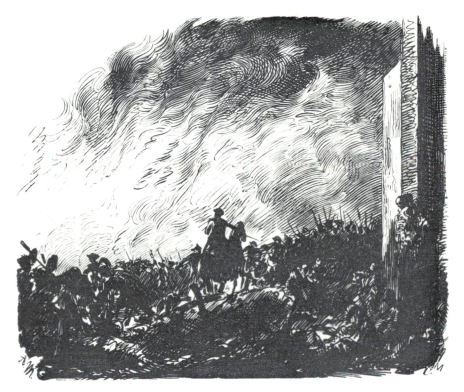

24. Adolph Menzel: Battle at Night.

springing into action of the military machine are made plain. But inevitably the picture has a slightly posed quality. To some eyes at least, Menzel's more impressionistic sketches or, on the other hand, some of his more stylized images strike a more powerful note of reality.

Menzel's illustrations for the last segment of Frederick's reign, the twenty-three years after the end of the Seven Years War, include some of his most atmospheric images and a few striking symbols. A vignette of a hand holding up a rickety wall (Fig. 26)—the wall strangely reminiscent of Klee's 1916 lithograph *Destruction and Hope*—introduces a discussion of policies of economic reconstruction, to "heal the wounds caused by the Seven Years War." A passage on draining marshes and building dams to make land arable is illustrated by a landscape, with the king and three officials on the banks of a stream (Fig. 27). The picture is based on a sketch Menzel had recently made in the countryside near Berlin (Fig. 28). The rendering of a contemporary scene becomes the source for his interpretation of a similar subject seventy years earlier. Kugler's balanced analysis of the first partition of Poland, in which he expresses sorrow over the "approaching end of a magnificently gifted people that once had been great and powerful," is accompanied by Menzel with images less sympathetic to the Poles. One sketch is of a

43

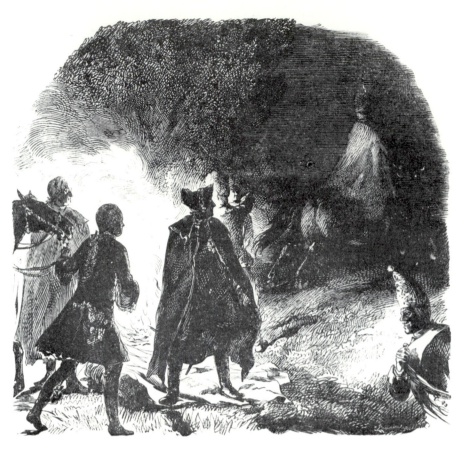

25. Adolph Menzel: Frederick by a Campfire.

26. Adolph Menzel: A Hand Supports a Wall.

44

27. Adolph Menzel: Frederick on the Banks of a Stream.

28. Adolph Menzel: *Landscape*.

45

29. Adolph Menzel: The Polish Crown.

meeting of the Polish Diet, a few nobles and a decidedly unsaintly cardinal in the foreground. The drawing a few pages further on, of a Polish crown robbed of its jewels (Fig. 29), is Menzel's comment on the political bankruptcy of the state.

Throughout the book, later illustrations allude to earlier ones, reinforcing the work's aesthetic unity while tracing the continuity and change in a man's life. A drawing in the penultimate chapter, showing the old king reading at his desk (Fig. 30), is a var-

30. Adolph Menzel: Frederick Reading at His Desk.

iant of the same theme in a chapter on internal policy before the Seven Years War (Fig. 31). In a note to the earlier picture Menzel adds that the king's study remains as it was in 1786, and that the drawing was made on location. Again we note his attempt to combine verisimilitude with immediacy. The king is not presented in a formal manner but is seen from another room through open double doors—in the later drawing one wing has been shut—as though the reader were passing by. These are among Menzel's illustrations that other artists were to copy and adapt for the next three generations, a process of borrowing that further popularized Menzel's way of seeing the king and gave it universal validity in Germany.

In their treatment of Frederick's last years and death, Kugler and Menzel permit themselves a degree of emotion that at times comes close to bathos. A vignette of the old king, seen from the back, standing among tombstones (Fig. 32), concludes an ac-

31. Adolph Menzel: Frederick Working at His Desk.

32. Adolph Menzel: Frederick among Tombstones.

count of Frederick's gradual withdrawal from relatives and closer associates, and of his comparable isolation in the changing cultural environment of Germany. Kugler refers to the king's inability to understand the works of the new generation of German writers—a failure his critics long held against him—and comments that this lack of comprehension "once again . . . reveals a singular and characteristically tragic note" in Frederick's life. The elegiac tone of the collaborators' account of an old man's life fading is interrupted with the depiction of the seventy-three-year-old—a cloaked figure on horseback, gesticulating with his sword—conducting maneuvers in a driving rain (Fig. 33). The scene, at once dreary and demonic, conveys for the last time the energy, harshness,

33. Adolph Menzel: Frederick on Maneuvers.

48

and violence of Frederick's nature, which the reader has observed throughout the book. Then follows a drawing of the dying man sitting in the sun before the Potsdam palace (Fig. 34), its façade, which Menzel gives a more classicistic appearance than in fact it had, already hinting at the coming of a new age, the towering pillars and the shrunken figure contrasting the continuity of the state with the transient existence even of a king.

34. Adolph Menzel: Frederick Sitting before
the Potsdam Palace.

IV. MENZEL'S HISTORICISM

JUDGING from the reviews of the *History of Frederick the Great*, contemporary readers approached the text and the illustrations as two equal partners in the enterprise of elucidating the past. They seemed not to distinguish between the historian, who develops his interpretation from a study of the primary and secondary sources, and the artist, who—though in this case of exceptionally strong scholarly bent—relies on his imagination more fully and certainly more obviously than does the writer. Readers of the 1840s, in other words, did not draw a hard-and-fast line between scholarship and art. At most they noted the clarity and strong narrative of Kugler's prose, and the absence of a scholarly apparatus—both of which brought his scholarship still closer to art. A century and a half later, we are driven to make a stronger distinction: Kugler's text may be scholarship, Menzel's images can only be art. In fact, Kugler's text has now lost whatever limited scholarly value it once possessed—his interpretation of Frederick is no more to us than a source for certain attitudes and ideas of the early 1840s. Menzel's wood engravings are that too, but they have survived as works of art.

Our point of view today may, nevertheless, be too limiting. Even alone, unsupported by Kugler's text, Menzel's illustrations do project a coherent image of Frederick's personality and life; they are not a bad example of a certain kind of narrative history. It is, of course, also true that at least one other work of the imagination created in these years in which historical problems are major themes is not only greater art than are Menzel's wood engravings but far more substantial history than Kugler's and Menzel's book—Georg Büchner's play *Danton's Death*. Büchner weaves into his dialogue very extensive passages from contemporary sources—especially the minutes of the Convention and records of the Revolutionary Tribunal—to create an interpretation of a key phase of the French Revolution; and though it is only one possible interpretation among several, it retains its interpretive power to this day. *Danton's Death* is the most impressive example of the continuing interaction, even synthesis, of history and the arts in Germany before the Revolution of 1848. And like *Frederick the Great* it becomes a document of the political conflicts of the time.

Something must still be said about two further aspects of Kugler's and Menzel's *Frederick the Great*: the extent to which it reflects eighteenth-century reality rather than nineteenth-century assumptions, and the content of its political message. We began our discussion of *Frederick the Great* by measuring the work against its model, and a return to the comparison may be useful. Both Laurent and Kugler treat their subjects from their particular points of view, with Kugler's the more detached and informed, the more scholarly of the two. But what of the illustrations? First, we note a somewhat surprising asymmetry. Although Menzel and Vernet were contemporaries, and both dealt with controversial leading figures in the history of their respective countries, who to varying degree remained in contention as forces in contemporary political discourse, the two artists approached their subjects from very different starting points. The period Menzel had chosen was more remote in time than was Vernet's, and the shorter distance be-

tween the Napoleonic era and the late 1830s was in effect reduced still further by Vernet's age. Menzel was born in the year of Napoleon's ultimate defeat; Vernet a generation of unequaled change earlier, in 1789. Toward the end of the empire he even held a commission in the National Guard, and in March 1814 saw a few days of active service in the defense of Paris, for which he was decorated with the Legion of Honor.[30] In short, Vernet—like his collaborator Laurent, who was born in 1793—was contemporary with the events he described and had first-hand knowledge of at least parts of his subject. But his conception of historical art minimized this advantage. Although Vernet thought of himself as a scholar-painter, and despite his accurate rendering of uniforms, at least French uniforms, few of his images display either a sense of period or a comprehension of the issues involved. They are elegant compositions, relating a gigantic adventure story of the kind Balzac was then writing, which might almost have occurred in the 1830s. Napoleon is depicted as a phenomenon of the July Monarchy, which in the minds of many people in France of course he was. Like Leutze in *Washington crossing the Delaware*, Vernet sought historical validity in surface appearances, and created a costume piece. He never attempted the difficult but essential process of thinking himself back into an earlier time.

Menzel, on the other hand, treats Frederick not as a contemporary in strange clothes but as a figure from another age, an age that he seeks to interpret realistically—that is, as far as possible according to its particular ideas and conditions. At a time that still condemned rococo, even Prussian rococo, as a style and period synonymous with frivolity and the artificial—indeed, when the term was sometimes used as an adjective signifying "out-of-date"—Menzel's objective re-creation of a world that he regarded as seriously as he did his own was evidence of very considerable intellectual independence. His immersion in the past, which his letters and sketchbooks show he pursued with fanatic energy, did not of course free him from his own times, and he would never have wished for such a liberation nor thought it possible. But he made great efforts to put himself in the place of the people he drew, and he was helped by the strong historicist trends in his cultural environment, which encouraged the search for the specific, time-bound, and unique. In Menzel, as in many of his contemporaries, a historicist view of the past was also fostered by a basically realistic temperament. The same intense wish to show things as they actually are that is apparent in his sketches of men and women in the Berlin of the 1830s and 1840s, of its buildings, gardens, and streets, of soldiers marching on guard duty, workers tearing down an old house, a boy chasing a ball in the rain, prevented Menzel from romanticizing the past, or treating it lightly or dismissively as a distant spectacle.

Menzel's outlook permits him to probe aspects of his subject in an intellectually serious manner. As every historian must, he analyzes not only the primary evidence but also secondary sources—in his case images even more than written material. Many of his illustrations are derived in whole or part from eighteenth-century works—paintings and graphics by such artists as Daniel Chodowiecki or the Prussian court painter Johann Bock, whose large etching of Frederick's death was widely distributed in the

1790s. But it is evident that Menzel's illustrations, like Vernet's, are not works of the period they depict but later interpretations. A comparison of one of his vignettes for the *History of Frederick* with its principal pictorial source may illuminate the distance that separates Menzel from his eighteenth-century informant, and his manner of adapting the material for his own purposes.

Menzel took the motif of the dying king sitting in the sun from an engraving by Eberhard Henne after Chodowiecki, who had frequently seen the king and had sketched and painted him, although Frederick did not much like his work (Fig. 35). The earlier picture shows Frederick on the terrace of Sanssouci rather than, as in Menzel's drawing, on the terrace of the larger Potsdam "city palace," which Menzel (as he noted in his "Historical Documentation") had sketched on location. The star of the Order of the Black Eagle on the sick man's robe is an invention, introduced, no doubt, because the public associated this decoration with the king; in other respects the engraving is faithful to eyewitness accounts of the king's last days, down to the enlarged boots on his swollen feet and legs. Chodowiecki and Henne had some difficulty in handling the perspective of the façade with its pilasters and arches. But they treat the architectural background and other supporting elements in the scene—the pair of lackeys and the contrasting pair of whippets between which the king is placed—with the same concern for accuracy in detail that they devote to the central figure, which but for its disproportionate size is given scarcely greater emphasis than are its surroundings. The engraving was a separate work, not one in a sequence of illustrations to a text, which may help explain its great specificity. Compared to its circumstantial profusion, Menzel's later adaptation is in shorthand (Fig. 36). He uses details sparingly, simplifies large masses, and by a radical change of scale turns his illustration from the depiction of a suffering old man into a human and political metaphor.

Menzel's historicism and realism gain additional power from his frequent use of symbols. Occasionally Vernet also resorts to symbols, but rarely for any purpose other than that of decoration. In *Frederick the Great* such images as the initial of the king's name drawn as a storm-whipped tree, Death running through the camp, a hand keeping the foundations of state and society from collapsing—or, more often, symbols within an otherwise realistic drawing—are central to the interpretation. They single out and emphasize those elements that Menzel regards as the dynamic forces shaping and propelling the events that he treats with "daguerreotype-like" accuracy.

From the text and illustrations the king emerges as a man of his age, with some qualities that are timeless: ambition, energy, courage, enlightened ideas. In his person he is presented as combining aristocratic and traditional characteristics with others that are modern and—we might almost say—bourgeois.[31] He drove himself and the society he ruled to unusual exertions whose only justification was to increase the power of the state. Kugler and Menzel take the desirability of this increase for granted. But they see the state as dynamic and changing. Even more than Frederick himself, his monarchy is timebound and yet points to the future. Half a century after the king's death, they conclude—and that is the ultimate political message of their book—the state continues to

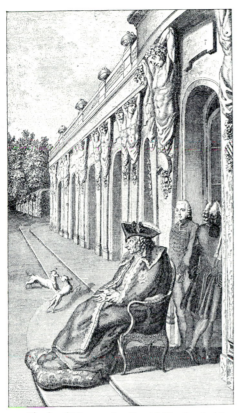

35. Eberhard Henne after Daniel Chodowiecki:
Frederick Sitting on the Terrace of Sanssouci.

36. Adolph Menzel: Frederick Sitting
before the Potsdam Palace.

have a rightful claim on men's allegiance and sacrifice. But it too has an obligation. The
state should look to its own best traditions, exemplified by the great king, and be in-
spired to move beyond him to become once again a force for cultural achievement and
social and political progress.

V. THE LATER HISTORY OF *FREDERICK THE GREAT*

AFTER SERIAL publication beginning in 1840, and the first complete edition in 1842,
Frederick the Great came out in a revised edition in 1846, and was reprinted the follow-
ing year. The book made an immediate impression on the educated public and in official
circles, and was a personal success for its author and illustrator. Kugler, already well
known, merely enlarged his reputation as a man of many talents, but Menzel was at
once recognized as a leading German historical artist of the younger generation. Some
critics acclaimed him as the Prussian Horace Vernet. Frederick William IV was too

much the romantic and too conscious of the dignity of the royal house to be an admirer of Menzel's realism, which some members of his entourage believed verged on the disrespectful. Under pressure from the court, two innocuous illustrations relating to the crown prince's adventure with a courtesan during a visit to the Saxon court were deleted from the second edition. But the king approved of Menzel's choice as illustrator for the limited "royal" edition of Frederick's works—a commission that launched the artist on his long association with the Hohenzollern, a shared journey through sixty years of Prusso-German history that eventually brought Menzel the highest Prussian decoration, the Order of the Black Eagle, and the title of nobility associated with it. Nor was the book a commercial disappointment, although the publisher had hoped for a greater immediate demand. It was translated into English, French, Italian, Dutch, and Russian, and the solid if not sensational sales in Germany gradually turned into an unusually long-lasting success: two printings in the 1850s, six more by 1870; only four printings during the next thirty years, but then a rise in demand justifying five further printings between 1900 and 1910. Since then the book has periodically reappeared in a variety of expensive and cheap "popular" editions.

The work was widely and almost always favorably reviewed, not only in Prussia but in Saxony and southern Germany as well, by critics whose outlook ranged from conservative to liberal and left of liberal. Typical were two discussions of the serial publication in the *Blätter für literarische Unterhaltung*, a cultural review sponsored by the important Leipzig publisher F. A. Brockhaus and addressed to the educated general reader. Kugler's text was praised as being far superior to the mass of new books on Frederick, for its clear organization, its use of the best sources, its treatment of Frederick's peacetime policies as well as his wars, and its rejection of many of the legends that had grown up around the king. The illustrations were said to add substance to the text; excellent as art, they also revealed careful study of the surviving evidence. "The artist's thorough research . . . will greatly help the younger generation visualize the increasingly remote age of Frederick the Great, and this will help make possible the achievement of national tasks"—a political statement the reviewer did not further elucidate, although he concluded that Kugler and Menzel were engaged in bringing out not only "one of the best popular books . . . in recent German literature," but "a work of national significance."[32]

In general, Menzel was praised for making the past come to life, even if some of his innovations, notably his dark night scenes, met with incomprehension. The most critical comments appeared while the work was being published in separate booklets. When the first installment went on sale in February 1840, an anonymous critic in the Berlin weekly *Literarische Zeitung*—apparently himself an artist—complained of Menzel's exaggerations, by which he seems to have meant his unceremonious refusal to grant historical subjects their customary dignity. Kugler dismissed the attack as silly, but even he thought that it might contain a small kernel of truth.[33] Potentially more damaging was a brief notice that appeared in both Berlin daily newspapers the following month and struck author and artist like "lightning out of a clear sky."[34]

The writer was Johann Gottfried Schadow, the seventy-six-year-old Director of the Royal Academy of Arts, father of Wilhelm Schadow, Director of the Düsseldorf Academy, with whom he shared a distaste for much of the new historical art. The elder Schadow, a distinguished sculptor, whose work represents the height of the Berlin synthesis of German and classical Greek stylistic attitudes, was one of the great names in the Prussian firmament. As early as 1792 he sculpted a monument to Frederick, which contrary to the wishes of the royal court shows the late king not in classical robes but in his plain army uniform, embellished only by an ermine cloak and a marshal's baton. His statues and busts of members of the royal family, Prussian soldiers and scholars, and gods and goddesses of Antiquity could be found throughout the capital. With the triple authority of an eminent artist, a survivor of the Frederician age, and a lifelong interpreter of Prussian history, Schadow dismissed Kugler's and Menzel's work as a commercial "penny-magazine enterprise"—a hit at one of Weber's most profitable innovations, the illustrated weekly *Pfennig-Magazin*, which by 1840 had a print run of 100,000 copies. Without naming the artist, Schadow criticized his "scrawls and scribblings," his way of presenting figures "in fantastically twisting arabesques, as though floating," and his resort to imagined incidents. Although most of the wood engravings in the first installment were not very far removed from conventional illustrations, so much had the engravers simplified and broadened Menzel's lines, Schadow was disturbed by their sketch-like character. But once again, Schadow's main objection was to the choice of everyday, transitory, "invented" incidents as subjects of historical art, and to Menzel's attempts to convey immediacy and movement.[35]

Kugler advised the publisher to counter the criticism with a press campaign against Schadow, whom he denounced as a "senile old man . . . almost totally blind," and Menzel sent the Berlin newspapers a brief, angry rebuttal, which invited the public to look at his illustrations and decide who was in the right. Schadow, who had liked Menzel's earlier work and usually was supportive of young artists, was magnanimous enough to admit that his criticisms had been mistaken, and the incident ended by giving the work in progress useful publicity.[36]

Before the complete book had appeared, a long essay on new publications on Frederick in Cotta's *Deutsche Viertel-Jahrsschrift*, the most important south German periodical on scholarly topics for the layman, speculated that a historical work without scholarly apparatus, like Kugler's and Menzel's, might be particularly appropriate for conveying the reality of the king's life. Unlike an academic treatise, "it can move without restraint between seriousness and humor, from the sublime to the comic." The anonymous reviewer, a man of moderate, centrist views, who described himself as not a Prussian and "therefore not obliged to praise Frederick without reservations," surveyed the reasons for the decline in the king's reputation after his death: his authoritarian system, his sympathy for French culture, his irreligiosity and cynicism. From the vantage point of the 1840s these traits no longer appeared all that damnable, although the author cited a recent article in the *Foreign Quarterly Review*, which castigated the king's "disgusting immorality," as an example of Frederick's continuing bad press.

Whether or not this judgment was correct, the reviewer declared that Germans should try to understand Frederick because "the past hundred years of German history were characterized by Frederick and by the French Revolution and its central figure, Napoleon." The memory of the king could serve as an effective force for unity, and the reviewer made it clear that in his view cultural unity was neither sufficient nor secure without political unity.[37]

One of the other works discussed in the essay, which ran through several issues of the periodical, was Karl Friedrich Köppen's *Frederick the Great and his Adversaries*. Köppen dedicated his short book to his friend Karl Marx, who in turn referred to it in the introduction to the published version of his doctoral dissertation. Several reviewers, among them such a spokesman of the older generation of Prussian liberals as Varnhagen von Ense, judged the book to be far inferior to *Frederick the Great*.[38] But the two works were hardly comparable. What Köppen had written was not a historical study but a political pamphlet, which commented on German conditions of the early 1840s from the perspective of a very positive interpretation of Frederick's ideas and policies. Köppen asserted that the political and especially the religious antagonists of the king were the spiritual ancestors of the forces that now kept Germany in bondage. His pamphlet ended with a declaration of faith and a call for action: "Popular belief has it that after a century man is born again. The time has come! May Frederick's resurrected spirit rise over us and with flaming sword destroy all enemies who seek to prevent us from entering the promised land. We in turn swear to live and die in his spirit."[39]

Köppen was even more explicit in an article in the *Hallische Jahrbücher*, the organ of the Young Hegelians. He called Frederick a "contemporary political force." The king "acts as a ferment of our present age . . . he is among those contemporaries who are 'in the right.' . . . We do not ask: what *was* Frederick's significance for us? But rather: what was he actually [*an und für sich*]? What is he today? What is he for us and for our age? What is he at the present decisive moment?" Köppen thought that Frederick, seen historically, stood at the dividing line between two epochs. "He introduced the spirit and ideas of the Enlightenment to the state, and thus is a pioneer of the modern age." Seen in the context of the present, "Frederick's spirit, the spirit of the Enlightenment, of science, of philosophy, of strict justice and the law, has invisibly gained strength and will sweep away the [Restoration system's] artificial network of lies like cobwebs."[40] It is not surprising that the *Hallische Jahrbücher* had difficulties with the censors and in 1841 could continue publication only by adopting a new title.

Köppen's book and article were not the effusions of a solitary enthusiast but expressed a general sentiment of the left. For some writers, praising Frederick in order to damn contemporary policies was perhaps no more than a tactic for embarrassing the censors. But appeals to Frederick's memory and example were too numerous and came from too broad a range of political opinion not to indicate a genuine belief that the king represented the best traditions of Prussia, which the state had abandoned after the reform era and needed to recover. It was in complete accord with its overall political tone

that the *Rheinische Zeitung*, under Marx's editorship the most radical newspaper in Germany, published a serious discussion of Frederick's essay on forms of government and the duties of princes, which concluded: "the little tract of the crowned democrat should be brought out in a cheap edition for the general public."[41] In the last days of the paper's existence in March 1843, after Marx had already resigned his position in a vain attempt to turn away the wrath of the Prussian censor, the *Rheinische Zeitung* ran a series of short articles on Frederick the progressive ruler. The final issue, headed by the farewell motto "Boldly we let the flag of freedom wave," included an article entitled "The Liberal Newspapers of Germany," which attacked most of the liberal press for its unwillingness to criticize authority, for representing economic exploitation, and for a lack of genuine progressive principles: "Frederick the Great would have been highly disgusted with the majority of German newspapers in 1843."[42]

The attitude of the left toward Frederick in the early 1840s is summed up with particular clarity in two discussions of *Frederick the Great*, the last reviews of the book to be mentioned here. Their author was the Young Hegelian Arnold Ruge, who at this time was beginning his political journey from liberalism to a radical-democratic position on the far left. As a delegate to the Frankfurt Parliament he was to call for abolition of princely rule and a temporary dictatorship on the Jacobin model. In 1840 and again in 1842 Ruge published two reviews of Kugler's and Menzel's work, which are among the most substantial appraisals it received.[43] Ruge's point of view combines considerable knowledge of Frederick's history with a clear sense of the political inferences he wants to draw from it. He criticizes aspects of Kugler's text as being insufficiently searching, giving as examples his analysis of the foreign policy of Frederick's father, and his treatment of the consequences of Prussia's survival in the Seven Years War: the moral triumph, great as it was, mattered less than did the accretion of the state's military and political strength. But he praises Kugler for being well-informed, balanced and tactful in his treatment, and finds that good as the text is, it is "further strengthened and given greater vitality by Menzel's art, . . . which creates a persuasive reconstruction of the period that is unique." The book itself, the ongoing publication of Frederick's writings, and the appearance of other works on the king are signs of the time: "Interest in the king and in his age must necessarily increase today, and will continue to grow as long as we Germans [do not possess] but can only long for the kind of historical energy and supreme intellectual freedom that Frederick represented for his time. Conscious of our current historical impotence, displeased with our subordinate role in the great issues of the day, we like to revert to our memories. . . . The publication of Frederick's collected works that we now witness may well be linked to this regression, which in fact is true progress. . . . Scholars and the people as a whole want to return to Frederick's ideas, and both know very well how much of the future lies in this past as long as the past is correctly understood."[44]

The content and tone of the reviews of *Frederick the Great* and of other works on the king, as well as these works themselves, leave no doubt of the political motives for

the growing interest in the man and his reign. The discussions of eighteenth-century Prussia voiced dissatisfaction with the general social and political condition of Germany in the early 1840s, or with some of its particular features. At a time when political action of even the most symbolic kind was still narrowly circumscribed, it could be tempting to escape from the stagnation of the day, or even to protest against it, by recalling a monarch who was nothing if not energetic, who had brought about great changes in Prussia and Europe, and whose personal style, critical and irreverent, could be appreciated by the progressive citizen a hundred years later. That Frederick had refused to modify the hierarchic structure of Prussian society could be explained as a regrettable result of the assumptions and political pressures of his age. At least, a remarkable number of reviewers of *Frederick the Great* pointed out, he had created a new power in Germany. It was the timeless quality of the man and his reign that mattered.

Even such authors as Köppen and Ruge, who were making their way toward radicalism, agreed that modern Prussia had inherited not only strong authoritarian strains but also more desirable features from its past. The monarchy, though often repressive, and still lacking the representative institutions that had been promised at the end of the Wars of Liberation, nevertheless was increasing the non-political scope of the bourgeoi-

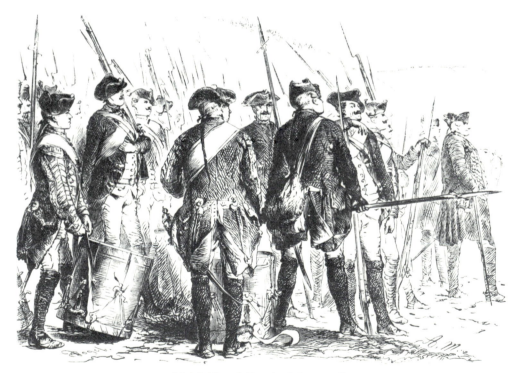

37. Adolph Menzel: Prussian Infantry at Rest.

sie by its commercial policies, its universities, and its expanding professional administration. Attitudes and policies that were commonly thought of as valuable parts of the Frederician tradition survived in the nineteenth century or could be traced back to the king, and that continuity made the link between the past and the present state more compelling even to its most outspoken critics.

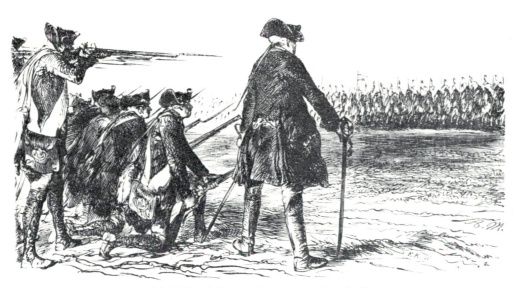

38. Adolph Menzel: Prussian Infantry Awaiting the Enemy.

The publications about Frederick responded to this mood. Among them, the work by Kugler and Menzel served as a significant bridge between scholarship and the broader literate public. The sobriety and balance of the narrative inspired confidence; the illustrations not only accented and expanded the text, but made the subject more accessible to many. Soon the book became more than a source of facts and interpretations. It helped confirm Frederick as a popular figure of middle-class culture in northern and central Germany, and Menzel's illustrations—far more so than the eighteenth-century portraits on which he so often based his work—fixed Frederick's image in the public mind. A few years after the Revolutions of 1848, Theodor Fontane, who by then was turning into one of the most prescient and critical observers of Prussia's climb to world power, was to comment that it was largely Kugler and Menzel who had made Frederick a popular hero. More accurately, their book with its unusually close integration of text and image was the most effective work in the large array of scholarship, prose, poetry, pictures, and monuments that restored Frederick's public image, an image that remained a fixture in German political thought and fantasy at least until 1945.

Their book also documents an early stage of another historical development: the hopes, and eventually the demands, of Prussian liberals that the authoritarian nature of the state be changed and that they be given access to the political process. The political implications of Menzel's interpretation, which we might see more clearly today had he expressed himself in words rather than images, were not missed by his contemporaries. But since the liberals in the course of their strivings continued to embrace many of the traditions of the monarchy and the uses of political and military power to which these gave rise, the political energies they generated inevitably suffered from a peculiar ambivalence, which did not affect and inhibit their conservative opponents.

Fontane's *Prussian Songs*

VER SINCE THE 1820s German art, literature, and even music had been suffused by twin currents running backward in time: ideas about the past, and fantasies of the past. Realistic and romantic tendencies—the new fascination with an objective understanding of history and the longing for a generalized former age—clashed yet also revealed affinities, and in the work of some scholars and writers the two forces could combine. Even before the rise of historicist painting, the dominant prose genre in Germany became the historical novel. A native, Romantic, and mystical form exemplified by the work of such authors as Wilhelm Hauff was superseded in public favor by the writings of Sir Walter Scott and his many imitators, some of whom developed their own manner. In the novels on Brandenburg-Prussian themes that he wrote from the 1830s on, Willibald Alexis far outdistanced Scott in the exhaustively detailed scholarly reconstruction of earlier times, their ideals, ways of life, conflicts; but he was also inspired by a vision of the unity of a particular period, grouping events into great clusters that symbolized and exemplified general forces and attitudes, and tracing the links between the spirit of the age, its major figures, and ordinary men and women. A comment in his novel on Prussia's defeat in 1806—*To Stay Calm is the First Duty of the Citizen*—can serve as the guiding theme of all of Alexis' mature work: "A connection exists, though we do not see it, between the achievements of world history and the actions of the common people."[1] Kugler was saying something very similar when he appealed to historical painters to forgo "official" themes for the true forces of history.

This general orientation toward the past was not significantly diffused by the emergence, at the time of the Revolutions of 1830, of new writers who took up issues of contemporary life with a new intensity, criticized social injustice and cultural and political stagnation, and even called vaguely for political action. Some of these writers condemned historicizing tendencies in art and literature as an escape from present challenges into the safe past; but the realism that characterized their work could also serve as a link to the realistic components of the new historical art, and it was soon appreciated that historical and contemporary themes might be combined. That even rebellious spirits could be drawn into the realm of history is exemplified by the early writings of Theodor Fontane. It is true that from early youth Fontane had strong leanings toward history; but that a writer who became one of Germany's greatest novelists and a prolific poet who made certain genres peculiarly his own should be so greatly attracted to history is itself indicative of the atmosphere in which he lived and worked.

Fontane was born in 1819. His father and mother came from French families that had emigrated to Prussia after the Revocation of the Edict of Nantes, and Fontane—although assimilated and fully engaged in German life—always prized his liberating connection with the great world beyond the Rhine.[2] As a boy he hoped for an academic career in history, but he could not afford a university education and like his father

became a pharmacist. In 1841 he found employment as pharmacist's assistant in Leipzig, and soon joined a group of young men with literary interests, many of them inspired by the poet Georg Herwegh, whose songs of freedom were evoking great if short-lived enthusiasm throughout the country. Half a century later Fontane wrote about this "Herwegh Club": "We were six or eight, of whom two were executed by firing squads, which is a bit high (Robert Blum and Jellinek [in November 1848, after the revolution in Vienna had been suppressed]); two came to a bad end in America, two turned into Saxon philistines, and Max Müller [the Sanskrit scholar] became famous."[3]

Fontane wrote verse in the Herwegh manner. One poem voiced regret that spring, which "had broken the chains of winter," had not also broken the chains enslaving Germany. Another attacked the Jesuits as agents of autocracy, but already "thrones shake and tyrants quake, / Peoples of the world arm for the ultimate battle. / Now with swords, now with ideas, / At last, at last they will triumph!" A third work compared Herwegh himself to the Alps and his poems to a stream that revived the parched desert. Some verses evoking the image of cemeteries of soldiers who had been killed in the Wars of Liberation, concluded that "the whole of Germany appears to be the cemetery of freedom."[4] Most of this was standard poetizing, but here and there a line foretold Fontane's later power and wit. And although himself in the grip of political rhetoric and cliché, Fontane did not fail to note the faddishness and pretense that too often accompanied the literary cult of freedom. A poetic monologue of self-praise by a liberal who feels the divine spark in his breast, who supports a Polish freedom fighter, draws inspiration from Schiller's *William Tell*, and will soon take up arms to put an end to all repression, declines again and again into the sad refrain: "But walls have ears, / and I hardly know you, / And I would be undone / If the police overheard me."[5]

In 1844 Fontane returned to Berlin to fulfill his military service obligation as a one-year volunteer, the privileged category for men of some education and private means. In September he was invited to join a literary club of far greater importance than the one he had left behind in Leipzig, named, in nonsensically poetic allusion to the river flowing through Berlin and to Brunel's engineering feat of building a tunnel under the Thames, "Tunnel over the Spree." Members and guests met every Sunday afternoon to read and discuss their poems, dramas, and novels. A chairman and secretary guided the discussion, the salient points of which were summarized in the minutes, and saw to it that each work submitted to the group was given a grade. Works on political themes and the discussion of political issues were prohibited, and members were forbidden to address each other by their titles, whether of nobility, rank, or profession. Instead they used pseudonyms, Fontane choosing or being given the rather obvious "Tunnel name" Lafontaine. A third of the members, Fontane later wrote, were officers, another third noble officials in the Justice Ministry, two of whom eventually became ministers of state. Others were in the professions or were artists—Kugler and Menzel joined some years after Fontane—merchants and actors. This social diversity, in which men belonging to the military and bureaucratic elites mingled with others far less privileged, was typical of Berlin literary and artistic associations at the time; but even in this self-con-

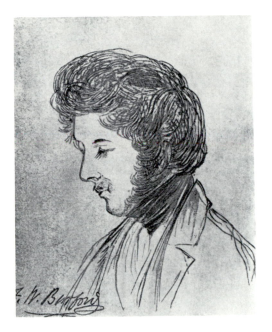

39. J. W. Burford: *Theodor Fontane*, 1844.

sciously egalitarian group of lovers of literature, a pharmacist without private income, barely maintaining a foothold at the edge of the bourgeoisie, was an exception. Winning the club's approval was therefore doubly important to Fontane: it would bolster his self-confidence as a poet, and it might gain him the support of influential members. In fact friends he made in the Tunnel were to help him at several turning points in his long, difficult climb to critical acceptance and economic security.

The first poems Fontane presented in the Tunnel were still in his earlier Leipzig mode, "attuned to freedom," as he later put it, and gained only qualified approval. The minutes that summarized the members' discussion and recorded their vote on the quality of each work did not openly condemn the content, although Fontane certainly transgressed against the prohibition of political themes. But the manner in which he treated his subjects was rejected as unrealistic, tendentious, and above all unpoetic. It was made clear to him that he "had not quite caught the appropriate tone."[6] No doubt this judgment served as a cover for the group's disapproval of the more or less openly political note of some of Fontane's verse. Although many members of the club held moderately liberal views, few believed that contemporary politics as such was a suitable subject for poetry—at least as soon as the ideas expressed departed from the conventional formulae of monarchic loyalty and Prussian patriotism.[7] Some lyric pieces—a field in which Fon-

65

tane rarely excelled—also failed to please, and he turned to the ballad, a form that other members had already tried with considerable success. The literary ballad, with its tendency to narrate a tale in antiquarian terms or even to mimic folksongs—that is, to assume the imagined tone of the common people in rural, pre-industrial society—was an attractive alternative to riskier contemporary approaches. After some initial failures here too, Fontane won the Tunnel's acclaim at the meeting on 15 December 1844 with a short ballad on an imagined fire in the Tower of London.

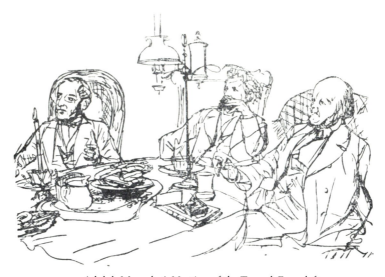

40. Adolph Menzel: *A Meeting of the Tunnel*. From left:
Judge Wilhelm von Merckel, the art historian
Friedrich Eggers, Franz Kugler.

The ballad was the result of a brief trip to London, which Fontane had made in the previous summer as a guest of a well-to-do friend. It was Fontane's first encounter with England, a country that came to play an even more important role in his life than did his ancestral France, for its history, its political system, and its self-assured society. During a visit to the Tower he was profoundly impressed by its historical significance, "more than [by] that of any other place I came to know, excepting not even the Capitol, the Forum, and the Palatine Hill"—we might guess it held fascination because monarchs and nobles had been executed there.[8] In the poem "The Fire in the Tower," ghosts of the executed come upon a smouldering pine log, with which they try to set the castle on fire. A sudden storm spreads the flames, but the walls have been made fast against fire by the tears and blood shed there; only the contents of the halls and cells are emptied like cups by the thirsty flames; the Tower remains standing, and through the empty structure the ghosts continue to walk at night.

Fontane developed this historical fantasy with a technical virtuosity new in his work. The scene is set and the tale told in eight quatrains, and the rapid, energetic tempo

and strong effects gloss over the thin poetic substance of the whole. But clearly "Der Tower-Brand" was among the best poems so far presented by any member of the Tunnel, and the enthusiasm it evoked not only impressed the twenty-five-year-old author but also confirmed him in his long-standing interest in the ballad form. His basically non-lyrical, narrative, and aphoristic talent combined with the current literary fashion for historical, untopical themes to turn him for some years into a writer primarily of ballads, if the term is applied loosely enough: accounts of conflicts between man and nature, and between the forces of nature themselves; of social tragedies—the relationship between lovers of different social standing—usually set in the past; and of historical subjects, the most notable pieces treating figures and events from English, Scottish, and Prussian history. With these works he established himself as a leading member of the Tunnel, and achieved a modest literary reputation even beyond the confines of Berlin. In 1849 he took the risk of giving up the practice of pharmacy and decided to earn his living as a writer. For the next decade and a half of a precarious professional and economic existence, until he began to gain new popularity with his explorations of the local history, legends, and traditions of the counties surrounding Berlin, the Mark Brandenburg, he remained best known to the German reading public as the author and translator of ballads.

The ballad of the Tower had been Fontane's breakthrough to the new direction. His next and even greater triumph came with the first of eight ballads on figures in Prussian history, which he wrote in 1846 and 1847. Seven of the eight were published in newspapers and journals soon after they had been read and discussed in the Tunnel; after the weakest poem, rejected by the Tunnel as only "fair," was replaced by another ballad, written in 1849, a Berlin publisher brought out the whole group in 1850 in a slim volume with the title *Men and Heroes: Eight Prussian Songs.*[9]

In concentrating on writing ballads Fontane had followed his own bent, reinforced by the literary atmosphere of the day and the aesthetic preferences of his companions in the Tunnel. With the *Prussian Songs* he took a further step and turned to a subject that was certain to win the Tunnel's particular approbation. But his choice also entailed a risk. The members' familiarity since childhood with the figures in Prussia's military pantheon, and the conventionally monarchic view of Prussian history held by most, made the Tunnel sensitive to any perceived slight to the Prussian military ethos. The discussions following the readings and the grades given each work show that a patriotic theme did not by itself protect the author from criticism. As a group the *Prussian Songs* were enthusiastically received, but objections were raised to aspects of Fontane's style and interpretation that contravened the Tunnel's political views or its conception of the correct poetic approach to history.

Each of Fontane's ballads has its own characteristics, but seven are similar in form and subject and also reveal certain similarities of treatment. Each consists of between five and nine stanzas of eight short iambic lines, which are doubled in one ballad. Each develops the personality and character of a soldier in Brandenburg-Prussian history (they have been called "character ballads" as distinct from the more usual narrative

ballad): Derfflinger, a field marshal in the army of the Great Elector; five generals of the Frederician period—Prince Leopold of Anhalt-Dessau, Zieten, Seydlitz, Schwerin, and Keith; and Schill, a major who in 1809, against orders, tried to launch an uprising against the French. Each ballad celebrates the virtues of courage, daring, and persistence as demonstrated in war. The failed eighth ballad, on the last will and testament of Frederick William I, was replaced by another that was equally out of tune with the rest: a poem addressed to a contemporary political figure, Count Schwerin-Putzar, a moderate liberal, who for a few months after the 1848 Revolution in Berlin was head of the Prussian Kultusministerium. He was related to the Prussian field marshal of the same name, and the ballad draws the link between the military prowess of the ancestor and the political courage and independence of the descendant, concluding with the appeal: "You, too, without timidity / Fight on for sacred rights. / Slavish obedience is not true fidelity / Only the free man is faithful."[10] But this open political message was a product of the revolution. In the ballads of 1846 and 1847 political allusions are masked, or are contained in the general celebration of force of character, judgment, and courage.

In the *Prussian Songs* Fontane aimed for the utmost simplicity of language, symbol, and metaphor. Among his models were two ballads on Frederician themes by Willibald Alexis, of one of which, "Fridericus Rex, our King and Lord," Fontane wrote: "It has become a folksong so completely that almost no-one knows the author; most people would swear that the poem was written more than a hundred years ago, in the days of the Seven Years War."[11] Whether or not Alexis had really caught the tone of the common people, Fontane was too reflective, too much the analytical student of the past, and far too conscious of the historical and contemporary ambiguities posed by the Prussian monarchy and its military tradition for his ballads to be anything but works of art. Even as verses to be sung they seemed not quite appropriate. Only one, "Old Zieten," was ever set to music (though one or two were printed with melodies of other songs), while Fontane's adaptations of English and Scottish ballads, unburdened by the poet's preoccupation with contemporary political implications—"Archibald Douglas," "Barbara Allen," "Lord Maxwells Lebewohl," and others—greatly appealed to composers of Lieder.[12]

The *Prussian Songs*, like Menzel's wood engravings, which influenced their writing and to which they are a literary counterpart, are works of sophisticated interpretation, addressed to an educated audience that could appreciate them as re-creations of a heroic age—which is how they appeared to the great majority of Tunnel members. Educated readers and listeners would likely be impressed and charmed by the strong images and straightforward language of poems that appealed both to their idealization of the German *Volk* and to their belief that they—the educated elite—constituted its natural leaders. But the major patriotic and historical statement of the ballads was accompanied by minor themes, and Fontane's public could if it wished delve beneath the celebration of martial virtue to find disturbing analyses of character and equally disturbing allusions to Prussia and Germany in the 1840s.

The contemporary message is sounded most clearly in the first ballad, but in a

manner that could hardly give offense; Fontane himself thought the poem the best in the group. Its subject is a mercenary soldier, Georg Derffling or Derfflinger, who served with the Saxons and Swedes during the Thirty Years War, later entered the service of Brandenburg, fought against the Swedes and the French, and rose to the highest rank in the army. Fontane chose the tradition that in his youth Derfflinger was a tailor's apprentice as the basis of his poem, which is constructed on the antithesis tailor-soldier.[13] Plays on words strengthen the antithesis, and the unforced confrontation of different meanings casts an easy humor over the entire work. The young Derfflinger feels that the cramped space of the workroom, colloquially called "tailor's hell," is Hell itself, and exchanges the needle for the sword. In former times he had gone on the traditional journeyman's tour from town to town; now he is tireless in fighting—the verb *fechten* serves for both activities (together with the derivative *Gefecht*, "combat" or "battle"):

> Sonst focht er still und friedlich
> Nach Handwerksburschen-Recht,
> Jetzt war er unermüdlich
> Beim Fechten im Gefecht . . .

When in advanced old age he feels death approaching, Derfflinger prepares himself with another play on words, *Hülle* signifying both clothes, garment, and mortal frame. "He said: 'As an old tailor / I always knew / We change our clothes: / Nor do I regret it. / The old garment / Now lacks breadth and length; / As the soul expands, / The body becomes too narrow to hold it.' "[14]

The six stanzas that outline the hero's life and death are introduced by a stanza that draws a general lesson from the tailor who becomes a field marshal: "All classes of society / Have their value as fighters, / Even the hands of a tailor / Once grasped a hero's sword."[15] The ballad of Derfflinger, and with it the entire sequence of *Prussian Songs*, opens with an egalitarian message: personal courage and the ability to lead pertain not only to the nobility; they exist in all social groups. A commoner can fill the highest position in the army. What is more, this claim is confirmed by Prussian history—or at least by patriotic legend.

The other ballads reflect the more recent Prussian reality that unlike Derfflinger in the seventeenth century, commoners in the Frederician era and later only rarely rose to senior rank. The subjects of the poems are a prince and members of the high and the minor nobility. Fontane now conveys his view of the Prussian past and his dissatisfaction with the present not by praising a man of the people but in other ways. In the 1840s, which he regards as a time of stagnation and bureaucratic repression, and—as he says—a time of words, he celebrates Frederician soldiers who distinguished themselves by their energy and their moral as well as physical courage. He does not idealize his heroes, merely some of their character traits. He depicts them as harsh, not always agreeable; one he subsequently apostrophized as petty in small things but a genius when it mattered. They are worth recalling because they stood out from the mediocrity of the mass, thought for themselves, and were good at what they did. Aristocratic ethos goes

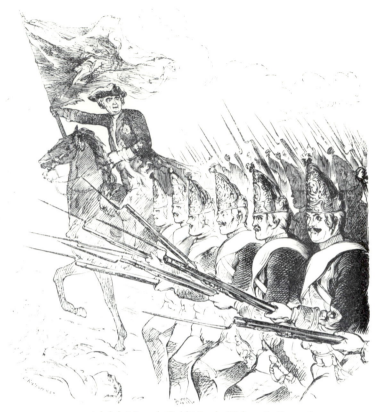

41. Adolph Menzel: Field Marshal Schwerin Returning
to the Attack.

unmentioned, as does any special sense of the obligation to the state that may or may not have motivated them. Indeed, the word "state" never occurs, "Prussia" appears only in the title of the book, Frederick the Great figures only in two of the ballads, and in several instances the hero demonstrates his stature by ignoring or acting independently of orders—one, Schwerin, is killed while salvaging an attack ordered by Frederick and turning defeat into victory. Throughout, the ballads stress strength of character, which only the free personality can possess, the inevitability and peril of conflict, and the tragedy of human existence.

Each ballad is constructed around a major theme, which is sometimes supplemented by an anecdote that expands on the hero's personality, and six of the eight end with accounts of the hero's death that use terms and motifs related to the principal theme. This is not an inappropriate way of ending poems on soldiers, but Fontane may also have chosen it to give his audience the sense that the hero's entire life from triumph to the ultimate defeat of death had passed before them. The most concise version of this pattern is achieved in "Old Zieten," which with "Derfflinger" is the most successful

of the ballads. The historical Zieten was a light cavalry leader of genius, whose ability and willingness to act on his own stood out in an army that found its greatest strength in the disciplined, cohesive movement of masses of soldiers acting in unison on command. The poem consists of six stanzas. Its opening two lines—merely the name and occupation of the man about to be praised—sound like a trumpet call. Fontane had to reverse the order of Zieten's Christian names to create the rhythm he wanted: a rapid, stuttering sequence leading to the drawn-out "*Tsee*-t'n" of the family name, followed in the second line by the more evenly accented "General of Hussars":

> Joáchim Háns von Zíeten,
> Husárengénerál.[16]

The rest of the first stanza tells of Zieten's combativeness, and ends with a key phrase that sums up the man who hides in thickets and woods to ambush the enemy: "Der Zieten aus dem Busch."

The main body of the ballad consists of four stanzas, divided into two pairs. The first pair expands on Zieten's way of fighting, his individualism and daring which supplemented Frederick's generalship: "They never came alone, / Zieten and Frederick: / One was thunder, / The other was lightning."[17] The second pair of stanzas, rather more literary in tone than the first, recounts an anecdote after the wars, when Zieten fell asleep in the king's presence. A courtier wanted to wake him, but was stopped by the king: "Let the old man sleep: / Through many a night / He stayed awake for us; / He guarded us long enough."[18]

The final stanza tells of Zieten's death in words that have regained the forcefulness of the opening lines. As he once had surprised his enemies and snatched them away, so Death now comes at him "like Zieten out of the woods":

> Wie selber er genommen
> Die Feinde stets im Husch,
> So war der Tod gekommen
> Wie Zieten aus dem Busch.

The simple theme, the inspired reversal of roles in the last stanza, the return in the final line to the beginning, and above all the natural, straightforward syntax and language move these verses far from the studied, literary, often quasi-religious sentiment for the *Volk* that pervaded German poetry in the 1840s. In the ballad of Zieten Fontane had not written a true folksong, but he had clothed the popular conception of a historical figure—"Der Zieten aus dem Busch"—in convincing and above all unpatronizing literary form.

Other ballads end in much the same way: the poet tells of the hero's death in words that carry the reader or listener back to the opening verse. Derfflinger, the tailor-soldier, meets death with reflections drawn from his early days when he worked with needle and thread. Seydlitz, an elegant but restless and troubled cavalry general, conducts war like a dance and dies, still a young man, in bed—had he been on horseback, death would

never have caught him. Keith, a Jacobite exile, who serves in one army after another, like a traveling actor moving from theater to theater, role to role, is killed in battle, crying out that to die an honorable death is the best play. Not surprisingly, the Tunnel did not care for this particular conceit. The poem was rated only "good," the characterization of Keith as a comedian was condemned as "ignoble," and his dying not as a hero but as an actor was judged to be a serious error on the author's part.[19]

All in all, as his Tunnel companions recognized from such questionable, raw passages, Fontane had written a strange group of patriotic poems. They could not be said to glorify the vaunted "old-Prussian," Frederician tradition, unless the elements of energy and individual creativity and initiative in that tradition were separated from its other major force: autocratic control in the service of the monarch and of the country's military and landowning elites. Nor—even by implication—do the ballads praise the modern Prussian system.[20] Whenever Fontane introduces a reference to contemporary conditions, he does so to contrast them with the past and finds them wanting. "We are in dire need," he writes in the ballad of Leopold of Dessau, "Despite all the good advice we are given, / And we almost deserve to blush / Before this man of action."[21] The nature

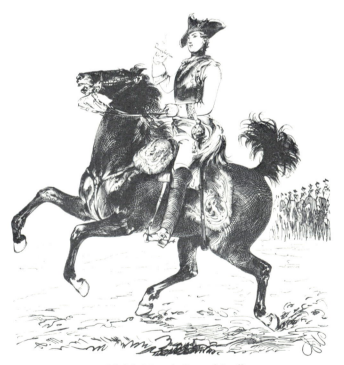

42. Adolph Menzel: General Seydlitz.

72

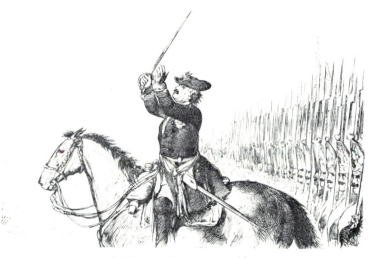

43. Adolph Menzel: Prince Leopold Praying
before Battle.

of the action Fontane longs for, he does not, of course, state explicitly. It is the ballads'
reserve that helped to make them acceptable to the Tunnel, and also to make them
better poetry than the still largely unsublimated outcries of Fontane's Herwegh period.
The *Prussian Songs* share with most works of art the attribute of conveying second and
third meanings through the interstices of their overt message.

The ballads afford us some insight into Fontane's conception, in the second half of
the 1840s, of Prussian history and of the relation between the Prussian past and present.
But they are more than an expression of his ideas and feelings on these matters. They
mark a phase in his development as a writer; and beyond their significance in the *oeuvre*
of the poet Fontane, their muted comments on the persistence of monarchic-bureau-
cratic absolutism in a changing society reflect more general attitudes among the German
bourgeoisie.

The ballads on Prussian heroes were Fontane's first major statement on a complex
of themes that was to occupy him for the rest of his long life. As journalist, poet, popular
historian, and eventually novelist he wrote on a vast array of themes. But gradually
Prussia—her history, society, and politics—became his main concern. A special object
of his attention was the country's nobility, particularly of the core counties around
Berlin, which he first encountered socially in the Tunnel and among which he formed
personal and professional relationships that more than once were to exert a decisive
influence on his future. In his writings he described and interpreted the nobility in all its
gradations from the Junker on his estate to the officers and high officials of the capital,
the court nobility and the newly ennobled bourgeois. He admired and praised the
strengths of this tenacious, dynamic elite, but he also rejected its social and intellectual

73

narrowness and its politics, the egotism of which he regarded not only as unjust but, increasingly, as catastrophic for the country. From the beginning, the relationship between Fontane and the favorite subjects of his art was shot through with ambiguities, which were felt by both sides. Despite his unquestioned success in the Tunnel and his popularity among its members, the minutes of the Tunnel meetings and letters from the friends he made there are filled with amicable expressions of concern about his rebellious streak. In turn, his efforts to please were punctuated by frankness. Only a few weeks after the Tunnel had enthusiastically welcomed the first of the Prussian ballads, Fontane read another ballad in the club, "Jung-Emmy," which it found wanting. The work is certainly inferior to "Derfflinger," but the Tunnel objected mainly to the subject: a love story between a peasant and a peasant girl, with a secondary theme of the seduction of the girl's mother by a nobleman. Members rejected the motif of the aristocratic libertine, and the club's secretary, Wilhelm von Merckel, a senior judge who became Fontane's lifelong friend and supporter, wrote in the minutes: "Why must it always be counts and barons who are the sinners and the Mephistophelites?"[22]

It is ironic that the author of the *Prussian Songs* and of the other poems on Frederician and Prussian themes that he was to write in the future, as well as of many histories and novels on Prussian subjects, was for long considered the special literary champion of Prussia's elites. His own feelings of approval were decidedly mixed, and those members of the nobility who took an interest in literature never lost a certain sense of unease concerning their middle-class bard. A time would come when both parties cooled to each other.

In the larger cultural and political context, Fontane's ballads are clearly associated with Kugler's and Menzel's *Frederick*. They praise some of the same figures that appear in the book, and relate incidents identical with or similar to those used by Kugler and Menzel. The ballads are part of the Frederician revival of the 1840s, which, we have seen, expressed a new interest in the country's past and admiration for its heritage but which, in addition, might serve as a safe vehicle for criticism of contemporary Prussia. We have also noted the problematical aspect of criticizing the state by praising and elevating as standards for public policy the very institutions that now most rigidly resisted change: the autocratic monarchy and the social and military elites on which it rested. Liberal sentiments conveyed in this mode could hardly speak with a powerful contemporary voice. For Fontane, of course, the Prussian ballads were only one means of communication among many. He was more intensely political than either Kugler or Menzel, and in other poems he fully and openly joined in the general literary chorus with which the German middle classes gave vent to their frustrations and were beginning to make demands and even threats. A poem like "Our Peace," subtitled "Summer 1844," is of a kind with the aggressive political lyrics being written throughout Germany in the last years before the Revolution.[23] "Peace" in the poem's title refers both to the poisonous, destructive peace of total inertia, "which is threatening to be more dangerous than any war could be," and to the healthy peace of the future, which will

come about when today's rottenness has been swept away. Fontane recognizes that the new world can be brought about only by violence, and that inevitably the innocent will suffer along with the guilty: In a summer storm, lightning "will smash some trees, / But it will also strike the pestilential swamps."[24]

The Biedermeier quietude so often evoked as characteristic of German culture of the 1830s and 1840s applies only to one strand of that culture among several. The message of overtly revolutionary works, especially in literature, was plain enough. But similar messages were given more subdued expression in such works as Fontane's *Prussian Songs* and Kugler's and Menzel's *History of Frederick*, which did not fly the revolutionary banner. Even words and images that conveyed an air of stability, of contemplation and love of the past, of a modest, secure existence in the embrace of one's family and of all-caring government, might carry further meanings that reveal a society seething with the wish for and the prospect of change.

THREE

The Revolution of 1848

I. THE YOUNG RETHEL

THE REVOLUTION of 1848 in Germany inspired two major achievements in the visual arts: Menzel's painting *The March Casualties Lying in State*; and Rethel's sequence of six woodcuts *Another Dance of Death*. Other artists created historically interesting works—especially cartoons, but also a few paintings on political subjects, among which *A Town Council* by the Düsseldorf painter Johann Peter Hasenclever, an early document in art of the division between bourgeois and worker, is the most striking—but failed to rise above the competent and second-rate. They treated unfamiliar themes in conventional ways. Rethel and Menzel, on the contrary, penetrated new territory. Both addressed the central element of violence in the Revolution in interpretations that fused strong personal reactions to the political and social strife of the times with the originality and the aesthetic concepts and means each had developed in his progress toward artistic maturity. Menzel gave a realistic account of a political and highly emotional event that he himself had witnessed: the public lying in state of 183 civilian casualties of the street fighting in Berlin on 18 March 1848. Rethel reached back into the German past for an artistic and cultural motif of tremendous potency, not to elucidate a single episode of the Revolution but to create a myth that conveyed a larger meaning of the Revolution in its entirety. The painting and the woodcuts not only were statements about the Revolution that made use of aesthetic and thematic motifs created or suggested by it; through their contemporary impact they themselves became part of their subject. That Menzel never completed *The March Casualties*, and that Rethel's woodcuts were misunderstood and misused as political propaganda from the day the first print was sold, may also make the works fit symbols for a revolution the failures of which were even more significant than its achievements.

When *Another Dance of Death* burst upon Germany in the spring of 1849, during the final spasms of the Revolution, the work's immediate relevance and unique aesthetic characteristics were shattering in their impact. But the woodcuts were also the consequential outcome of the artist's development over many years, and it is worth tracing their roots in Rethel's life—roots that compromise neither the work's political testimony nor its aesthetic power but rather serve to explain both. Rethel, a few months younger than Menzel, was born in 1816 near Aix-la-Chapelle, the son of an Alsatian who held a post in the French administration in the Rhineland during the Napoleonic era, married the daughter of a local businessman, and remained in Germany after French rule collapsed in 1814.[1] The rumor that Rethel was partly Jewish—presumably through his father, whose last name like that of many central-European Jews derived from the name of a town—may be correct but has never been documented. A small chemical factory that the elder Rethel started did not succeed, and he entered the em-

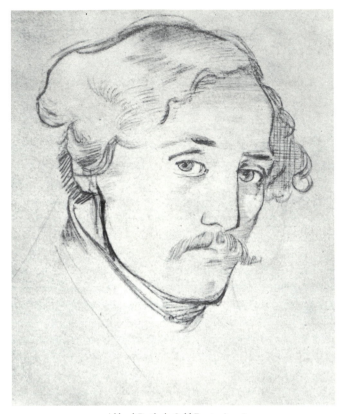

44. Alfred Rethel: *Self-Portrait*, 1839.

ploy of Friedrich Harkort, a pioneer in Germany in building machinery as well as in fighting for humane working conditions and the abolition of child labor. In 1818 Harkort set up a factory making steam engines and mechanical looms in an abandoned fourteenth-century castle on the Ruhr river, and Rethel's father became head bookkeeper of the concern. This extraordinary setting that united old and new—its crumbling walls capturing the coming transition of Germany from a rural to an industrial society—became part of the young boy's world, until at the age of thirteen he was enrolled in the Royal Academy of Arts in Düsseldorf.

Rethel, a friend later wrote, soon became the academy's acknowledged prodigy.[2] A surviving self-portrait, painted when he was fourteen, attests to his precociousness, but its introversion and sadness also sound a warning note. A later self-portrait, a sketch done at the age of twenty-three (Fig. 44), reinforces the suggestion of emotional suffering, and indeed for much of his life Rethel experienced bouts of severe depression. We know little about their specific psychological content, but a preoccupation with death clearly played a large role. In the early 1850s an undiagnosed disease, possibly brought

about by an early syphilitic infection, exacerbated his condition and he declined into a state of total apathy from which he did not recover. He died in 1859 at the age of forty-three.

In 1829, when Rethel entered the Academy, the institution was at the height of its influence.[3] Düsseldorf had been transferred to Prussia at the Congress of Vienna, and the town was an important factor in the government's efforts to integrate the Rhineland with Prussia's central and eastern provinces. Funds were made available not only for economic and administrative growth but also for cultural development. Music and drama soon prospered, and the moribund art academy, founded in the previous century, was reconstituted as the center of the state's art education in the western parts of the monarchy. After its first director, Peter Cornelius, resigned in 1825 to become head of the Munich Academy, the Kultusministerium in Berlin chose Wilhelm Schadow (eventually von Schadow) as his successor. As a painter Schadow was limited—a transitional figure between the idealistic, contemplative religious direction of the Nazarenes, among whom he had worked in Rome between 1810 and 1819, and the more robust romanticism of the following generation. But he was a gifted administrator and teacher. He took pains to create a sense of the high calling of art and a strong community spirit among the students, for whom he developed a solid curriculum of intellectual as well as technical instruction, a nine-year course concluding with the so-called master class, which provided the most talented students with individual studios from which to launch their careers. The Düsseldorf Academy was soon known for its high standard of portraiture, for religious and historical painting with pronounced and already somewhat old-fashioned idealistic and symbolic tendencies, and, increasingly, for lovingly detailed genre painting. Its reputation spread beyond Germany: by the mid-1830s over forty foreigners were enrolled, the largest contingents coming from Scandinavia and the United States.

By that time, however, much of the best work in Düsseldorf was being done either in opposition to Schadow—Lessing's paintings of John Hus, for example, which Schadow rejected as tendentiously Protestant—or by artists who left the Academy and organized an independent art organization in the town. When Kugler visited the Academy a few years later, he was in no doubt that it had passed its peak. The school still offered useful studio instruction, he found, but even the work of its better students was bland and timid: "The most brilliant period of the Düsseldorf school coincided with a time of intellectual quietude in Germany. People liked to lose themselves in their feelings, their hearts and souls, and it was this tendency that the school above all fostered and implemented."[4] Schadow's system—at once firmly institutionalized and highly personal, even missionary—had its drawbacks. The emphasis on community and shared values fostered an emotional, dogmatic, somewhat provincial atmosphere. Insisting on the rightness of only certain kinds of art and affording students little opportunity to see works of differing directions failed to prepare them for the clash of styles and opinions in the world beyond Düsseldorf. Cliques developed, and a split opened between students from the Rhineland and others who had followed Schadow from Berlin and who, some stu-

dents and professors claimed, were favored by the Director. The Academy replayed in miniature the conflicts between local liberalism and the centralizing forces emanating from Berlin that periodically erupted in the Rhineland throughout the 1830s and 1840s. Rethel, who was rapidly working toward his own style, appears to have been at the center of student discontent. The rooms he shared with two fellow-artists are described as the meeting-place of the disaffected, and in 1836 he left the Academy to continue his studies with Philip Veit in Frankfurt.

In Düsseldorf Rethel had formed intimate friendships with two men, somewhat older than he, who left records of these years that supplement his own letters. One was a fellow-student, the painter and poet Robert Reinick, co-editor with Franz Kugler of the *Songbook for German Artists*, whose correspondence illuminates the world of art and literature of the *Vormärz* from the perspective of a sensitive, energetic, if not exceptionally talented personality. He is remembered today as the author of "Frohe Botschaft" and a few other texts set to music by Hugo Wolf. Rethel's other close friend was the physician, poet, and critic Wolfgang Müller von Königswinter, who was closely associated with Düsseldorf art circles, about which he published an informative book (dedicated to Kugler) in 1854. Seven years later Müller wrote a short book commemorating the recently deceased Rethel, the first biography and still valuable today. Apart from his great ability, two characteristics of the young Rethel impressed his friends: the forcefulness of his work, and his interest in history. "His mind [was] impregnated with the historical spirit," Müller writes. If in his early years at the Academy he still adopted a generalizing view of the past, which harmonized nicely with the kind of historical painting practiced in Düsseldorf, he soon became dissatisfied with Schadow's idealizing, philosophic, and often passively sentimental historical art. "What distinguished him from most people was his genuinely historical outlook. With poetic sensibility he combined scholarly energy . . ."[5] Rethel found most of his subjects in history, which he liked to combine with religious themes. His first major painting, done at the age of sixteen, is of St. Boniface, apostle to the Germans, who has just cut down Wotan's sacred oak and planted a crucifix in the stump—a heroic interpretation, judged a critic in the *Allgemeine Preussische Staatszeitung*, who took the painting to be the work of a mature artist. The martyr who brought Christianity to the Germanic tribes continued to interest Rethel; among other works on the saint he produced a sequence of drawings on his martyrdom and that of his companions.

In more than one respect this series is representative of much that was to come. By far the greater number of Rethel's surviving paintings and graphics deal with strife or death: the self-sacrifice of Arnold of Winkelried in the Battle of Sempach, the barge of the dead, the funeral of a troubadour, Nemesis pursuing a murderer, the corpse of Gustavus Adolphus on the battlefield of Lützen—to mention only some of the subjects he chose as a student. Many of these works belong to series in which a narrative is carried forward from image to image, or a concept is developed by means of a number of variations. Imaginary portraits of medieval and Renaissance emperors express the vitality and power of Germany in former times. A cycle of oil paintings retells the historical

achievement of St. Boniface. Characteristically, Schadow criticized its attempt to depict the garb and hair-style of the heathen according to the latest historical findings, recommending instead the timeless cloaks and robes of the Nazarene school. Rethel made extensive studies for another cycle, this one on Hannibal crossing the Alps, based on Livy and with captions taken from Livy's text. These drawings form a work of exceptional coherence and drama; but people accustomed to the glorification of great men by conventional historical art found them disturbing. The prominent historical painter Wilhelm Kaulbach objected that Hannibal was not even a central figure of the work; instead Rethel chose the common experience of the Carthaginian army as his main theme: the mountains and the weather that soldiers and animals had to contend with, and man's horror of the unknown.

In itself, Rethel's preoccupation with cycles was nothing unusual. Commissions for decorating public buildings often called for sequences of works. But Rethel evidently was receptive to a method in which a temporal development breaks the bounds of a single painting. Cycles possess literary qualities, at times even characteristics that might be regarded as musical. The several images, each of which aspires to self-sufficiency, are also thematically and aesthetically connected; only in this way can they form a larger whole. Motifs may be linked and repeated from image to image, and must be capable of variation and expansion over the course of the work. The aesthetic response is guided and sometimes even created by the appeal to the viewer's ability to follow a story that is composed of separate episodes. The viewer perceives and reacts over time; a manner of perception that may be reinforced if he is compelled to move from one unit to another, to walk from fresco to fresco, or even to turn the pages of a book.

In his years in Frankfurt, Rethel illustrated a number of books, his work ranging from pictures lacking true continuity to images so closely linked that words are scarcely needed to carry the plot. He was one of the illustrators of Karl von Rotteck's *History of the World*, a standard work of early German liberalism. For a book by Reinick, *Songs of a Painter with Sketches by his Friends*, he decorated a page with eight scenes encircling the text of the poem "The white Doe." With three others he drew sketches for woodcuts for an edition of the *Nibelungenlied*, which were executed by some of the same engravers, Unzelmann and Vogel, who at this time worked on Menzel's illustrations for *Frederick*. Although the individual image still dominates, the *Nibelungen* woodcuts are steps toward the complete unity that at the end of the decade Rethel was to achieve in *Another Dance of Death*. The setting and figures of each illustration, including the decorative border which the overall design of the book imposed on Rethel, are integrated to convey a single concentrated impression. In the print "How They Threw out the Corpses" (Fig. 45) the magnificently derisive gesture of the central figure, Volker, who shows the surviving Huns how easy it had been to kill their comrades, is echoed by the playful arabesques of the border. In "How Iring was slain" (Fig. 46) an enormous thistle, perhaps emblematic of Hagen's character, surrounds and twists between the two fighters, its swooping main stem following Hagen's thrust as his spear pierces Iring's shield, face, and helmet. The psychological and physical violence of the

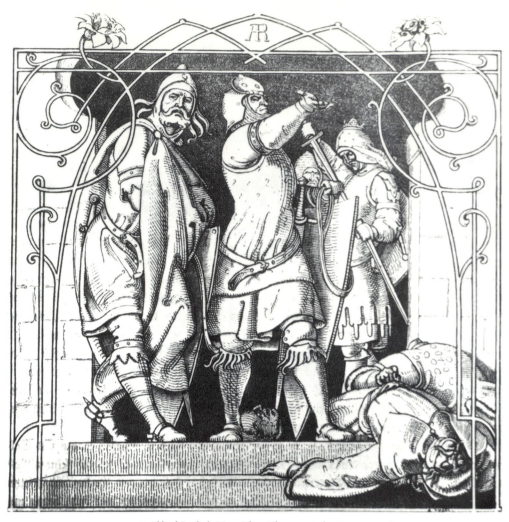

45–46. Alfred Rethel: How They Threw out the Corpses and,
at right, How Iring was Slain.

poem is captured with a power of composition and a sparse, harsh line new to German art of the nineteenth century.[6] Among the few individual works of Rethel's youth not on historical or biblical subjects are a portrait of his mother, today in the Nationalgalerie in West Berlin, one of the most searing character studies in German painting of these years, and a landscape, an oil of the castle-turned-factory on the Ruhr where his father had worked (Fig. 47). Its juxtaposition and confrontation of old and new is an early statement of an issue that came to hold a special meaning to the artist.

It is not known why Rethel, who was already rejecting the assumptions of the Nazarene school, chose to study with Veit. But Veit's profound piety may have exerted a strong appeal on a young artist who saw historical themes largely in a religious context, and Veit had the reputation of being an excellent teacher: unencumbered by Scha-

dow's need for absolute authority, he encouraged rather than controlled. In retrospect Rethel wrote, "He led me to the great masters, in whose work I found confirmation that I was on the right path."[7] Other statements and his sojourns in Italy suggest that Rethel felt or sought an affinity with major Italian painters of the sixteenth century, especially the Raphael of the Vatican *stanze*. But his borrowings from the Italian and German Renaissance were increasingly transformed into a personal style. He remained strongly derivative only in his use of color, still finding it difficult to shed the flat, bright, smooth finish prized by the Academy. A severe, at once intellectual and highly physical artist had broken out of the Düsseldorf mold. In his paintings and especially in his sketches, figures seem carved out of wood, three-dimensional, their surfaces made up of angles and planes. Eyes and hands are centers of psychological analysis. A figure's unique char-

47. Alfred Rethel: *Harkort's Factory in Castle Wetter.*

acteristics are turned into general statements without sacrificing its individuality. The compositions are firm, clearly structured, often monumental. Unlike most historical painters of his generation, who liked to crowd the canvas with telling detail to achieve authenticity, Rethel worked with few elements. His great narrative talent was informed and disciplined by an effort to re-create and interpret the past, which for him meant above all reaching a conclusion about the essential aspects of a historical situation, and then determining how men and women in that situation would respond to it emotionally, intellectually, and physically. A new friend in Frankfurt, Johann Daniel Hechtel, teacher at the city Gymnasium, guided his reading and acquainted him with original sources on the Middle Ages. The seriousness with which Rethel studied these materials, the contemporary interpretation he gave them, and the degree to which they influenced his art are revealed in a prospectus he submitted in a competition for decorating the Imperial Chamber in the Gothic town hall of Aix-la-Chapelle with frescoes on the life of Charlemagne.[8]

For the seven panels specified in the competition, Rethel submitted preliminary sketches for six scenes from Charlemagne's reign and for a seventh that conveyed the

emperor's influence on later generations. All made use of Carolingian architecture and artifacts—thrones, weapons, jewelry that Rethel had seen in the towns and museums of the Rhineland—and of the new historical costume manuals that were being published. Six of the incidents represented were taken from such sources as Pertz's three volumes of Carolingian and Ottonian writers in the *Monumenta Germaniae Historica*, Einhard's *Vita Caroli Magni* in Bredow's edition, Caesar Buronius' *Annales ecclesiastici*, and Jacob Grimm's *Deutsche Mythologie*. The seventh scene, the Battle of Cordoba against the Moors, lacked adequate documentation, and Rethel noted apologetically that he was compelled to rely on Friedrich Schlegel's epic poem *Roland*, based on Archbishop Turpin's chronicle. The sketches were accompanied by a memorandum that justified the artist's approach in historical and ideological terms. For the entire sequence, he wrote, "I let myself be guided by the basic thought expressed in Charlemagne's life and constantly reiterated in his momentous enterprise: the penetration of the state by Christian principles, the eradication and transformation of heathen attitudes brought about by Christianity . . . Everywhere Charlemagne appears as the Christian hero, the antithesis of paganism and Mohammedanism."[9]

It is apparent that Rethel did not distinguish sharply between the Carolingian empire and more modern political systems; he thought of Charlemagne's pre-feudal construct as the forerunner of the centralized, united Germany that did not yet exist. Charlemagne seemed to him a second Boniface, and Christianity the ideology that created and justified his state. In the modern world its role would be assumed by an all-German patriotism that elevated the ideal of national unity above loyalty to particular German states. The yearning of many of Rethel's contemporaries for a united fatherland gave rise to his program and no doubt contributed to its acceptance by the jury. Rethel's prospectus responded, evidently with greater logic and force than those of his competitors, to the demands of the time to be inspired by the past, and to its willingness to exploit the past for its own ahistorical purposes, to the extent of altering the physical remnants of a vanished culture according to present needs and tastes. Scarcely anyone expressed concern over the muddle of periods and styles that would result from placing on the walls of a fourteenth-century building frescoes that claimed to link the spiritual and political ideals of the ninth and the nineteenth centuries.

At the age of twenty-four Rethel had been entrusted with one of the great public art projects of the century. His reputation as a leading historical painter was assured, and he became economically independent. Nevertheless his triumph had a dark side. The verdict in the competition immediately led to a debate that helped delay work on the project for nearly seven years. The stylistic principles according to which the hall was to be restored formed one major issue; other points of disagreement were the nature of Rethel's program—some critics demanded that the frescoes celebrate the history of the town rather than that of an emperor—and the choice of Rethel himself. Schadow found the "frenetic enthusiasm" for Rethel's proposal distasteful, and pamphlets and newspaper articles critical of the jury's decision appeared. In the end the polemics changed virtually nothing. In a personal audience in 1846 Rethel gained Frederick Wil-

48. Alfred Rethel: Frontispiece of the *Hannibal* cycle.

liam IV's backing for his somewhat amended program, and in June of the following year he began to paint the first fresco. But the long postponement, which had exacted a steep emotional price, prevented him from completing the cycle. He painted four panels—the last three with the help of assistants—before his psychological and physical deterioration made it impossible for him to continue. "Significant works, but harsh in color," was Fontane's judgment when he passed through Aix-la-Chapelle in 1852 on his way to London.[10] The remaining panels were painted by Rethel's former assistant Josef Kehren, who followed his master's designs exactly but without spirit. During the Second World War the town hall was repeatedly hit by bombs, which destroyed three frescoes and damaged the rest. Today the restored frescoes, some moved from their original locations and deprived of the ornamental borders executed by others after Rethel became disabled, convey only a fragmentary sense of his intention and achievement.

49. Alfred Rethel: Study for *Otto Descending into the Crypt of Charlemagne*. The study does not include all of the details of the finished fresco.

The first two panels Rethel painted develop psychological themes that were of profound personal significance to the artist and are central to his conception of Charlemagne. Compositionally they are not the strongest of the series, but they are sufficiently representative for our discussion to take them for the whole. The first panel in the sequence, which runs from left to right along three sides of the hall, is chronologically the last. It was not Rethel's original intention to begin at the end: he decided on the shift in the course of adjusting his plan to the remodeling of the hall. But he had resorted to a similar reversal in his Hannibal cycle, which opens with two mountaineers in a desolate Alpine pass, showing travelers the debris or relics of the Carthaginians' march: a broken siege-ram and the skull of an elephant, half buried in the ice (Fig. 48). The frescoes in Aix-la-Chapelle begin with a documented incident, which, like the invented opening of the Hannibal cycle, reveals the impact of his subject on later generations. In the year 1000, nearly two centuries after Charlemagne's death, Otto III descended into his crypt

to strengthen himself, in the words of Rethel's prospectus, "with a profoundly felt prayer before the mighty corpse, begging for strength to emulate [his predecessor] in thought and deed." Rethel's text also points the general lesson of the event: "Under the harshness of the times . . . the depressed national sentiment sought to make up for the misery of the present by lovingly reflecting on its great past"—words that describe equally Otto's motivation and the attitudes of the 1840s, and that indeed sum up the function of the cycle in the Imperial Chamber.[11]

The fresco is painted on a space, slightly over twenty-one feet at its widest and nearly eleven feet at its highest, that is framed by an asymmetrical Gothic arch (Fig. 49). In accord with the sources, the embalmed emperor is shown seated on his throne, which has been placed over an open Roman sarcophagus. A veil obscures his face; he wears the imperial crown and holds scepter and orb. An open book lies on his lap.[12] Otto kneels before him, turned slightly away from the viewer; behind him kneel three companions, one holding a smoking torch which provides the main source of light in the darkness. On the far right, two more men climb down one of the ladders that have been lowered through a hole broken into the ceiling of the crypt. The massive vertical of the emperor, before which the spiralling curve of the descending and kneeling men comes to a halt, gives powerful aesthetic expression to the underlying political myth of the corpse, emblematic of the imperial idea, towering over the living supplicant like another Barbarossa awaiting the day when at last he will rise to redeem the Germans.

The second fresco, larger than the first and framed by a symmetrical Gothic arch, represents an incident from the Saxon wars. A preliminary study (Plate I) conveys Rethel's intentions more accurately than does the heavily restored fresco. A pagan idol in a grove of fir trees, the Irminsul or pillar of Irmin, has been pulled to the ground. In the center of the painting the emperor, half turning to a group of Saxons, points with his right hand to the broken idol, whose enormous, still threatening head is being dragged away by four men-at-arms. In his left hand he holds the imperial banner, bearing an eagle with a superimposed cross. The emperor's figure dominates the churchmen and knights behind him and to his left, as well as the grieving Saxons on his right, who know that the destruction of the pillar signals the end of their traditional way of life. Only two pagan priests remain unswayed by Charlemagne's personality and authority; they walk away into the forest, observed by a monk standing behind the emperor. Rethel's colors emphasize the differences in position and attitude of the men and women in this confrontation of the old and the new. The Saxons are painted in earthen tones that blend with ground and forest, as is their idol; the German knights stand out in white and silver; the emperor is rendered in red and gold, colors that reappear on the white ground of the banner of sovereignty. The upright firs behind the victors and the bent birch behind the Saxons are a further comment on the struggle that has taken place. Rethel conveys the emotions of the defeated with great clarity, but he does not exaggerate their sorrow into pathos. His Saxons are as stern and dignified as their conquerors. The movement of the crouching, agitated crowd in the left of the picture and of the four men in the right foreground who haul away the idol's head does not diminish the calm

that emanates from the emperor. A latter-day Boniface, Charlemagne has extended the reach of true religion and enlarged his empire.

Shortly after Rethel won the commission for the cycle on Charlemagne, historical art in German received a powerful stimulus from another country. It may be useful to conclude the outline of Rethel's life and work before he turned to the Dance of Death with a brief account of this development—the exhibition in Berlin, Düsseldorf, Munich, and other German cities in 1842 of two paintings by Belgian artists, Louis Gallait's *Abdication of Charles V* and Edouard de Bièfve's *Compromise of the Dutch Nobility*, both painted the previous year.[13] These depictions of important incidents in the more remote history of the newly independent Belgian state were greeted throughout Germany as expressions of a noble struggle for national self-determination. Burckhardt, discussing the paintings in his review of the Berlin Academy exhibition of 1842, attributed much of their quality to the political context from which they arose. As we have seen, Burckhardt explained the lack of convincing historical art in Germany by the absence of a vigorous "public life." For the time being German artists could not be expected to create powerful historical interpretations, since in this genre power depended on art being suffused by a strong public—that is, political—impulse. Gallait and Bièfve, on the contrary, worked in a political atmosphere that stimulated them to choose episodes of activity or conflict as themes, and to penetrate to their factual rather than their symbolic truth. They sought the reality and drama of particular episodes, which they re-created in oil paintings of impressive dimensions—each work measured nearly five by seven meters—showing men and women in costumes authenticated by scholarship, their features based wherever possible on contemporary portraits and descriptions, in settings attuned to the event, painted in rich colors and in a bravura style inspired by one of the greatest names in the Flemish past, Rubens. Compared with these works, even Lessing's *Hus* now seemed static, intellectual, and above all not faithful to the facts. To Lessing it was a matter of indifference that his Hus wore the robes of a later century and had the face of Melanchthon: it was the *idea* of the reformer that he wanted to convey. Burckhardt agreed that the philosophic tendencies of German historical art had value, but noted that they reflected only one facet of the past. Standing before them he missed a force that emanated from the Belgian paintings: "the breath of drama and history."[14]

The realism and activity of the Belgians' concept, reinforced by their emphasis of color over line, made a deep impression in Germany but also encountered strong criticism. In a rebuttal to Burckhardt's review, Ernst Förster, Kugler's conservative co-editor of the *Kunstblatt*, characteristically objected that in the *Abdication of Charles* Gallait erred in showing the emperor as an ill and troubled old man. Such psychologically disturbing and aesthetically displeasing details could only detract from the dignity and symbolism of the scene. Kugler responded in Burckhardt's defense that to idealize the abdication would be to falsify it. Modern historians like Ranke had proved that Charles was old, hypochondriac, and oppressed by a sense of failure: Gallait was right to state these truths.[15] Today we are impressed less by the uncompromising nature of the Bel-

gians' realism than by its ambiguities. They locate the events in imaginary stage-settings, composed of pillars symbolizing Roman virtue or Christian piety, architecturally illogical balconies to hold crowds of onlookers, a profusion of curtains, wall-hangings, rugs. Among this opulent scenery, dozens of people are arranged like the principals and supernumeraries of an opera on a historical theme by Bellini or Meyerbeer. Verisimilitude is aimed for in clothes and faces—many figures give the impression of individual portraits later inserted into the mass—but the whole is staged and deeply unreal. The Compromise of 1556, which Schiller had described in all its political twists and accidents of personality, the conjunction of individual calculations and general principles and aspirations, is here presented as an assemblage of worthies striking dramatic poses for posterity. Evidently what impressed contemporaries, beyond the documentary nature of the portraits, were the currents of mobility running through the composition and the energy and color of the artists' execution, all of which seemed important achievements of realism, just as did the specificity and simultaneity of Menzel's illustrations for *Frederick the Great*, which were appearing at the same time. The reaction Gallait and Bièfve evoke in the viewer is not a calm or tearful reflection on the nobility or vanity of existence—the message of so much of German historical art of the time—but an appreciation of the struggles, the personal commitments, the sheer sensationalism of history.

Not surprisingly, Rethel was immune to the influence of such works. Even the rich palette and broad brushwork of the Belgians, which lent their oil paintings an impressive surface vitality, could mean little to him at a time when he had to master the technique and coloristic possibilities of the fresco. But he was basically a different kind of artist, tragic rather than dramatic, and his conception of history and how it should be treated in art could hardly be reconciled with theirs. For one thing, Rethel's compositions are exceptionally lucid; even when they contain large numbers of people their structure is immediately apparent. Each figure—whether principal, attendant, or onlooker—is realized individually, and relates and responds to all the others; a balcony with a mass of undifferentiated spectators placed on the canvas for psychological and compositional reasons, as Bièfve painted it in the *Compromise*, would be unthinkable in his work. To revert to our musical analogy, like the Belgian paintings Rethel's may suggest opera—not the disposition of soloists and chorus on stage, but the vocal line and the instrumental score, the ensemble of singers and the orchestra interacting and combining. This highly articulated aesthetic links with and expresses a sense of the past in which not only leaders but also the people—warriors, monks, heathen—are major historical actors; in one form or another the complex relationship between leaders and the mass is present in nearly all of his historical works. Kugler recognized this characteristic when, two years before the Revolution, he declared that German historical art should "seek above all to bring out the morally ennobling significance of history, and should emphasize depictions that contain the essence of history and that express the poetic elements of popular life." Some historical paintings in Germany, he thought, among them Rethel's studies for the frescoes on Charlemagne, already formed a sound basis and gave promise for further development.[16]

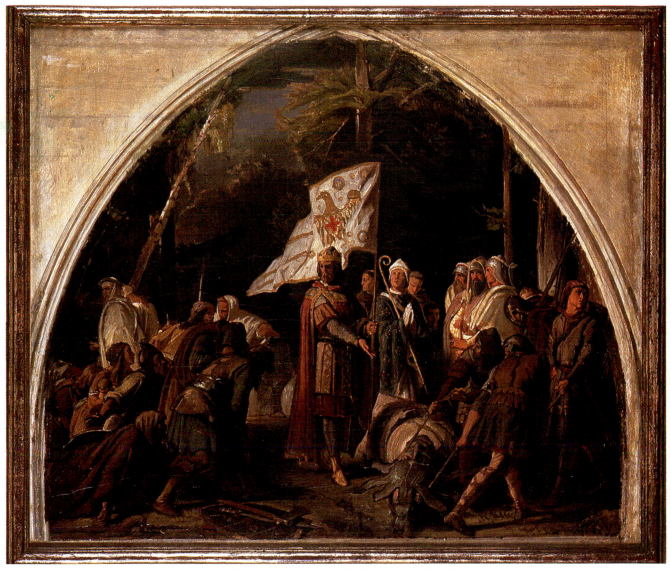

PLATE I. Alfred Rethel: Study for *The Destruction of the Irminsul.*

II. MENZEL'S *THE MARCH CASUALTIES LYING IN STATE*

AT THE OUTBREAK of the Revolution of 1848, Rethel was at work on the second fresco of the Charlemagne cycle. Before considering his interpretation of the political storm that would now sweep over much of Europe, we must turn to the Revolution itself, and to Menzel's reaction to one of its most significant symbolic incidents in Berlin. More than most revolutions, which are never unitary responses to a single determining problem, the Revolution of 1848 in Germany originated in a broad range of difficulties and conflicts, complicated further by a regional diversity under whose impact even similar issues could assume different forms. Among the causes were food shortages and pauperism, which neither society nor governments had the knowledge or will to ameliorate; very rapid population growth; the destructive effect of early industrialization; mismanagement and scandals that undermined the efficiency and moral authority of a number of governments; financial difficulties, which in Prussia led to the calling for the first time of a state-wide United Diet, raising expectations of true constitutional government that were soon disappointed; the imbalance between the political impotence of the middle levels of society and their constantly growing economic power and cultural authority; the rigidity of most of the ruling systems, and the ineptitude and arrogance of too many of their agents; the drawbacks—real and imagined—of the country's political fragmentation, which heightened the seduction of nationalism. The Revolution was composed of many smaller revolutions, breaking out under different conditions, often facing different problems; and from the beginning those who fought against the political, economic, or social reality of 1848 could be driven by different motives. At least in the early weeks and even months, the basic aims of liberalism—a constitution under princely rule, some degree of representative government, equality before the law—enjoyed broad appeal across the country and throughout society. But even in March the tendency of liberals to equate the concerns of the well-to-do and educated with the general weal was, to say the least, short-sighted. The peasants who rose in Baden, Hesse, and parts of Bavaria in April and May, and who demanded a German federal republic, expulsion of the Jews, and destruction of the nobility and officialdom, scarcely fit into the liberal mold. A cluster of issues in one state or region might briefly fuse different groups into an alliance; the consolidation of the gains each revolutionary action had achieved required that a measure of cohesion be maintained and, in the final analysis, that the various revolutions be united into a single force.

In Berlin the news of the February Revolution in Paris alarmed the government and encouraged liberal agitation for freedom of the press, a constitution, and other changes. During the second week of March open-air meetings in the Tiergarten, illegal but conducted in orderly fashion and for the time being tolerated by the authorities, discussed petitioning the king for these reforms. On the thirteenth the Berlin garrison reinforced the guard battalions customarily stationed in and near the palace, and took up positions throughout the city. A public meeting that day heard workers call on the government to take steps against unemployment and protect working people against capitalist ex-

ploitation. When the crowd dispersed in the early evening, cavalry detachments, sabers drawn, rode down some people on their way home. The following day the king received a deputation of the magistrates, stated that the United Diet would reassemble at the end of April, but showed no awareness of the increasingly dangerous political situation and the threat of violence in the capital. That evening several smaller meetings were broken up by troops. In one incident officers lost control over their men, who wounded a number of unarmed residents of the Brüderstrasse, a solidly middle-class area. The clashes increased tensions between the garrison and the population. For over a century no European city had been as greatly dominated by, and as accepting of, the military as Berlin; now demands that the troops leave the city became general. The following evening, the 15th, soldiers fired into a noisy crowd before the palace, killing at least one man and wounding others. In response the first barricades were built in the streets. A major confrontation between army and inhabitants was clearly imminent.

The news of the revolution in Vienna and Metternich's fall brought the crisis. Frederick William now agreed to the relaxation of censorship, held out the prospect of a constitution, and made other concessions, among them an earlier meeting of the Diet. The calming effect these steps might have had were dissipated by his brother, the later Emperor William I, and other conservatives, who managed to postpone the public announcement until the early afternoon of the 18th, at which time the king was cheered by large crowds now permanently gathered before the palace. But demands that the garrison leave Berlin persisted, while the king's brother and his associates opposed any true decrease in the power of the crown. Both the far right and the extreme left maneuvered to exploit the tenuous balance and worked toward open conflict. Almost inevitably, it came. In the afternoon of the 18th, soon after the king had been applauded for agreeing to reforms, units of the guards cleared the square before the palace, in the course of which two shots were fired under circumstances never fully explained. No one was hit, but the crowd panicked and became enraged, rumors of a massacre spread, and hundreds of barricades were erected with astonishing speed to block the movement of the troops and challenge their control of the city. Fontane, who joined the revolution armed with an ancient carbine, did not think that the barricade he ran to defend—its materials included painted stage sets—would stand up to serious assault; others were carefully sited and constructed, and presented great difficulties for the attacks that now began.[17] The fighting lasted through the afternoon, evening, and the night from the 18th to the 19th. All social groups were represented on the barricades, but if the casualty figures are representative of the whole, the brunt of the fighting was borne by artisans and skilled workers—men holding solid positions in the world of small shops and workshops.[18] Three hundred and three civilians were killed or later died of their wounds. Nearly seven hundred prisoners were taken. Twenty of the soldiers were killed and 252 wounded, according to the official report. Neither side had gained a true victory. Some barricades fell, others were held; the troops remained loyal to the crown, but the morale of some of the units was shaken. What proved decisive was the king's loss of nerve. After lengthy discussions with official and unauthorized advisors, Frederick William

50. Anonymous: *Attack on the Barricade on the Alexanderplatz
on the Afternoon of 18 March.*

agreed to the withdrawal of the garrison. In the confusion that reigned both in the palace and the headquarters of the military, made worse by the incompetence or ill will of some senior officers, the greater part of the royal guards, which were to have remained, also marched out of the city. A new militia, composed primarily of members of the middle and lower-middle classes, took their place. Its provisional commander, the chief of the Berlin police, was soon succeeded by a retired major, a well-known writer on military subjects, who was a member of the Tunnel over the Spree. The king was left in the hands of the inhabitants of Berlin; his life was never in danger, but he was submitted to a number of humiliations, the first being that on the afternoon of the 19th he was forced to salute the corpses of the men and women his troops had killed.

This encounter between the dead and the momentarily vanquished monarch was soon followed by the greatest symbolic event of the revolution in Berlin. On the morning of Sunday the 22nd, 183 coffins of the civilian casualties were placed before the New Church in the great square of the Gendarmenmarkt, the focus of a ceremony in which tens of thousands of Berliners took part. In the words of a contemporary newspaper account, the square "seemed like a painting, the features of which no pen can describe. Interspersed among the black, surging masses were countless guild banners and the German colors black-red-gold, which fluttered in the rays of the sun . . . Nevertheless order and calm prevailed; yes, almost a profound silence, creating an impression

95

that sanctified the occasion [*die einen heiligenden Eindruck machten*]. No loud word was heard; each face expressed the deep seriousness of the occasion . . . In the background of this sea of humanity rose the gloomy scaffolding with its coffins . . . At two o'clock church bells began to ring; the chorale 'Jesus, my Joy and Trust,' played by a brass choir, gave the signal that the procession would begin." The coffins, followed by the city magistrates, the rector and professors of the university in their gowns, students with their dueling sabers, guilds, communal and professional organizations (writers and journalists behind a banner proclaiming "Freedom of the Press"), delegations from other parts of Germany—some twenty thousand men and women by one estimate, far more according to others—moved past the palace, where the king once more saluted the dead, to a municipal park outside the city gates.[19]

Menzel, who had not been in Berlin during the fighting, returned to the city on the 21st. The following morning he sketched the lying-in-state before the New Church; then, as he wrote a friend, he observed the funeral procession from a number of vantage points, impressed like the reporter with the serious, silent behavior of the crowd. Finally he drew in outline the placement of the graves in two concentric squares in the park.[20] It is not known when he began the painting of the lying-in-state, nor when he interrupted the work, never to return to it. The canvas, today in the Hamburg Kunsthalle, is dated "1848" beneath his signature, and it seems probable that he began it soon after the event.

The small picture (Plate II), about 45×63 centimeters, is crowded with hundreds of figures. On the far side of the square rises the irregular mass of the New Church against a blue-gray sky, its cupola cut off by the frame. In the far left background, houses are beflagged in the black-red-gold of a united Germany. Before the colonnade of the church, which is wreathed in black, coffins are stacked three or four tiers high in a flat black pyramid. Small groups of mourners and militia detachments move across the square; from the left foreground a coffin is carried through the crowd toward the church. The little procession diagonally divides the foreground and middle distance; to its left university students stand to attention and citizens pay their respects; in front of them and at the extreme left additional spectators and mourners are sketched in, but the figures are not completed in oils. To the right of the procession, a larger, more agitated crowd is divided into people who watch the continuing carrying in of the dead, those who discuss the recent events and the future, and others who are reading announcements posted on the side of the steps leading up to the Royal Theater at the extreme right. The platforms flanking the steps are crowded with further spectators. In the foreground, to the right of the passing coffin, a well-dressed man has taken off his hat. On his other side stands a member of the militia in civilian clothes and top hat, shouldering a drawn saber; before him two children, their backs toward us, watch the coffin. One, a little girl, carries a small flag, its black-red-gold echoing the flags in the far distance. To the children's right, a middle-aged man in top hat and green overcoat, the largest figure in the painting, walks toward the viewer. His dark, bulky, mysterious presence repeats the outline of the portico and the pyramid of stacked coffins, and con-

trasts with the gesticulating figures in brighter clothes behind him as the brown, black, and ochre New Church contrasts with the bright sky and the gray and yellow houses and colorful flags beyond it.

Even someone who does not know the specific subject of Menzel's painting will immediately recognize that it depicts a serious event with political overtones: a funerary ceremony, arranged not under the usual official auspices—the only items of dress reminiscent of uniforms are the caps, sashes, and gauntlets of the university students—but by the inhabitants. The painting conveys the impression of a communal enterprise, which was the essential fact of the lying-in-state, and as other witnesses attest it shows us "wie es eigentlich gewesen" on the Gendarmenmarkt that day. The possibility that Menzel's account may not be accurate in one or two respects to be noted further on does not detract from the inspired truthfulness of the whole. What helped make the lying-in-state so impressive a spectacle to contemporaries was the spontaneity and freedom with which Berliners of many social classes used a public, ceremonial space of their city as the setting for an open expression of their feelings. For a short time a sense of community must have been palpable to many in the square and in the procession. It had emerged out of the shock of the fighting and the shock over the dead, with whom the participants felt a bond that was relevant to their conception of their place in society, in the city, and in the Prussian state. The ceremony was a high point of the first phase of the revolution in Berlin, and at the same time its terminus; were it not for Menzel we today would not have the same clear recognition of the ceremony's communal and political as well as human aspects.

The painting is a visual document of an occurrence that is now part of history. Does it depict this event from a specific political point of view? Some interpreters regard the work as "objective," politically neutral. In his classic study of Menzel, Karl Scheffler writes: "Menzel painted the Revolution with complete impartiality, neither as an apologist nor as an accuser; all the more objective was his artistic vision."[21] Others assert that the painting celebrates the Revolution, that it takes sides and makes precise sociopolitical statements. They base themselves on two elements—one outside the paintings—Menzel's political attitudes—and one within it—the gentleman in the foreground who has taken off his hat as the coffin passes. A recent catalogue of the Hamburg Kunsthalle explains the significance of this figure in the following terms: "An elegantly dressed gentleman has made way for the coffin and removed his hat. With this gesture he shows that his class has been forced to accept defeat, but he remains apart from the people"—this last a reference to the space that separates him from the pallbearers and from the militiaman to the right.[22] The political interpretation may gain additional support from another fact that I have not seen previously mentioned. Although the gentleman makes the conventional response to the coffin being carried past him, his left hand remains in his coat pocket. Is Menzel saying that this rude behavior reveals the well-dressed man's true feelings?

A variant of the political interpretation, but with very different content, recently proposed by Elke von Radziewsky, holds that the painting is Menzel's comment on the

Revolution in its entirety: "Together with the optimistic hope for the fulfillment of the ideals of the *Vormärz, The March Casualties Lying in State* reveals resignation over the end of the insurrection, demonstrates the separation and dispersal of people who have lost interest [*das interesselose Auseinanderstreben der Menschen*] . . ." In the foreground "a few strongly characterized figures, which are developed with great plasticity, . . . disperse without interest in all directions instead of taking part in the ceremonial event."[23]

To understand whatever political character the *March Casualties* may have, we must not merely search for relevant clues in the painting: our search must deal accurately with the evidence—which is simply another way of saying that we should respect the artist's efforts, even if they seem to go against our predilections—and we must also respect the historical facts of the Revolution. Beyond that, we ought to take note of Menzel's political opinions; and finally we should ask why he left the painting unfinished. It is not surprising that evidence from such a variety of categories does not immediately present unambiguous results.

We might begin with Radziewsky's encompassing interpretation. The claim that Menzel shows people dispersing can be based at most on four figures: the disproportionately large man walking out of the picture (who seems troubled and intense rather than uninterested); possibly two men on the extreme right, who may be leaving the square or equally well may be joining others in the milling, arguing crowd; and perhaps the gentleman who has taken off his hat. His back, to be sure, is to the church and the massed coffins, but his gaze is directed at mourners and spectators. Compared to the hundreds of people in the painting who clearly have not lost interest, this is scarcely sufficient evidence that people are leaving, and that by painting their dispersal Menzel expresses resignation over their attitude. It seems equally odd to speak of "the end of the insurrection" on 22 March when Berlin would be the scene of a multitude of revolutionary and counter-revolutionary activities for the next seven and a half months, including mass demonstrations and attempts at armed insurrection. But perhaps the reference is not to March but to a later period when Menzel was working on the painting; or it is suggested that the artist was predicting a future development. We are offered no explanation, and it is difficult not to conclude that an important aesthetic element in Menzel's painting, the movement of people to and fro, the way the artist guides the viewer's eye back and forth, from the large man in the foreground to the church across the square, has been given a wholly fanciful political gloss.

As might be expected from its realist creator, the painting does contain specific information on the crowd, but it is the kind of data that art historians who favor a political interpretation tend to misjudge or ignore. Those figures whose clothes indicate their social status are a few members of the upper levels of society and many more bourgeois and petit-bourgeois—merchants, professionals, militiamen, women in cloaks and greatcoats, and master craftsmen. Several men in the group at right are workers, but the very poor are not in evidence. If Menzel meant his crowd to stand for the revolutionary forces as a whole, he unduly minimized apprentices and unskilled workers but

51. Adolph Menzel: Detail from *The March Casualties Lying in State*.

correctly conveyed the leading part played by master craftsmen, journeymen, and the middle levels of society. He also accurately reflected the social variations of the groups that made the revolution in Berlin, variations that too often are submerged in the comprehensive cliché "the people," implying workers and the poor. The many men in top hats scarcely fit that scheme, nor do the university students. And it can by no means be taken for granted that the gentleman in the center foreground, the romantic key figure

99

of so many political interpretations, represents a class "that has been forced to accept defeat." He may equally stand for the educated and economically secure who fought on the 18th, and who made up a large part of liberal opinion in Germany. Three men with titles of nobility were among the 303 civilians killed in Berlin—a percentage slightly higher than the proportion of nobles to untitled in the population. Historians and art historians should take care when they use such schematic terms as "the people" to identify and explain revolutionary forces or, better, should forgo these vague but highly charged labels altogether.

Although many of the specific political allusions that have been read into the *March Casualties* are untenable, the belief that the painting is sympathetic to the Revolution may gain some support from Menzel's political attitudes. We know that at the time he drew the illustrations for *Frederick the Great* he expressed liberal opinions, which—even if we give little weight to the political determinism of background and economic condition—are characteristic of a young man of petit-bourgeois antecedents and some education, making his way in one of the "free professions" (that is, holding no appointment in the state bureaucracy). Fontane's condition was rather similar. Menzel's letters of this period reveal that his earlier opinions did not change as he was gaining recognition and receiving important commissions from the state. The letters also suggest that political and social issues were not a matter of intense, abiding concern for him—he never shared the political commitment of a Courbet. After the food riots in Berlin in the spring of 1847, he commented that the events show "how far things can go when one half of the population is left defenseless before the brutal greed of the other half"; adding, "the initial excesses caused by dire need were succeeded by a mass of low and disgraceful acts, in which the common people in Berlin [*Berliner Plebs*] are no less proficient than those elsewhere." He welcomed the meeting of the United Diet.[24]

His long letter of 23 March, after his return to Berlin, is filled with comments on what he has seen and heard, but contains no political judgments. A jocose note two weeks later to a close friend, a physician in the army, begins: "Although your sentiments are with the guards, and I am totally for the plebeians . . ." At the head of the letter Menzel drew a miniature militiaman in top hat and a soldier wearing a spiked helmet (Fig. 52). On 3 May he writes another friend that he regrets not having experienced a revolt—that is, street fighting—and adds: "I must confess that something to which I had always been pretty much indifferent now *pains* me for the first time: that I did not

52. Adolph Menzel: Sketch at the head of a letter.

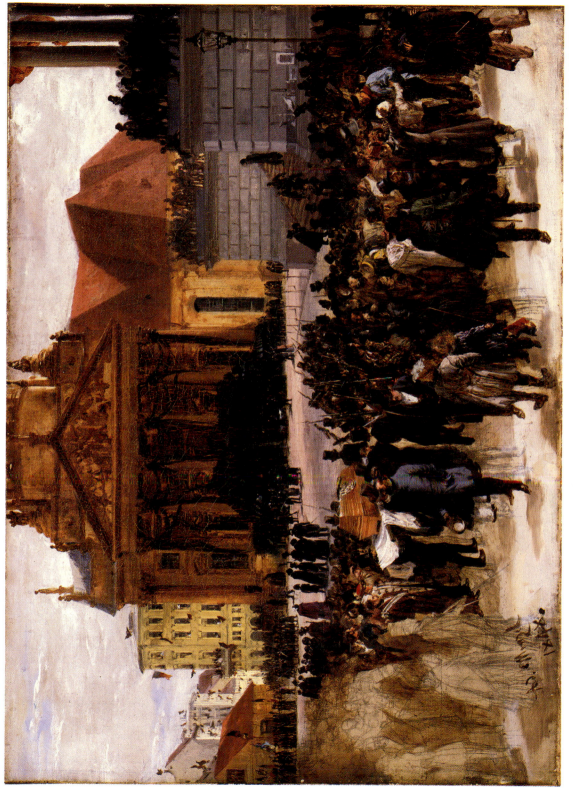

PLATE II. Adolph Menzel: *The March Casualties Lying in State*.

grow up to be a tall, strong fellow." Finally, in September he reminds the same friend of their talks before the Revolution: "Neither of us at that time thought the outbreak was so close, and good sense so remote! Once again one [or 'we'?] had too much confidence in mankind; the (justified) indignation over [people at] the top has now led only to indignation over [people at] the bottom. We merely exchange one schoolbench for another." Only four letters from 1849 survive. None mentions politics, unless a New Year's wish refers to public rather than private matters: "May God straighten out in the New Year what went awry in the Old!!!"[25]

Menzel's references to politics do not extend beyond generalities to specific aims and programs. We are not told his views on German unification, for instance, nor whether he preferred a republic to a constitutional monarchy. His letters leave no doubt that he supported the March uprising; but he did not hesitate to use mildly derogatory terms for the common people [*Plebs, Janhagel*], and like Fontane he could note strengths and weaknesses on both sides. More than half a century later he offered further information on his political attitudes in 1848 in a statement that remains his only known comment on the *March Casualties*. In 1902 Alfred Lichtwark, Director of the Hamburg Kunsthalle, bought the painting for his museum. After the purchase Lichtwark visited Menzel in his studio, and in a letter to his board of directors reported the artist's comments on his work: he had sketched the ceremony from the steps of the church opposite the New Church. "The elegant man who salutes the coffin had been a stranger [i.e. a visitor to the city], who had attracted his attention by his immaculate appearance and air of distinction. He saw him only once. As he sat and sketched, the uncontrolled crowd of common people, whom hard times had made unemployed, was in front of him. The people talked only of their own heroic deeds. Everyone had taken part, on this or that barricade . . . A few members of the mob on the balustrades of the theater had attempted to sneak down the steps to get closer to the ceremony, but a single militiaman faced them down and sufficed to shoo them away [an incident Menzel depicts in the painting] . . ." Menzel had begun work on the painting "with pounding heart and in high enthusiasm for the ideas in the service of which the victims had fallen. But before he had finished he had recognized that everything had been a lie or stupidities [*dass alles das Lüge oder dummes Zeug gewesen wäre*], and he had turned the picture to the wall and in his disgust had no longer wished to lay a hand to it. Many years later he had pulled the picture out again and had been pleased with it, but felt no temptation whatever to complete it."[26]

The political parts of this statement suggest that Menzel opposed the radicalization of the Revolution. The Marxist art historian Wolfgang Hütt seems to have accurately summed up his attitude in the later spring and summer of 1848: "On the one hand, Menzel was disappointed in his expectations of the Revolution; on the other, he shared with many liberals the fear of true popular rule."[27] Any number of developments might have disillusioned and frightened people who had wanted no more than moderate reforms. The élan and cohesion of 18 March could not persist. It was an indication of the

brittleness of revolutionary sentiment in Berlin that less than two weeks after the fighting and after the widespread demands that the garrison quit the city, the magistrate recalled troops to maintain order, a step that had the support of many inhabitants and the acquiescence of most, with only a small minority objecting. Not only in Berlin but throughout Germany the defeat of the established authorities led not to a new stability but to dissent and conflict. Political action and public opinion fragmented as the difficulties of unification became apparent, conservatives recovered their spirit, and the divisions between moderates and radicals deepened. An event in April left a deep impact on moderate opinion. In a gamble to restore the out-maneuvered democratic minority in the Baden assembly, the deputy Friedrich Hecker proclaimed the republic, and tried to rally the population between Lake Constance and the Black Forest to its cause. But the peasants were not attracted to Hecker's democratic pronouncements, and within two weeks his poorly armed followers—supported at the last minute by a force of workers and students organized by Georg Herwegh, a sad attempt by the poet to translate verse into action—were defeated and dispersed by government troops. Marx sharply condemned Hecker's adventure; in the public mind he came to symbolize anarchy and political violence, an anti-hero whose memory persisted for decades. A popular song of the time begins:

> Look at the great Hecker,
> A feather in his hat,
> Look at the man who rouses the people,
> Thirsting for the blood of tyrants,
> He wears hipboots with thick soles,
> Carries a saber and pistols . . .

Subsequent incidents, among them the storming of the royal armory in Berlin by crowds in search of weapons, could only increase liberal apprehensions.

Nevertheless, Menzel's "lie or stupidities" is an unusually harsh term for causes of popular discontent and even for their exploitation by radicals—especially when we recall that as late as September 1848, at a time when he may already have put aside his painting, Menzel could still write to a friend that indignation over those in power had been justified. An artist's statement about his own work deserves the greatest respect, but should we simply accept Menzel's words to Lichtwark as the complete explanation? His political views certainly changed in the intervening fifty years, and in later life he became accustomed to a brusque, forceful manner of speaking. Is it not conceivable that his words in 1902 exaggerated the substance of his opinions in 1848, and their impact on his work? No doubt he was a moderate who did not believe in democracy and found political agitation distasteful, but it is not apparent why such radicalism as did exist should have prevented him from finishing a painting that in any event would never have glorified the Revolution. Even with the completion of the mourners and spectators in the lower left corner, the *March Casualties* would have fallen short of being a Prussian version of Delacroix's *Liberty Guiding the People*.

We will never know the answer. But even if we suppose Menzel's statement to Lichtwark was accurate, need it have been the whole explanation? Nothing in it precludes the possibility that in conjunction with his disappointment in the course of the Revolution aesthetic considerations kept him from completing the work. Some art historians, ignoring rather than rejecting the assertion that it was his politics that stopped Menzel, have proposed compositional problems as the reason. Such formal difficulties as the painting's perspective and its disappearing foreground may indeed have troubled the artist.[28] Another difficulty has to do with Menzel's realism. The agitated crowd on the right, breaking like surf against the steps of the Royal Theater, marvelously completes the ebb and flow of mourners, militia, and spectators that fills the rest of the painting. But seen from close by, the crowd jars. The other figures in the center, to the left, and in the background blend into the mass, which has stylized aspects; even the two children, the gentleman, the militiaman, and the two students in the foreground, though fully realized, contribute to the painting's somber, stable aura by their silence, posture, and relative lack of movement. In the crowd on the right Menzel departs from the newspaper reports of the lying-in-state. Here people are neither silent nor immobile. They confront each other, question, argue, gesticulate. Lichtwark cites Menzel to the effect that on the 22nd some spectators in the Gendarmenmarkt did behave this way. It is also possible that Menzel introduced one of the many agitated crowds he observed throughout Berlin during these days into his interpretation. The problem is that the most prominent members of this group are treated anecdotally. A figure such as the man bent forward, hands clasped, listening open-mouthed to what is evidently a shocking piece of news does not harmonize with the basic tone of the painting. We may consider his presence, and the presence of others like him, an expression of a higher realism. The Revolution consisted of both gravity and excitement, and probably even the lying-in-state itself witnessed both types of behavior; but in the painting Menzel was unable to blend the two in a satisfactory manner.

The anecdotal treatment of separate figures in a group is not unusual in Menzel's *oeuvre*, and it often posed difficulties for him. His intense concentration on one or a few individuals could interfere with the process by which he combined them into a more encompassing entity. The accumulation of realistically achieved figures may degrade the realism of the group. Sometimes Menzel solved this problem, for instance in his magnificent paintings of society at the imperial court in the 1870s. In other works, his close observation—far more penetrating than the attention we usually pay to people in a crowd—detracted from the whole. In the *March Casualties* the problem is exacerbated: it is not that one or two figures fall out of the context Menzel created for them, but that he saw and painted two crowds differently, and that he was unable to bring the two conflicting interpretations into harmony. Realism interferes with realism. Perhaps the painting escaped the artist's intention, and was consequently left unfinished, as he was to abandon—after working on it for years—a large painting of Frederick addressing his senior generals before the Battle of Leuthen: a decision that so far as I know has never been interpreted as signifying Menzel's rejection of Frederick.

Its unfinished state does not make the *March Casualties* a failure. Flawed though the painting is, it is admirable both as art and as an account of the ceremony, fraught with political meaning, that took place before the New Church in March 1848. If the different interpretations of the work are tested against the painting itself, and checked against other reports of the event and against Menzel's letters, the evidence strongly supports the opinion that it is indeed a work of conspicuous impartiality. A painting may have a political subject, but if the artist is not a propagandist his political sympathies will take second place to his aesthetic intentions or—very rarely—become one with them. Throughout Menzel's life, his conception of reality, of the essence of the thing he painted or drew, dominated his subject, whether that subject was Berliners burying their dead, Frederick the Great dining at Sanssouci, or workers turning iron ingots into finished bars and plates. Goya's *Third of May* and Manet's *Execution of Maximilian* are incomparably greater achievements, in part perhaps because they were not the work of an eyewitness who also happened to be a realist painter; but how many political incidents of the nineteenth century were interpreted by artists with the veracity of reporting, psychological understanding, and aesthetic quality we find in Menzel's painting? Or, put somewhat differently, how many historical events before the development of photography can we visualize as accurately as the lying-in-state of the March casualties?

III. RETHEL'S *ANOTHER DANCE OF DEATH*

IN THE SPRING OF 1848 the Revolution had achieved great, seemingly decisive results. Everywhere the old authorities retreated before demands for change, and the stage was set for creating new constitutional systems and bringing about German unity. By the fall, these victories had been compromised and were being reversed. Since May a German parliament had at last been meeting in Frankfurt, but it lacked executive power and could never gain sufficient control over domestic affairs or carry out an effective foreign policy. In September, after the diplomatic and military campaign to support the German independence movement in Schleswig and Holstein ended in failure, the delegates in Frankfurt had to rely on Austrian, Prussian, and Hessian troops for protection against an uprising of populist and radical-left elements. The following month revolution broke out again in Vienna and was suppressed by imperial troops at the cost of several thousand dead among the insurgents and the uninvolved population. In November a military coup d'état exploited the by now extreme factionalism of the center and left in Berlin and Prussia. On the 10th a force of 13,000 infantry and cavalry entered the capital. That afternoon their commander, Field Marshal Wrangel, rode to the Gendarmenmarkt and closed the Prussian parliament, which was in session in the Royal Theater. During the next days the militia was disbanded and a state of siege declared. The autonomous Prussian monarchy, a conception of the state in which Frederick the Great figured not as a guarantor of enlightened thought but—according to a conservative leaflet of the time—as the embodiment of military power and social discipline, had

triumphed over the threat that Prussia would be dissolved in a united Germany. The Frankfurt parliament continued to deliberate until June 1849, but with authoritarian governments again in control in Vienna and Berlin efforts for a constitution and for national unification were almost inevitably in vain.

Throughout the spring and summer of 1848, Aix-la-Chapelle had remained peaceful, and Rethel painted the second fresco of his Charlemagne cycle undisturbed by the Revolution. Because he could work in the Imperial Chamber only when the temperature was mild, he moved to Dresden for the fall and winter, to proceed with his final studies for the third panel, the Battle of Cordoba. In Dresden Rethel found himself in one of the centers of republican sentiment in Germany. The Saxon bourgeoisie tended to be further to the left than in Prussia, the numerous industrial workers were well organized, and even some army units were affected by political agitation. Meetings and public demonstrations occurred throughout the fall, followed here and there by a riot or the destruction of industrial machinery. In this atmosphere Rethel turned from the Middle Ages to the political and social conflicts around him for a new theme. One is reminded of a similar shift that Richard Wagner experienced in Dresden some months earlier: after completing the score of *Lohengrin*, he writes, he "had for the first time the leisure necessary to look about and study the course of events."[29]

It is not known what gave Rethel the idea for a cycle of woodcuts on the dance of death as an allegory of revolution. His friend Robert Reinick, who wrote the verses that accompany the pictures, later claimed that the original concept was his.[30] As we shall see, Rethel's earlier work and his recent experiences contain so much of relevance to the scheme that if the suggestion did come from the outside it must have struck the artist as a sudden illumination of thoughts and feelings long at work within himself. That Rethel was the dominant partner in the collaboration is beyond doubt; the woodcuts are the essential element, the verses subsidiary, and at the artist's request Reinick changed the text to bring it into closer agreement with the pictures.[31] Rethel completed the sketches in March 1849. They were cut in wood the following month in the workshop of the painter and lithographer Hugo Bürkner, and published in Leipzig in the second week of May. This was the time of the last, hopeless outbursts of violence in many parts of Germany for the causes of unification and an all-German constitution. In Dresden barricades were built on 3 May, the king fled, and it required six days of street fighting before Saxon and Prussian troops suppressed the uprising at a cost of thirty-one soldiers and some 250 civilian dead. Within a month of the restoration of order in the Saxon capital, *Another Dance of Death* had been twice reprinted. "It is the only work of art that now sells," Bürkner wrote Reinick from Dresden.[32] The cycle was widely reviewed and discussed. The Conservative Alliance of Saxony arranged for a special printing; in Potsdam and Munich political clubs bought copies for distribution to the public, there may have been pirated editions, and sequels and parodies soon appeared. Friedrich Eggers, Kugler's and Fontane's friend and a fellow-member of the Tunnel, was inspired to write a sequence of ballads on the *Dance*. By the middle of 1850 nearly fifteen thousand sets of the woodcuts had been sold. The cycle had become the best-known interpreta-

53. Alfred Rethel: *Another Dance of Death*, Plate 1.

tion of the German Revolution in the fine arts,[33] a place it retained at least until Menzel sold the *March Casualties* fifty years later and the painting was finally put on public view in the Hamburg Kunsthalle.

Rethel's *Auch ein Totentanz*, which may be translated as *Another Dance of Death* or *This, too, is a Dance of Death*, consists of six thematically linked woodcuts, 22.9 × 32.9 centimeters, with brief explanatory verses, published as a portfolio of six separate sheets or, the woodcuts reduced in size, on one sheet. The first woodcut, and because of its allegorical complexities the weakest of the six (Fig. 53), shows Death climbing out of his grave, greeted by five female figures with claws instead of feet, who are sending him on his revolutionary mission. They have overpowered and robbed Justice. She is seen in the background, hands tied, on a throne the foundations of which are giving way. The central figure, Cunning, presents Death with the sword of Justice, Dishonesty holds out her scales, while Vanity puts a hat with a cock's feather and a revolutionary badge on his skull. Behind these three, Bloodlust waits with a pruning hook (a weapon-like alternative to the scythe usually associated with Death the Reaper), and Fury leads a horse forward. The crossbar and handle of the scales and the hilt of the sword repeat the form of a crucifix that was broken when Death burst open his grave. Reinick's

54. Alfred Rethel: *Another Dance of Death*, Plate 2.

accompanying verse ends: "Oh people, see, here comes the man, / Who can make you free and equal."[34]

In the second plate (Fig. 54), Death rides through open country toward the town that is to be the scene of his activities. Above the town walls rise narrow, steep-roofed houses and the spires of a Gothic cathedral, but also the factory chimneys of the new industrial age. Death is now booted and spurred; he wears a loose overcoat, possibly part of a uniform, which contrasts with his broad-brimmed hat, in the 1840s a symbol of nationalism or radicalism. Two peasant girls run off to the right, an oddly stilted pair perhaps adapted from Poussin's *Rape of the Sabines*. By a milestone on the edge of the road two ravens watch the horse and its rider, while a third flutters away.

Now in the town (Fig. 55), Death has dismounted before an inn, marked by the traditional sign of wine and spirits for sale, a six-pointed star. Workers, a woman, and children have gathered round the stranger, who entertains them with a trick. He holds the scales of Justice by the indicator, not by the shears, so that the clay pipe of the common man seems to weigh as much as does the crown.[35] On the wall behind him he has posted a manifesto that calls for Liberty, Equality, and Fraternity. In Rethel's sketch for the woodcut, the German word for "Fraternity"—*Brüderlichkeit*—has been re-

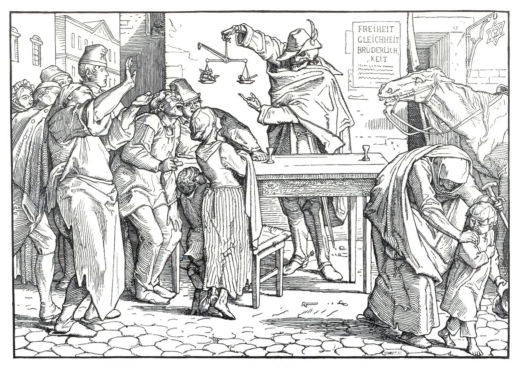

55–57. Alfred Rethel: *Another Dance of Death*, Plate 3 (above), Plate 4 (upper right), and Plate 5 (lower right).

placed by *Liederlichkeit*, "Slovenliness." In the right foreground, an old woman with a rosary pushes a small boy away from the spectacle: "You blind woman, why are you sneaking away? / Do you see more than the others?"[36] Behind her, the horse of Death stares at its master and the crowd.

The crowd has become a mob (Fig. 56). One man is raising his fist, another a stick; a third already has picked up a stone. From a wooden platform Death, now wearing the sash of an officer or official as a mark of authority, offers the sword engraved with the words "People's Justice" to outstretched hands below. On the platform beside him, a worker—a stonemason or blacksmith, judging from his apron and hammer—holds a flag bearing the letters "Repu[blic]" and with his other hand points to an approaching column of soldiers; but Death ignores him. Violence has already erupted: smoke rises above the rooftops, and at the edge of the square a man has been slain.

The fifth woodcut depicts the climax of Rethel's political dance of death (Fig. 57), and the last draws the moral. A barricade of crates, lumber, and barrels filled with paving stones is being defended against a detachment of soldiers. A cannonball has just shattered a beam, and three men are falling. Others take their place; elsewhere on the barricade men continue to fire, supported by snipers from the windows of a house.

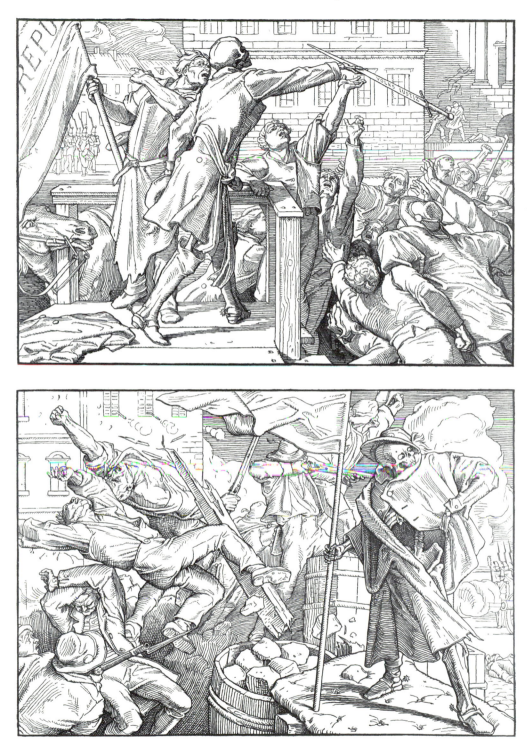

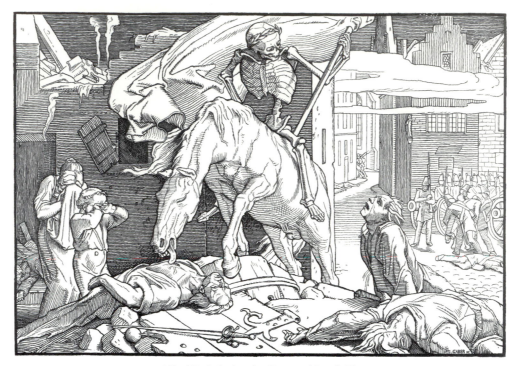

58. Alfred Rethel: *Another Dance of Death*, Plate 6.

Death stands on a mattress atop the barricade. In one hand he holds the flag of the revolution, the other lifts his coat to reveal not the body of a man but a skeleton.

This terrifying violence is followed by a scene of desolation (Fig. 58). Parts of the town are in ruin. Some soldiers are already marching off; others guard the square and tend to their dead. On the corner of the building behind them a small statue of a saint faces the destroyed barricade. A mother and her son weep for the dead. A dying man—perhaps copied from Delacroix's *Liberty Guiding the People*—raises himself on his arms and stares at the leader who has betrayed him and his companions: the naked skeleton of Death, riding over the barricade, a wreath of victory on his skull. His horse, now without harness and saddle, licks the blood from the chest of a corpse (or does its drooping tongue merely signify exhaustion?) and steps over the sword of Justice, which has been dropped on a door torn off its hinges. The times are out of joint, even if order has been restored. The intense horror that emanates from the woodcut makes it unique in nineteenth-century art. A comparison with the work of 1848 that is perhaps closest to it in subject matter and force, Meissonier's *The Barricade* (Fig. 59), reveals the distance Rethel had traveled. Delacroix, after seeing Meissonier's factual but cold rendering of corpses and torn-up cobblestones, wrote that although the picture was "truly

horrible, and . . . one could not call it inaccurate, it lacks perhaps the indefinable something that turns an odious subject into a work of art." Rethel's rhetoric falters neither before the defeat of the Revolution nor before the tragedy of the lives it enveloped. Realism, symbolism, and sorrow over the human condition become as one.[37]

Of the many strengths of Rethel's cycle we may, for the present, note in particular his use of an old and powerful motif—the dance of death—which he applies to an issue of great contemporary concern, and the dance-like continuity from image to image created by the leading actor in his various roles. Other elements in the sequence further bind its separate stages together—the horse, for instance; the sword and the revolutionary hat in four of the plates; the stolen scales of justice; the pruning hook in the first three plates, which turns into the revolutionary banner in the last three—elements that

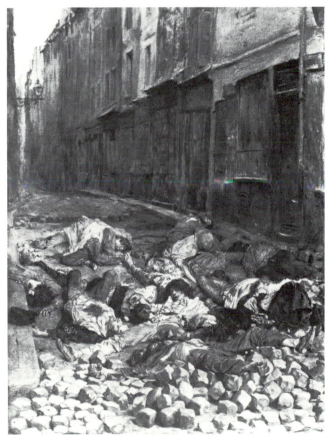

59. Ernest Meissonier: *The Barricade*.

111

may change from image to image, and thus reflect the inconsistencies of life and the ambiguity of the events depicted: the various moods of the horse, ranging from horror to weariness; the hat, now with one feather, now with two, the brim folded on the right or the left; the sword with and without legend, and with a different hilt in the last woodcut; the coat that is sometimes a cloak; and others. The richness of detail invites us to search through each picture, but we are never in danger of losing sight of the clearly defined major themes. The firm composition of each plate and its dramatic, often emotional execution are enhanced by the woodcut technique, easily legible and appealing even to the unsophisticated. Finally there is the message of the work as a whole, which interprets revolution in strikingly simple and hostile terms.

In his six woodcuts Rethel presents Death as an almost omnipotent seducer, who uses the illusion and rhetoric of equality to induce urban artisans and workers to rebel against the state. Death appears to be motivated simply by the wish to expand his realm, to quicken the dance of death. He is shown as a malevolent force, who does not have the interest of the common people at heart but drives them to destructive and ultimately self-destructive behavior. His appeal to equality is a trick; what he offers is not social, political, or economic equality, but merely the equality of death. His ideological neutrality may be slightly obscured in the concluding lines of Reinick's verses for the last woodcut:

> Their leader was Death!
> He kept his promise.
> Those who followed him lie pale,
> Brothers all, free and equal.
> See, he has unmasked himself!
> As victor, high on horseback,
> The mockery of decay in his eyes,
> The hero of the red republic rides away.[38]

Reinick's "hero of the red republic" may suggest that the republican creed was genuine, and only its outcome inevitable. But the first woodcut makes it plain that the Furies send Death to the peaceful town to seduce and kill by whatever means. For them and for him, political, social, and economic issues are important only to the extent that they can inflame people; this particular revolution, at least, has no ideological justification. Its outcome is presented as a tragedy, but also as inevitable and just: good people are misled into committing criminal acts and must take the consequences. In the spring and early summer of 1849, when liberal reform and the last revolutionary movements in Germany were faltering, this message could count on a strong reception among conservatives, and also among many who a year earlier had hoped and fought for political change but now were disillusioned.

The Revolution generated a profusion of cartoons, illustrated broadsheets, and even sequences of pictures and rhymes such as *Der Politische Struwwelpeter*, a parody of a famous children's book by the Düsseldorf artist Henry Ritter. But from the day of

publication it was recognized that *Another Dance of Death*, although related to this literature and using some of the same symbols (the scales, Justice shackled, the broad-brimmed hat of the radical), was something apart. With the methods of mechanical reproduction Rethel had created a work of great aesthetic power that had wide public appeal and that made a strong political statement. The work's adoption by the Conservative Alliance of Saxony expressed the belief, widely held then and ever since, that the statement was directed against the Revolution. Characteristic was the judgment of Ernst Förster, Kugler's co-editor of the *Kunstblatt*. Some years earlier Förster had rejected Burckhardt's thesis of the interaction of a vigorous public life and vigorous art; now he praised Rethel's *Dance of Death* as a "beneficial medicine against the raging epidemic of political insanity." Often this interpretation was linked to the inaccurate assumption that in the *Dance of Death* Rethel reacted against the horrors of the civil war he had witnessed in Dresden. His friend Müller von Königswinter writes that the fighting in Dresden stimulated the artist to undertake the work. The article on Rethel in the German national biographical dictionary even states that he gave the figure of Death the features of Bakunin, the Russian anarchist who fought with the insurgents in Dresden, while Josef Ponten, perhaps the most important of all Rethel scholars, interprets the politics of the *Dance of Death* as an "indictment of the revolution in Dresden" and Rethel's political position as "critical and royalist." More recently, T. J. Clark, who characterizes Rethel as a reactionary artist, has written that "Rethel's series . . . was drawn in Dresden after the insurrection of 1849," and left-wing scholars in general have branded the woodcuts as counter-revolutionary.[39] Contrary and more nuanced interpretations have also been proposed. An early example may be found in the biography of Rethel by Müller von Königswinter, who rejects the claim that *Another Dance of Death* expresses the position of the *Neue Kreuzzeitung*, the combative newspaper of Prussian conservatism, but concedes that the cycle is didactic and partisan.[40]

As we know, Rethel completed the drawings for the cycle and Bürkner's shop cut them in wood before the beginning of May 1849; the natural assumption that Rethel, at that time in Dresden, had the May insurrection in mind must therefore be erroneous. But the conventional interpretation of Rethel's woodcuts as an anti-revolutionary tract rests on better evidence, and it is not surprising that it has dominated responses to the work from 1849 to the present. If we shift our attention from the work of art to the person of the artist, however, we encounter a puzzle: Rethel was not a conservative; he was not even opposed to the uprising in Dresden, one of the more violent episodes of the Revolution. A letter he wrote from Dresden to his mother after the insurrection was defeated describes his reactions: "A few hours ago the dreadful catastrophe that had befallen this town was decided in favor of the military—that is, of the king. A great, magnificent effort for the glory of Germany has fallen to coldly calculating military force, to the sword! I watched the growth of this movement with suspicion and expected a red republic, communism with all its consequences. Instead, true popular enthusiasm in the best sense of the term sought to bring about a great and noble Germany, a mission that God entrusted to [the people], not one brought about by the radical babble of bad

newspapers and agitators. Men of all classes fought on the barricades . . . From all parts of the country vigorous, well-armed young men came to the aid of the threatened town. When the magnificent cohort of students from Freiburg marched in, each more manly and beautiful than the next, tears came to my eyes, the impression was too powerful: a good and noble cause elevated the group."[41]

Rethel's statement that in Dresden the barricade fighters carried out God's will is difficult to reconcile with his critical, accusing treatment of revolution in the six woodcuts. If we take this contradiction seriously enough to want to resolve it, we must look further into Rethel's politics and return once more to his earlier work. We may then find not only that the *Dance of Death* is in harmony with his political beliefs, but that it is characterized by motifs and compositional solutions with which he had experimented for years.

It is from his years as a student at the Düsseldorf Academy that we possess the fullest evidence of Rethel's political views prior to the year of the Revolution itself. In the fall of 1833, the seventeen-year-old Rethel and two friends wandered down the Rhine, a month-long journey filled with historical musings, song, and poetry, which he later recorded in a lengthy and detailed letter to his parents. In Ingelheim he engaged in a "very liberal" conversation with a lady whose comments on politics had got her into difficulty with the authorities. In Johannisberg he joined a large party in singing the *Marseillaise* and, later, the Burschenschaft song *Princes Away!*, with its concluding verse "Now the land is free, now plant the tree of liberty!" On the Main river on the way to Frankfurt, a Hessian officer led the passengers in singing political songs. At a meeting of the Frankfurt choral society, Rethel and his companions "heard nothing but songs of liberty." Later they attended a meeting of the Liberal Club, in which waitresses wore black-red-gold aprons and the waiters black-red-gold sashes, the prohibited colors symbolizing German unification. On another day he joined a crowd of sympathetic onlookers cheering a student who had taken part in the recent attempt to start a republican uprising in Frankfurt, and who was being transferred from one prison to another.[42]

Rethel's liberal enthusiasm was characteristic of bourgeois opinion in the Rhineland in the period after the Hambach meeting of May 1832, when over thirty thousand people demonstrated for political rights and German unification, and after the subsequent student putsch in Frankfurt. We do not know his views then, or later, on such specifics as the extent of the franchise; but it is certain that his desire for a united Germany was no passing phase. In a letter of April 1849 he continues to hope, as many liberals still did, that Frederick William IV would accept the imperial crown, a step that would also have meant accepting an all-German constitution and significant limits on the autonomy of the separate states.[43] Even after the last insurrections in Saxony, the Rhineland, and Baden had been put down, Rethel remained loyal to the ideal of a new Reich, and expressed his allegiance openly in the arena that mattered most: his work. In the last two murals of the Charlemagne cycle that he painted between 1849 and 1851, he introduced black-red-gold banners—according to legend the colors of the em-

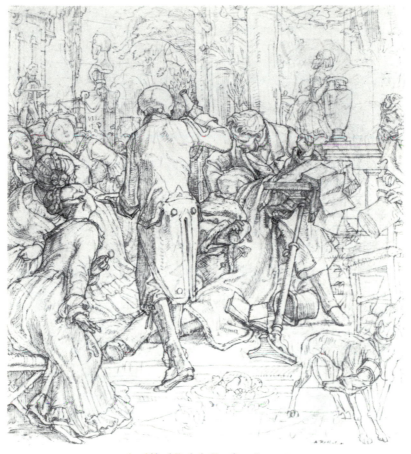

68. Alfred Rethel: *Death as Servant*.

peror, but also the colors that the Frankfurt parliament had chosen to symbolize the new national unity. The Charlemagne cycle itself is, of course, a plea for that unity.

Rethel's letters suggest that he belonged to that large though never precisely defined group of moderate liberals near the center of the political spectrum in the 1840s—a Rhenish counterpart of Menzel's Prussian reformism. If we resist thinking of the Revolution as a unitary struggle between "democracy" and "reaction," but recognize its multifaceted character as a cluster of conflicts in which opinions and positions might change over time, it is not difficult to see that *Another Dance of Death* should not be dismissed out of hand as counter-revolutionary and that its political message need not contradict the views of its creator. To go further, to gain a sense not only of the political but also of the historical significance of the *Dance of Death*, we need to enter more deeply into its aesthetics and trace their links with some of Rethel's earlier works that until now have not been mentioned.

The fascination that death as an aesthetic theme had long held for Rethel entered a new stage shortly before the Revolution. From 1847 on he experimented with personifications of death in a contemporary setting or in an undated, ahistorical environment. One subject, suggested by a personal experience, he treated in at least two drawings, which he entitled *Death the Servant* (Fig. 60). At a literary party that Rethel attended, another guest suffered a fatal heart attack while reading to the group. Rethel interpreted this event by drawing Death as a skeleton in servant's livery, pouring wine. A guest whose glass he has just filled has collapsed, upsetting a reading stand from which books and papers are falling. Two whippets in the lower right corner of the sketch have the same compositional function as and similar postures to the raven in the second plate of *Another Dance of Death*. The one who turns and looks at Death raising the bottle to

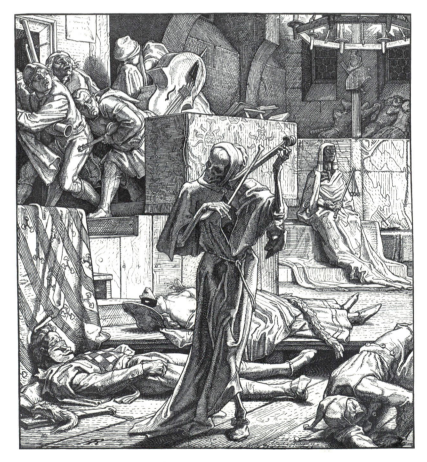

61. Alfred Rethel: *Death as Enemy*.

116

serve others is also the double in posture and expression of the horse in the fourth woodcut, craning to watch Death as he holds out the sword of Justice to the crowd.

Another motif, first treated in 1847 in a sketch entitled *The Cholera*, was developed into a woodcut with the alternative titles *Death the Murderer* or *Death as Enemy* (Fig. 61). We see a hall which only seconds before had been filled with masked dancers. In the center, surrounded by the dead and dying, Death plays on a violin made of two bones. Musicians and guests are rushing out of the hall. On a stone bench sits Cholera herself, wearing a vaguely Egyptian headdress and a flame-covered robe. Heine's account of the cholera epidemic of 1831 in Paris appears to have inspired this print, but the confrontation between the timeless symbolism of skeletal Death and contemporary life is not as clear as Rethel made it in *Death the Servant*. The dancers are in costume,

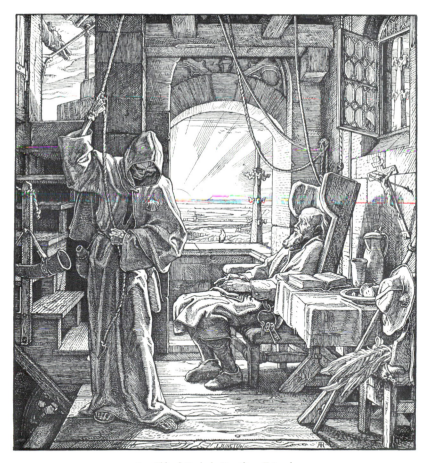

62. Alfred Rethel: *Death as Friend.*

117

63. Alfred Rethel: Illustration to a poem by his wife.

and cannot be identified as belonging to a particular period. The musicians carry modern instruments and their music-stands also seem modern; but their clothes are of the sixteenth rather than of the nineteenth century, and the segment of the hall that we see is an architectural fantasy whose components are as difficult to reconcile stylistically as structurally.

Of Rethel's separate graphic works that bring the figure of Death into scenes of everyday life, a third, the woodcut *Death as Friend*, had the greatest popular and critical impact (Fig. 62). High in the tower of a vast church, an old bellringer has passed peacefully from sleep to death in his armchair. Death, wearing the shell emblem of a medieval pilgrim on his hat and robe, rings the knell. Through a window and open arches we see the setting sun, Gothic finials, and a gargoyle, which resembles the whippet in *Death the Servant* and the horse in *Another Dance of Death* and is repeated in simplified form

in the background of the last plate of that cycle. Again the historical era of the scene is not clearly defined.[44]

For a time, according to Müller von Königswinter, Rethel thought of adding to his images of skeletal Death in a variety of settings, and publishing them as a second cycle. A sketch of a skeleton working in the fields, cutting grain (Fig. 63), with which he illustrated a poem by his bride, may be connected to this project, which he eventually laid aside. But we can see how easily the idea of the dance of death might have occurred to him once he brought his interest in sequential images and narrative elements together with his interest in the motif of death. Nor was the theme unusual at the time. The modern scholarly literature on the dance of death was well on its way by the 1830s, and earlier dances of death, including the two great series of woodcuts by Hans Holbein, were being republished in more accurate editions after the poor copies or adaptations of previous decades and centuries. Artists, too, were occupied with the theme, which since the late Middle Ages had never completely disappeared from European art, and which was undergoing a revival in Romantic literature and music. Paintings of episodes from dances of death were frequently exhibited; in 1831 the Swabian writer Ludwig Bechstein published a poem *The Dance of Death*, illustrated with forty-eight engravings after Holbein, and in 1837 a modern dance of death in woodcuts by an artist identified only by the initials H.R. was published in Germany. The very title that Rethel gave his cycle of woodcuts on the Revolution indicates that he wanted it to be understood in relation to its great predecessors. If much of his earlier work had been inspired by the Carolingian age and the German empire of the High Middle Ages, he now turned to a theme that reached its supreme aesthetic expression in the waning Middle Ages and the Renaissance.

The motif of the dance of death is documented from the first half of the fourteenth century on, first in the form of processions and dramatic performances, then in murals in churches and cemeteries in many towns, from Paris and Basel to Dresden and Lübeck, and finally in paintings, books, and graphics. The dance generally consisted of a procession or continuous chain of couples, a man and a woman, one of whom is about to be carried off by Death, who is represented either as a skeleton or as a decaying corpse. In the 1520s Holbein adopted these two ways of depicting the death of a human being, but broke up the procession into self-contained images. Some show only Death and his victim—*Death and the Knight*, for instance (Fig. 65). In others, Death singles out one person among several—*Death and the Bride*, or *Death and the Small Child* (Fig. 68). In a few plates several Deaths appears—*Death and the Old Woman* is an example (Fig. 69).

Some of the victims react with dignity, as does the Empress, who on a walk with her attendants is approached by Death, cloaked as one of the ladies, and politely ushered to an open grave (Fig. 64). Others struggle. Still others are taken unawares as they carry on their profession—for example, the physician in the beautiful and ironic print in which Death leads an old man to a healer who cannot heal himself (Fig. 66). Like its medieval models, Holbein's sequence conveys a message of the inevitability of death,

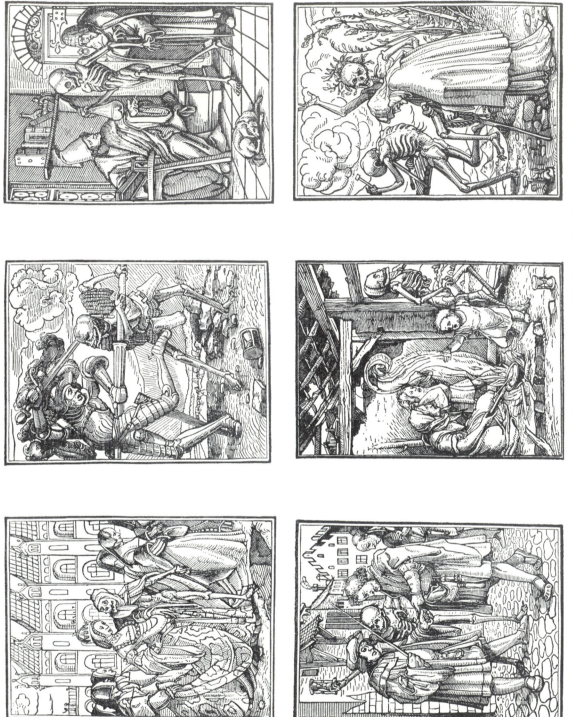

64–69. Hans Holbein the Younger: Plates from *The Dance of Death*.

and his vigorous realism, suffused with the spirit of the German Renaissance, may still retain enough of an earlier attitude to echo the medieval dance's appeal to the viewer to reflect on his approaching end, lead a better life, and die a holy death. Holbein reinforces the message that death levels all by stressing the vanity of human effort and by occasionally striking a note of social criticism: Death takes a nun from a cell that is a place of assignation rather than of piety; an attorney accepts a bribe while Death shows him that his time has run out (Fig. 67). In each image the emotional as well as the aesthetic drama derives from the confrontation of men and women with the ultimate reality, and at the same time with an impossibility: a skeleton or moldering corpse that moves and acts like a human being but possesses absolute power. This terrifying encounter of the familiar with the unknown is absent only in a few introductory and concluding woodcuts, which provide an explanatory framework for the entire sequence: *The Creation, The Fall, The Eviction from Paradise, The Last Judgment*, and the woodcut entitled *The Bones of All Mankind*, which in accord with the late medieval wall paintings opens the dance. It represents the vision of Ezekiel, but also the medieval celebration of All Souls' Eve when the dead leave the charnel house or rise from their graves, and go out into the world to attack the living.

Holbein's dance served as a model, perhaps even as the decisive external point of departure for Rethel; but he adopted neither the very small size of Holbein's prints, their tight, interlocking compositions, nor the relatively even, heavy execution of their designs.[45] In some respects Rethel's sequence owes as much to other German artists of the time, especially to Dürer. The expansiveness of his images, combining several parts and incidents into firm compositions that spread across the page; the intense preoccupation with detail; the gradations in strength of lines and hatchings—all point to such works of Dürer as the *Revelation to John*, of which Wilhelm Waetzoldt wrote that the only graphic work of a German artist executed in a kindred spirit is Rethel's *Dance of Death*.[46] One figure in the sequence—the old woman in the right foreground of the third plate—even seems a pastiche of a late-fifteenth-century woodcut. Dürer did not draw a dance of death; but Rethel could have studied any number of his woodcuts, etchings, and drawings that personify Death, from an early illustration for Brandt's *Ship of Fools* to the engraving *Knight, Death, and the Devil*. It may even be that the third rider in *The Four Horsemen of the Apocalypse* (Fig. 70) suggested the motif of Death riding toward town to foment revolution, the purloined scales of Justice swinging from his right hand.

IV. *ANOTHER DANCE OF DEATH* AS A SOCIAL DOCUMENT

RETHEL'S *Death as Friend* and other graphics on the personification of Death, Holbein's *Dance of Death* and Dürer's treatments of Death, place Rethel's cycle of woodcuts into perspective and help us gain a better sense of its political message and historical significance. We might begin with the element of realism in his *Dance*, which in its own way is as pronounced as Holbein's. To be sure, by the middle of the nineteenth

70. Albrecht Dürer: *The Four Horsemen*.

century the particular style of woodcut that Rethel demanded from Bürkner had an archaic quality that differed greatly from some contemporary lithographic representations of the Revolution, which already approach the non-linear, atmospheric character of photography. Not his style but the content of the cycle is marked by the artist's search for realism, as a comparison with newspaper illustrations of the time reveals. For instance, pictures of street fighting in Berlin in March 1848 and in Dresden in May 1849 show the same type of barricade that appears in Rethel's fifth and sixth woodcuts: piled-up paving stones, barrels, and planks. From neighboring houses people are firing in support of the main body of insurgents, and on the barricade itself the attitude and postures of the defenders are similar to those of the men in the fifth plate.

Rethel gives contemporary attributes even to the fantasy element in his images—the personification of Death. In the spring of 1848 a revolutionary style of dress quickly developed. It is illustrated in a well-known portrait of Friedrich Hecker, the leader of the insurrection in Baden (Fig. 73), which shows him wearing the broad-brimmed, feathered hat, long coat, and boots that are familiar to us as the uniform of Death in Rethel's woodcuts. Another illustration, this one of an insurgent who has been executed, again includes the familiar hat with the revolutionary badge (Fig. 74). The firing squad marching off is the double of the soldiers who appear in the last three woodcuts of *Another Dance of Death*. Like Holbein, Rethel placed his fantasy in a context that was as realistic as he could make it—with one highly significant exception that I note below.[47]

But in some basic respects the two cycles are dissimilar. For one thing, they ascribe different roles to the figure of Death. Holbein presents Death as an ever-present natural force. In some cases the skeleton-surrogate of this force may act as judge, unmasking and punishing hypocrisy and evil; but Death strikes the just and unjust alike. Nothing in Holbein's woodcuts qualifies the basic truth that has always given the motif its fascination: the inevitability and evenhandedness of Death.

Rethel's view is more complex. As we noted earlier, he presents Death as a seducer. The strength of the seduction derives from the identity of the seducer: the seduced victim will die. But for the duration of Rethel's dance, Death is not a universal but a selective force. He and the female personifications of evil that send him on his mission have chosen a specific group of men and women that he must mislead if they are to die. In

71. Johann Kirchhoff:
Combat on the "Great Barricade," Berlin, March 1848.

72. Anonymous: *The Defenders of the Barricade in the Grosse Frauengasse*, Dresden, May 1849.

Rethel's woodcuts the skeleton gains his hold over the viewer because we recognize and accept him as a symbol of the impermanence of our existence; but his universality has been placed in the service of something specific and finite: a social and political message. Death advocates an ideology that is a malevolent force which ultimately destroys its followers. Yet we can defend ourselves against it. The old woman and the boy in Fig. 55, who leave the crowd that Death is seducing, will presumably escape for a while the fate of those he tricks into believing that a clay pipe weighs as much as a crown. In reality it is the artist who performs the sleight of hand: the universal power of Death has become attached to a particular ideology, which is made terrible by it, but which need not be believed. Death is imminent only for those who are seduced into rebellion. In the first days of May 1849 Rethel must have reacted with a sense of artistic prophecy to the announcement that one of the three leaders of the Dresden uprising was the Saxon politician Karl Gotthelf Todt—Death.

A further basic difference between Holbein and Rethel springs from this interpre-

tation of Death as seducer. Rethel presents him as the leading actor in a tightly constructed narrative, in which he approaches his victims, and tricks and betrays them. In Holbein's dance only the framing images—*The Creation, The Fall*, and so on—lend a slight narrative continuity to the whole: Adam and Eve's sin has the dreadful consequences for the rest of us that will now be detailed. The main body of the cycle consists not of linked but of separate images. Each woodcut is a drama itself; the impact of the work as a whole comes from the strength of the single theme, which is repeated and varied in dozens of images. The order of the plates is not fixed; even in the earliest editions their arrangement changes.

Rethel's sequence is much shorter and tells a story that depends on each image occupying a fixed place in the sequence. Compositionally, each woodcut is self-contained; but the first three plates derive practically all of their meaning from their function as essential steps in the narrative. The remaining three, continuing and closing the sequence, are equally necessary; but each can be and often has been shown separately, its meaning subsuming the messsage of the entire dance. Death and his message hold the dance together. Motifs that run through parts of the sequence help strengthen its continuity.

73. Anonymous: *Friedrich Hecker* as
Leader of the Baden Insurrection.

We have already noted the purloined sword of Justice, which becomes a revolutionary weapon until it is abandoned in the final woodcut, or the revolutionary hat, transformed at the end into the laurel wreath of triumphant Death. The presence of animals in five of the six plates underlines the inadequacy of man by contrasting the confused townspeople with unreflective creature existence, which may instinctively sense evil, as do the ravens, frightened by the horseman who rides toward his victims. The animals are also given specific functions. In the first plate a worm and a lizard strengthen the graveyard image created by the broken cross, the skull half buried in the ground, and the opening grave from which Death is rising. The lizard further ironically symbolizes resurrection. The horse, watching the actions of Death, serves as a surrogate for the viewer, whose visual response is sharpened by seeing an observer within the picture. Since at the same time the horse involuntarily takes part in the drama, a participation especially stressed in the final plate, the animal may also stand for the artist whose emotions compel him to create the dance of death. The women present in four of the six plates form two themes that play against each other. Helpless Justice in the first woodcut is followed by the frightened peasant girls in the second, the little girl and the wise old woman in the third, and the grieving woman in the last. The perpetrators of the tragedy, female symbols of evil, are succeeded by the laughing woman whom Death has won over in the third plate, and, more dramatically by the addition of female attributes to death himself. In the second plate the lower half of the skeleton's pelvis is drawn as an exaggerated vagina, and in the fifth, the climax of the dance, Death lifts his coat in a flirtatious gesture while men around him are dying.

Such thematic bridges and developments lend a pronounced musical quality to Rethel's narrative, which is further borne out by the dance-like postures of some of the figures—the baker in the left foreground in the scene before the inn, or Death on the platform, haranguing the crowd. The dramatic and musical characteristics of the work emerge even more clearly when we consider it in relation to a theme that has a long history in European literature and music, the theme of Don Juan, with which the post-medieval dance of death does, in fact, share a common ancestor.

The Don Juan theme in the classic form it was given by Tirso de Molina, Molière, and da Ponte and Mozart combines two ancient literary concepts: the compulsive seducer, and the return of the dead to punish the living. The social and political characteristics of the seductions as they are expressed in the different treatments of the theme, the identity of the various individuals involved, statements by the hero, his servant, his victims—all make it apparent that in his relentless assault on women Don Juan not only transgresses against sexual morality, but rejects all authority. He is the supreme rebel, an amoral, primal force, until he is destroyed by the specter of a man he has killed, whose return to the world expresses God's will to protect the moral and social order. In Rethel's dance of death, the seducer and the avenger have become one. Death stands for evil but is also its consequence: it is evil to seduce, it is also wicked to be seduced, and the people who are misled into rebellion must pay for the transgression.

Unlike Holbein, then, Rethel constructs his dance in the form of a narrative. But

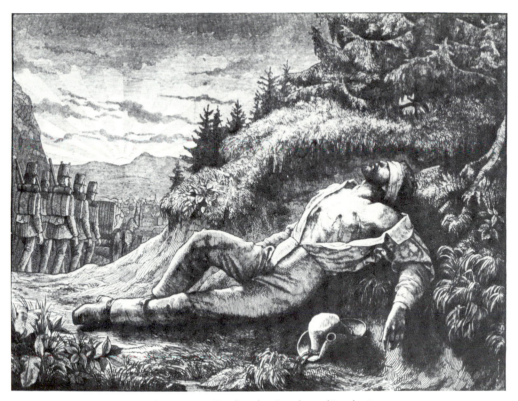

74. Anonymous: *Pardoned to Powder and Lead,* 1849.

the mechanism by which Rethel turns his revolution into a morality play is borrowed from Holbein and from Holbein's predecessors. Rethel returned to the dance of death in its very early, fourteenth-century form, All Souls' Eve, when the dead rise from their graves to trick, frighten, and punish the living. The first woodcut of his cycle is a new version of this event, which usually opened the late-medieval dance of death. Rethel combines this old motif with an invention of his own, expressed in the idiom of nineteenth-century symbolism—the defeat of Justice by base emotions—to motivate the political role that he has given his leading actor.

The coming together of the old and the new, of reality and fantasy, which is so prevalent in Rethel's work, is basic to his dance of death, starting with his decision to introduce a specter into a nineteenth-century town, and to interpret the politics of 1848 by means of a theme borrowed from medieval and Renaissance art. But Rethel also discovered the duality of old and new in his overt subject. He depicts a society in transition. Traditional values—symbolized by such Gothic remnants as the cathedral in the second plate, and the church and the statue of a saint in the last—coexist with the

factory chimneys of a new world before the power of which they must bend. The conjunction of a factory installed in a castle that he painted as a student is an early statement of the theme of transition. In *Another Dance of Death* the people deceived by the ideology that Death promotes are victims of this transition. It is possible that some of the men in the crowd scenes work in factories, but we cannot be certain. Everyone who is clearly identified belongs to the older, traditional society of artisans that is being pressured and displaced by the Industrial Revolution. The baker in the third woodcut; the young silver-miner behind him, identified by the traditional, tall embroidered cap of these aristocrats of early modern labor in central Germany; perhaps also the laughing man in the old-fashioned smock, who may be a waggoner, and whose clay pipe, according to Death, marks him as the king's equal; the blacksmith in the next plate—these are people peculiarly susceptible to revolutionary appeals because they are losing their economic security and their firm place in society to modern capital formation and new methods of manufacture and distribution.

Historians today would agree with Rethel's identification of this group as a driving force of the Revolution of 1848. But he ignores other kinds of participants. It cannot be accidental for an artist of Rethel's passion for detail to draw crowds in which we recognize neither industrial workers nor anyone who appears educated and well-to-do. In Menzel's *March Casualties Lying in State* the crowd of mourners and onlookers is a cross-section of society, even if the bourgeois element may be overemphasized. In Rethel's crowds we see no civil servants, no members of the professions, no students—groups that played a major role in the urban uprisings of 1848 and were again prominent in the fighting in Dresden in May 1849. Rethel's revolutionaries are artisans, journeymen, small shopkeepers—a German variant of the *sans-culottes*.[48]

This narrowing of the social character of the revolutionary crowd is significant in itself; it also explains the apparent inconsistency between the pronounced conservative tone of *Another Dance of Death* and Rethel's liberalism. His woodcuts do not condemn all revolutions, merely populist movements of the lower classes whom a clever agitator can rouse to suicidal attacks on law and order. The slogan "Liberty, Equality, Fraternity" on the wall of the inn and the republican banner of the insurrection never reflected Rethel's politics. He supported the bourgeois revolution that sought a greater or lesser degree of national unification, constitutional government under a hereditary ruler or rulers, and an increase in participation in public affairs by those who had an economic and cultural stake in the country. The radicalization of this revolution—demagoguery and communism, as he put it in May 1849—he feared. He rejected the extension of political rights to men that he regarded as unqualified, whether they were artisans facing ruin or peasants leaving the land to work in new factories. If Rethel's crowd is made up of *sans-culottes*, their interpreter is a Girondin.

The woodcuts thus express the views of a major segment of liberal and moderate bourgeois opinion in Germany, which wanted to be rid of absolutism and the more extreme forms of particularism, but supported neither republicanism nor the leveling of

all class distinctions. Rethel did not intend his dance to be a critical parable of the Revolution of 1848 as such. His cycle should rather be seen as a forceful expression of one of several positions held by those who opposed parts or all of the status quo. It is only in accord with the historical realities of 1848 that the woodcuts are also representative of a more general development that transcends the events that inspired them. When we relate their message to economic and social change in the 1840s and to Rethel's political outlook, we see that the woodcuts are an early document of modern class conflict. Once more Rethel has enlarged the function of the skeleton in his narrative. From a symbol of death the skeleton has been changed into the symbol of an equally pervasive and permanent aspect of human experience: conflict.

From the time of its original publication, when it was adopted as useful legitimist propaganda by Saxon conservatives, the most immediate impact of *Another Dance of Death* has been that of a conservative morality play. But once we delve beneath the surface of its images, we encounter a specific liberal point of view, which implicitly approves some parts of the Revolution of 1848 and openly rejects others. Probably this intermediate position of the artist, which from one perspective might appear ambiguous, contributed to the widespread misinterpretation of his work. Aesthetically, the woodcuts constitute a grandiose attempt to combine modern and traditional idiom, which permitted Rethel to comment on events of his day in a tradition that went back to the Renaissance and earlier.

Finally, the woodcuts confirm what we know well but what is always worth recalling: aesthetic statements, whether or not they refer to politics, derive much of their energy from their environment and background. Reactions to the present always have their roots deep in the past, not only in the political and cultural past but also in the psychological history of the artist. Rethel's inner life remains largely closed to us. But we do know that death powerfully affected his imagination. We also know that in this cycle of woodcuts he took a symbolic image of the end of everything—the skeleton—turned it into a causal force, and applied his private fantasy that destruction is the father of all things to the Revolution of 1848.[49]

IN *Another Dance of Death* and in *The March Casualties Lying in State* two contemporary artists respond to the Revolution in very different ways. Menzel's painting preserves for us the reality and atmosphere of a specific event. The objectivity and spirit of realism with which he painted the picture do not, of course, imply an absence of artistic imagination—it is his imagination alone that gives the work its lasting power. Nor does Menzel's objectivity mean that he lacked a political point of view. But in an artist like Menzel, aesthetic forces will win out over politics. The painting neither glorifies nor condemns; it is not propaganda, but the interpretation by a great realist of a political event which at the same time presented him with interesting problems of composition and color.

Rethel's woodcuts, despite the many elements of realism they contain, neither report facts nor claim objectivity. The artist addresses a specific political message to a large audience, and at the same time expresses his feelings and thoughts about the role of death in life.

From their different perspectives, the two works present information about the past—art as history. In turn, we may find that inquiring into their non-aesthetic antecedents and context helps our understanding of them as art. The historical evidence they offer relates to the same basic reality of the German Revolution of 1848: to a considerable extent it was a bourgeois revolution even if the majority of street fighters came from artisanal and other groups; and although large segments of the bourgeoisie favored political reform they did not seek a republic, and supported only limited social change.

From some Marxist perspectives the middle classes' refusal to go further seems a betrayal of the Revolution, just as such historians of the great French Revolution as Soboul accuse the Committee of Public Safety, caught in the assumptions of pre-industrial society, of having betrayed the common man as he emerged into the light of history in the Paris Commune and the *sans-culotte* sections.[50] But it is ahistorical to claim that the most extreme groups in any revolution invariably represent its true nature. Revolutions are made by factions, which will differ in their view of means and ends. It is also true that their disagreements offer targets for the forces of the status quo and introduce ambiguities into the political conflict.

The political statement of Menzel's painting is both thinner and clearer than that of Rethel's woodcuts. In the final analysis, *Another Dance of Death* conveys two messages: what Rethel meant at the time, and the implication of that meaning over time. Interpreting Rethel's woodcuts as a tract against revolution as such is inaccurate. But if we consider the deep currents of conservatism that swept through the German middle classes for a century after the Revolution of 1848, it is not without historical significance that Rethel, the supporter of constitutionalism and unification, should depict the people in arms as victims rather than as heroes, misled agents of their own and society's destruction. The political and social conditions in which *Auch ein Totentanz* was created help to explain the work; but, with the intensity and precision that is unique to art, the woodcuts also illuminate a force that helped shape the history of Germany in 1848 and beyond.

Scheffel and the Embourgeoisement
of the German Middle Ages

JOSEPH VIKTOR SCHEFFEL was born in 1826 in Karlsruhe, the capital of the Grand-Duchy of Baden. His father was an engineer who after serving in the Baden army rose to a senior position in the directorate of public works; his mother, a woman with a pleasant gift for occasional verse, came from a well-to-do family of merchants and municipal officials. The Scheffels were known to members of the Grand-Ducal family, and played a role in the social and intellectual life of the town; the son's youth was passed in that zone of society in which noble and bourgeois circles intersected. After receiving an excellent secondary education, which laid the basis for his later unusually refined knowledge of classical languages, he wanted to become a painter but bowed to his father's demand that he study law and entered the University of Munich. After a year at Munich, during which he formed a close, lifelong friendship with Friedrich Eggers, the friend of Kugler and Fontane, Scheffel continued his studies at Heidelberg and then in Berlin, where he roomed with Eggers, before returning to Heidelberg for the final semesters. Early in 1849 he received the degree of *Doctor juris* for a dissertation on a topic of Roman and French law, and entered the judicial administration.[1]

Throughout these years of peripatetic study, typical of the times, Scheffel was active in fraternities and student associations, which responded to his liking for good fellowship and confirmed and further encouraged the political ideas with which he had grown up. He was for German unity and constitutional government, but was also troubled by changes in society brought about by beginning industrialization. The poverty, crime, and prostitution he encountered in Berlin shocked him, and unlike many of his peers he seemed to have believed that at least some political rights should be extended beyond the educated and well-to-do to other groups of the population. His letters indicate that at the time he was also an anti-Semite—though not of the most rigorous observance—a position often adopted by students with progressive political views, who rejected even assimilated Jews as an alien element in German culture and thus a hindrance in the struggle for political unity. In later years he became more tolerant. "God preserve us from racial hatred," he wrote on the occasion of an anti-Semitic attack on his friend the writer Berthold Auerbach, "from class hatred, and from other such works of the devil!"[2] Scheffel expressed both his politics and his delight in student life in verse—a poem of 1846 on the Emperor Barbarossa awakening from his centuries-long sleep to save and unite Germany was a characteristic product. More unusual and far superior were his student-songs and drinking songs: some full of sentiment—"Alt Heidelberg, du feine"—the best witty, even anarchic, celebrating the eternal student and his hatred of bourgeois pretensions and anxieties. Many became famous and were sung and quoted throughout Germany long before they were published in the 1850s and 1860s as parts of larger works or in the collection *Gaudeamus*.

The outbreak of the Revolution was greeted by Scheffel as the dawn of a new and better age. He joined the Karlsruhe militia, and became second secretary of the liberal leader Karl Welcker, whom he accompanied to the Frankfurt parliament, although he regarded him as a little too far to the right and too closely allied to the Prussian nobility.[3] Scheffel devoted a cynical poem to their relationship, "The Special Envoy and his Secretary," who spent their days and nights drinking. For a time he edited a liberal newspaper. Early in April he wrote to his father that he welcomed the prospect of a constitutional empire being created at Frankfurt, but only as a step toward an eventual republic, "which must be our future."[4] When a week later Hecker proclaimed the republic in Baden, Scheffel condemned the insurrection but agreed with its long-term aims. His position throughout the Revolution may be described as left-liberal or moderate-republican, with a pronounced anti-Prussian cast. He accepted Prussian leadership in Germany only as a last resort to achieve unification. When the greater part of the Baden army revolted in May 1849 in support of the Frankfurt constitution and against the status quo in Baden, Scheffel helped defend the Karlsruhe armory against the insurgents. But in the period of repression and—as he put it—"spiritless and heartless reaction" that followed, his liberal record caused difficulties for him, and he took extended leave and finally resigned from the Baden civil service.[5]

In May 1852, at the age of twenty-six, Scheffel left Baden for Italy in pursuit of his old dream of becoming a painter. He soon concluded that he was too old, and in any case doubted that he had sufficient talent.[6] With the encouragement of friends he began to write instead. In Capri, within a few weeks, he began and completed a long verse epic, a love story between the daughter of noble parents and a commoner, set in seventeenth-century Germany, *Der Trompeter von Säkkingen*, which was published the following year and enjoyed a modestly favorable reception. To gain a settled position and a regular income he prepared himself halfheartedly for an academic career, studying medieval German literature and history and translating the *Walthari Lied*, an early German epic in Latin hexameters on Nibelungen themes. At the same time he began to write a long historical novel, a story of love and renunciation, derived in part from a disappointment in love he himself had recently experienced. The novel was published in 1855 with the title *Ekkehard: A Tale of the Tenth Century*, with Scheffel's translation of the *Walthari Lied* included as a poem the hero writes to recover from his infatuation. Neither of the two works was an immediate success; most of the important reviewers ignored them and sales were slow. For a few years Scheffel worked as a librarian and archivist, but from the end of the 1850s on, supported by his family, he devoted his entire time to writing and to philological and historical studies. Despite great efforts he was unable to complete a second novel; bouts of depression that had afflicted him since adolescence became more severe. In 1864 he married the daughter of a Bavarian diplomat, but the marriage made neither husband nor wife happy, and they soon separated. Offers of important appointments gradually came to him, notably the directorship of the Germanisches Nationalmuseum in Nürnberg, the new institutional center of cultural history in Germany, but he rejected all in favor of a withdrawn existence, re-

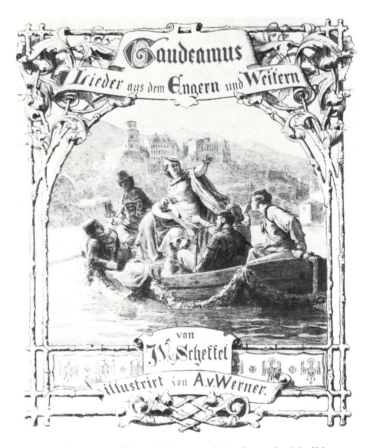

75. Anton von Werner: Title page of *Gaudeamus* by Scheffel.

lieved primarily by extended walking tours through Southern Germany and the Alps, and by a number of friendships with artists and scholars. The closest of these he formed with a young Prussian painter, Anton von Werner, who had come to Karlsruhe to study and who illustrated some of the shorter works of prose and poetry that Scheffel published in the 1860s, as well as a new edition of the *Trompeter*. In 1867 Scheffel's popular student songs finally appeared in book form, with illustrations by Werner, and proved a resounding success, achieving twenty printings within a few years and making Scheffel well known among contemporary authors. This could only help the sale of his other works, but the suddenness and extent of their recovery after a very slow beginning were unique in German publishing in the nineteenth century. Over five years had been needed to sell the first 1000 copies of the *Trompeter von Säkkingen*, and *Ekkehard* (which admittedly had a first printing of 10,000 copies) was not reprinted until 1862. Now their sales increased exponentially: 1870 saw the eleventh printing of the *Trom-*

peter, 1882 the 100th, 1892 the 200th; *Ekkehard* was reprinted fifty times in the 1870s; it reached the 100th printing by the middle of the 1880s, and the 200th by 1904.

During the 1850s and 1860s Scheffel's political views had not changed in essence, although he was now more skeptical about the ability of the mass of the people to withstand political agitation and rhetoric and govern itself. He continued to favor effective constitutional government, and he continued to dislike Prussia's increasing dominance in Germany. At the outbreak of the Franco-Prussian War in 1870 he agreed that the south German states were committed under treaty to support Prussia, but, he wrote to Werner, he could detect no enthusiasm for the war in Baden—he still hoped that an alliance of the medium-sized south German states, perhaps with Austrian or even Swiss support, could prevent Prussian hegemony in Germany.[7] Werner later recalled: "The imperial German crown on the head of a Hohenzollern struck him as a historical impossibility." To another friend Scheffel wrote, "I find it difficult to adjust to this completely changed age . . . in which we in Germany are moving toward a colossal military monarchy."[8] Unification nevertheless came as the fulfillment of a dearly held wish, and he accommodated himself reluctantly to the overwhelming Prussian presence in the new empire and to the exclusion of the German territories of the Habsburg monarchy.[9] In the remaining years of his life—he died in 1886—he wrote very little, being now more

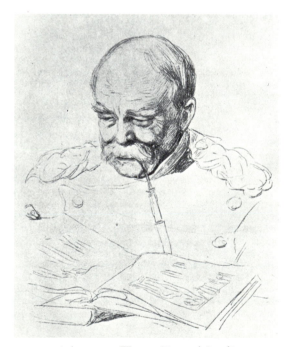

76. Anton von Werner: *Bismarck Reading*
"Gaudeamus."

interested in historical research, but he had become one of the great literary figures of the period. His fiftieth birthday in 1876 was the occasion of extensive public and private celebrations. The Grand-Duke of Baden raised him and his family to the hereditary nobility, and even Bismarck, who liked the poems and songs collected in *Gaudeamus*, sent his congratulations, to which Scheffel responded by telegram with the distich:

> A good page of history
> is better than a thousand pages of poetry.

The reading public's response to Scheffel's major works, eventually rising to a crescendo of approval in the generation before the First World War, certainly tells us something about the culture of imperial Germany. But exactly what is revealed may not be as self-evident as many students of the Scheffel phenomenon assumed during his lifetime and later. To give one example, the assertion—made approvingly before 1945 and critically since then—that *Ekkehard* and the *Trompeter* are paeans of militant Germanness lacks any basis unless one is willing to place great weight on a few passages taken out of context.[10] Nor is it possible to determine with any degree of finality why Scheffel became so popular. Perhaps his prose and poetry appealed to a growing tendency in German culture to question modern urban life, and even to condemn it as destructive of "native" values. Other, quite different, even contradictory elements may also have had an impact. Of course the reasons for the extraordinary large sales of some of Scheffel's writings—illuminating though these reasons would be—need not be identical with Scheffel's intentions when he wrote, nor comprise the whole of the message his works convey to the historian today. The purpose of the artist, the explanations for his commercial success, and the historical significance of his work are separate elements, even if they are related, especially the latter two.

These general considerations go beyond the focus of our discussion. We are concerned merely with certain aspects of an artist's work: his use of the past to interpret the present, and the significance of this work to the historian—be it a historical painting or illustration, or a novel or poems on historical subjects. We need not analyze Scheffel's entire *oeuvre* as we would have to if he were our primary concern; we can concentrate on his major novel *Ekkehard*, even to the exclusion of his verse fiction, *Der Trompeter von Säkkingen*, his second major narrative work, which like *Ekkehard* is set in an earlier age but, unlike the novel, uses the past only as scenery for a love story and not as a condition to be interpreted.

What are the novel's main elements, and how can we interpret their appeal to the German reader from the 1870s on? Scheffel found the basis of his plot in the chronicles of the Monastery of St. Gall; but he expanded the narrative far beyond even the implications of the medieval text, combined several historical personages into one fictional hero, and invented other characters and events. It is one of the most unusual and attractive attributes of the novel that Scheffel's very free exploitation of the evidence goes together with an expert's knowledge of the sources and a poet's understanding and love of the tenth century.

77. Anton von Werner: *Scheffel on a
Walking Tour*.

Ekkehard, some five hundred pages long in the standard edition of Scheffel's
works, takes place in the Duchy of Swabia, north and south of Lake Constance, an area
that Scheffel knew well from many walking tours. The young widowed Duchess Had-
wig asks the abbot of St. Gall to send her Ekkehard, a young monk and gatekeeper of
the monastery, to teach her Latin. Ekkehard joins her small court in the castle Hohen-
twiel, and does not realize that in the course of the lessons his pupil falls in love with
him. His failure to respond hurts the Duchess' pride; she comes to resent and then to
dislike him just as he falls in love with her. Their relationship is doomed from the start
by the difference in their stations in life, by her harsh, demanding character, and by his
naiveté; but its progress toward the inevitable catastrophe is delayed by an external
crisis when a force of Hunnish horsemen invades the country. Only after hard fighting
and many casualties can the Duchess' men-at-arms, the feudal levies, and armed monks
throw back the marauders. The experience of fighting and killing breaks down Ekke-
hard's reserve. In the castle chapel he tells Hadwig he loves her, but she has turned
against him, and because they have been overheard she protects her reputation by ac-
cusing Ekkehard of attacking her. He is imprisoned, and the enemies he has made in his
privileged position glory in his disgrace. The Duchess' lady-in-waiting, who herself may
be in love with him, helps him escape. He isolates himself on Mount Säntis near St.
Gall, overcomes his passion through prayer and reflection, and writes the *Walthari Lied*,

which tells of the invasion of the Rhineland by Etzel—or Attila—the Hun. The novel ends with Ekkehard travelling to the imperial court, where he will rise to high honors. As he passes the Hohentwiel on his way north, he sends Hadwig the *Walthari Lied* by shooting an arrow with the manuscript wrapped around it over the castle walls.

This romantically decorated but basically simple tale of the infatuation of two ill-matched people, from which at least the man eventually liberates himself to achieve greater maturity, is given depth by the author's characterizations. Even among the minor figures few are one-dimensional, and the complex personalities of the hero and heroine are developed at length. Ekkehard is intelligent, witty, physically brave; but so self-absorbed that he cannot see how he affects others. He has high standards and poor judgment; he is brash, tactless, and full of self-doubt. His ignorance of life is as great as his poetic talent. Hadwig, by contrast, understands how society functions, and at the beginning of the novel is confident of her strength. She has a sharp, ironic eye for the failings of others, but cannot recognize her own selfishness. Her charm easily gives way to callousness, even cruelty, yet she longs for affection and at last dimly perceives that although she dominates her little world she is psychologically helpless.

Typical of the ambiguities with which Scheffel invests even his minor characters, the Duchess' chamberlain is a brave and honest knight, but a fool. Dignitaries of the Church combine genuine piety with corrupt politics. The monks, who together with Hadwig's court and the raiding Huns form the novel's three prominent social groups, are pious and hard-working cultivators of civilization, knowledgeable in tricks that render monastic life more agreeable, watchful for any favoritism within the monastery, and suspicious and envious of members of other religious orders. The broader society, too, is marked by ambiguities. Germans are no better or worse than anyone else. Even the Huns on their murderous rampage have normal human qualities, some of which are admirable, and Scheffel refuses to exploit ethnic differences for patriotic tub-thumping. One of the Huns is revealed as a German captured on a previous raid, who has become a valuable member of the tribe. His counterpart is a Hun taken prisoner by the Duchess' men, who turns out to be a decent sort, and whom Ekkehard has to save from being stoned to death by superstitious German peasants.

These people, their feelings, and their actions are described in clear conversational prose, which accommodates poetic metaphors and excursions without becoming slack. Its main weakness is Scheffel's tendency to be content with the easiest formulation, as long as it accurately conveys his sense, which is usually intelligent but rarely profound. His style is not adventurous or speculative; clichés seem not to worry him: the concrete reality, colloquially expressed, is good enough for him. An example is the episode near the end of the novel when Ekkehard in his mountain retreat finally rejects the contemplative life. Scheffel describes the Alps in the fall, the first snow, and the peasants driving their cattle from the high meadows down to the valley for the long winter months: "Cowherds, herd, and goats disappeared among the firs; the song of the herdsmen and the tinkling of the bells faded in the distance, then everything became still and deserted as on that evening when Ekkehard first knelt before the crucifix of the wilderness

chapel. He went into his hut. In his quiet life on the mountain he had come to see that solitude is merely a school for life not life itself, and that in this grim world he who is content with passive self-absorption wastes his life. 'There is no help for it,' he said; 'I, too, must go down to the valley again. The snow blows too cold and I am too young, I can't remain a hermit.' " The prose then turns to verse: "Farewell, high Säntis, faithful guardian, / Farewell, green pasture that has healed me! / Be thanked for your gifts, sacred lonelines, / The old care is gone—gone the old pain. / My heart was purified, and from it flowers grew: / I long for new battles and for the world. / A youth lay dreaming, then came the dark night; / In the sharp air of the mountains, a man has now awakened!"[11]

It has been suggested that the clarity and specificity of Scheffel's prose constitute one of the main reasons for his popularity, and certainly his style presents few difficulties to the reader. Occasionally he introduces archaic syntax or word-formations, but his borrowings from an earlier manner of speech are no worse than those by such contemporary and far more gifted writers as Gottfried Keller and Conrad Ferdinand Meyer. His meaning is easily comprehended, there is no opaqueness to his writing—which is not to imply that his observations of human nature are simplistic, that he fails to exploit the power of symbols, or that his arrangement of incidents and the balance he strikes between narrative, description, and comment are without hidden relationships.

Two additional factors are significant in Scheffel's prose. His delight in the South German countryside and his faith in the power of nature—exemplified in the passage we have just quoted—are expressed in numerous passages, generally without pathos, and always closely attuned to the emotions of his characters and to the progress of the narrative. The second element is Scheffel's humor. In *Ekkehard*, as in his student songs and in the *Trompeter*, Scheffel is often very funny. His sense of the ambiguities of human nature feeds his humor, which ranges from the amused recognition of small vanities to bitter sarcasm, and by no means spares his principal characters. But it is the monks, above all, who are favored and rewarding targets. Scheffel's most extended joke—a bravura piece of ironic invective directed at an ideal of nineteenth-century German culture—takes up an entire chapter. It concerns the monumental anger of a Belgian monk, Gunzo, who has interrupted a journey at St. Gall, and was conversing with the monks in Latin when he committed a grammatical error, using the accusative instead of ablative form of a word that Scheffel never identifies. In his typically thoughtless way Ekkehard immediately corrected the mistake and humiliated Gunzo, who back in his Belgian monastery labored from winter through the following summer on a learned treatise that exposed the true nature of "someone who reproaches his fellow human being for the error of an ablative."[12]

The account of this perversion of scholarship, with its elaborate outline of Gunzo's arguments, his style, and his copious references to authors of Antiquity and Church fathers, could have been written only by someone who was himself a scholar, who scorned pedantry, and who despised the rivalries and backbiting among men who dedicate their lives to the pursuit of knowledge. But Gunzo represents only the seamy side

of learning. Scheffel contrasts it with depictions of scholarship as healthy and vital—notably with Ekkehard's studies and his efforts to teach Hadwig Latin, which turn scholarship into a central force of character development and a crucial device for the plot. Above all, Scheffel argues that the novel itself is a scholarly enterprise. One way in which he demonstrates this is to add 285 footnotes to the text, many in medieval Latin. On the one hand, these references are meant to impress the reader of the accuracy of the novel's treatment of the tenth century—including such matters as the length of cloaks worn at the time. On the other, the notes are a further expression of the author's humor. Scheffel knows the difference between fiction and historical research very well, but he is pleased in this particular case to combine the two.

The assertion or pretense of historical authenticity in *Ekkehard* reflected a broader cultural concern. Since the early works of the German adaptors and followers of Sir Walter Scott, the novel on historical themes had continued to gain popularity, and its claims of scholarly accuracy had expanded apace. Justifiably or not, the increasing number of readers of what might be called the more serious kind of lighter literature came to expect valid representations of the past in historical fiction. The adventures of ordinary people in their accustomed social settings, now described with a new appreciation of the particularities and uniqueness of each epoch, became favored themes. The similarity to developments in historical painting is obvious, as are the links binding these tendencies in historical art and literature to the study of cultural history, which was emerging as a new branch of the discipline of history. The great cultural authority that history had achieved by mid-century can scarcely be exemplified in more convincing fashion than by its relentless expansion, beyond philosophy and religion, into all areas of art and literature. Occasionally the link between literature and history might even be found in the work of the same person—notably in that of Wilhelm Heinrich Riehl, holder of the Chair of Cultural History at the University of Munich, who also wrote a great deal of fiction and poetry, for example a group of novels under the general title *Cultural-Historical Novels*, each of which had a carefully executed historical background. For a time even non-academic authors of this genre took pride in basing their plots and descriptions on more than a few published memoirs and some secondary works, and attempted to draw on primary sources for their fiction, which seemed at least to suggest "research."

The eventual outgrowth of this trend was a new category of historical novel, the *Professorenroman*—fiction by academics. The *Professorenroman* did not come to full flower until the 1870s, with such immensely popular works as *Die Ahnen*, a sequence of novels on German history from late Roman times to 1848 by Gustav Freytag, who began as an academic, and—on a lower level—*Ein Kampf um Rom*, a very long novel on ethnic, cultural, and ideological conflict in fifth-century Italy by Felix Dahn, a prominent professor of legal history and institutions at the Universities of Königsberg and Breslau.[13] A mildly derogatory sense was always attached to the concept—a whiff of pedantic awkwardness in the practitioners' treatment of human drama and comedy, an excess of *Geschichte* over *Geschichten*, of history over stories. But if we think of the

Professorenroman more generally as a work of fiction based on the study of the historical sources, which seeks authenticity in its treatment of the physical conditions of life and of such documented events as religious and political disputes related to the plot and that also pays attention to the impact the specific period may have on the protagonists' attitudes and thoughts, then Scheffel's *Ekkehard* may be considered an important precursor.[14]

In a brief introduction to the novel, Scheffel argues that history and fiction have much to offer each other: "This book was written in the firm belief that neither history nor poetry suffer if they form a close friendship and combine for a common task." Over the past decades research has revealed an astonishing amount about the Middle Ages, and yet "we have not managed to bring the pleasures of historical understanding to wider circles of society." Reluctance to move beyond the study of the sources, failure to distinguish the insignificant from the important, fear of drawing conclusions because new evidence may emerge—all this has led to "a literature by scholars for scholars, which is ignored by the majority of Germans, who cast their eyes heavenward and thank their creator that they don't need to read any of it."

The specialized, academic character of historical writing causes two problems: the layman is excluded from sharing in the new knowledge; and even for the scholar the past does not come alive. Scheffel asks how the historical re-creation of the past can be achieved, and answers: "Only if the creatively reconstructing imagination is not deprived of its rights, if he who digs up the old skeletons also infuses them with the breath of a living soul so that the dead arise and live again." When the historical novel resurrects the past on the basis of research, "it may well claim to be recognized as the equal brother of history." To the objection that the historical novel is, after all, fiction, Scheffel answers that invention is part even of historical scholarship: "History as it is generally written . . . is merely an acceptable welding together of the true and the false."

Fiction helps scholarship, and has the added advantage that its concrete, sensual, vigorous character opposes the enervating, abstract and generalizing tendencies of nineteenth-century culture. *Ekkehard* is meant to contribute to a more natural way of looking at a part of the German past.

In the second half of the introduction, Scheffel describes the main source for the novel, the chronicles of St. Gall, which inspired him to re-create the vigorous life in Southern Germany at the time the chronicles were written. "I may assert that not much is said [in this tale] that is not based on conscientious studies in cultural history, even if individuals and dates, perhaps even decades, are sometimes a little rearranged. For the sake of the structure and content of his work the poet may permit himself liberties that would be counted a sin in the writings of the strict historian. Even that unsurpassed historical author Macaulay says: 'I shall cheerfully bear the reproach of having descended below the dignity of history if I can succeed in placing before the English of the nineteenth century a true picture of the life of their ancestors.' "[15]

Scheffel's claim that good historical fiction not only transmits the findings of research to the non-specialist, but actually contributes to scholarship by making the facts

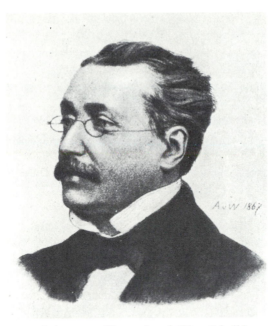

78. Anton von Werner: *Joseph Viktor Scheffel*,
1867.

come alive, must have been dismissed as facetious impertinence by many historians. Nevertheless, as the novel gained popularity its appeal as history became a matter of some concern. Adverse comments on this aspect of the work reached a climax with the publication, over twenty years after Scheffel's death, of a monograph, *Scheffel's Ekkehard as a Historical Novel*.[16] The author scoured the text for anachronisms, analyzed the footnotes, most of which he found irrelevant or designed to mislead the reader, and switching from details of Latin inscriptions and architectural design to the metaphysics of the *Zeitgeist* rejected Scheffel's characterization of the uncertain and irresolute Ekkehard as contrary to the virile breed of men in tenth-century Germany. Despite the fine things in the book, these defects, the author concluded, not only rendered it unscholarly but deprived it of the quality of being a true historical novel.

The main objections raised in this unconscious parody of scholarship, its grave paper-shuffling reminiscent of Gunzo's diatribe over the wrong accusative, had been dealt with by Theodor Fontane some decades earlier. Fontane was sympathetic to Scheffel's claim that history and the novel were closely related, but he was less interested in the concept of fiction as a conveyor of scholarly truth than in the timelessness of human emotions and character, which suggested to him that at least in this area the scholar and the writer of fiction deal with the same material.

Fontane's views are expressed in a short essay on *Ekkehard* he wrote some years after the book had appeared.[17] He begins: "Ekkehard is among the best books I have

read," and then turns to the criticisms of a lady of his acquaintance, who in a letter to him had protested that "only the frivolity of our age could find pleasure in this charming but at the same exceedingly tasteless book. The descriptions and local color are enchanting; the historical is untrue and impossible." Fontane finds this judgment valid only in its praise, not in its criticism. He mildly turns aside the accusation of bad taste—"If I consult my taste the book is certainly *not* tasteless"—and proceeds to compare Scheffel with the writer he regards as the best historical novelist of the preceding generation: "In art and scholarship Scheffel is superior to Scott, in subtle humor as well as in descriptive power and sense of locality he is his equal. Where Scott outdoes him is in creative vigor . . . [having written a dozen novels to Scheffel's one], but as an achievement in itself *Ekkehard* is a match for *Waverly*."

But are we given a realistic portrayal of the way people behaved in the early Middle Ages? Fontane's observations on this point are worth quoting at some length, reflecting as they do his recent experiences both in writing history and writing fiction. In the years preceding the essay on *Ekkehard* he had written a number of volumes on contemporary history and on the recent and more remote past of Brandenburg, *Wanderings through the Mark Brandenburg*, which won Ranke's praise, and had begun a historical novel, the first in a long sequence of works that were to establish him in the middle and old age as a major German novelist. It can hardly be doubted, he writes, that *Ekkehard* is the outcome of careful research. "Studies by themselves are, of course, not sufficient; historical insight and a prophetic intuition directed toward the past must be added. But true poets almost always possess this insight and this intuition. It has rightly been said that the great historian is always a poet as well. It is equally true that every genuine poet possesses historical understanding. When *life* is revealed to you, so are the *times* . . . Here, I believe, we touch on the deepest significance of the book. These figures of the tenth century are *also* human beings, of flesh and blood, equipped with the same features, good and bad, as ours. The difference lies in the 'costume,' in the world of externals, not in their feelings. People loved and hated, hoped and feared just as today . . .'"

If the characters in *Ekkehard* behave in ways that we find psychologically convincing, does Scheffel force them into situations or attitudes that would have been impossible in the tenth century? Fontane does not think so, and doubts that many such situations and attitudes could exist. "Unless the monks of St. Gall are depicted singing the 'Piff-paff-puff' aria or smoking Havana cigars, it is difficult to speak of 'impossibilities.' Could anyone believe that Emperor William, who five centuries from now will continue to live in legend like a second Barbarossa, was surprised by Bismarck while patching his old riding breeches and touching up their color with ink! If it is rooted in character and personality nothing of this kind is impossible. Almost nothing is impossible that pertains to the emotions. Impossible are only those things that by referring to a table of historical dates and names we can prove could not have happened. An abbot could get drunk in any century, but before Goethe's birth he could not recite Faust's monologue; a bishop could keep a concubine at any time, but during the Crusades he could not let his repeating watch chime, nor travel the route from Alexandria to Cairo by railroad.

It would be dificult to demonstrate such errors in *Ekkehard*, and for the rest, claiming that something 'goes against the spirit of former times' remains very questionable. Times that are furthest apart are often very similar; stretches of Australia are supposed to look just like the Mark Brandenburg or Pomerania.

"To be sure, one cannot have a Junker Bredow or Lüderitz address Elector Frederick the Ironheart: 'Sire, give us freedom of conscience!' And the son of a Nürnberg patrician during the reign of the Emperor Maximillian should not be made to say: 'Children cannot be too careful in the choice of their parents.' But it really would prove difficult to find passages or expressions along those lines in *Ekkehard*."

We might think that Fontane avoided the harder issue when he acknowledged differences only in externals and said nothing about such internalized processes as changes in religious beliefs, or in attitudes toward marriage or toward the state, which indeed might make customary behavior in one century extraordinary or impossible in the next. In his historical writings he took account of these developments. He did not expect a Brandenburg noble of the Thirty Years War to think and act like his nineteenth-century descendant, and he assumed that each generation was to some extent shaped by its economic, social, and political conditions, its cultural standards and its intellectual fashions. But more than the conditions themselves, Fontane was interested in how people dealt with them, and especially in their efforts to overcome restraints imposed from the outside. Conflicts between the individual and society and its conventions were to become a basic theme of his fiction. But when he wrote the essay on *Ekkehard* in the early 1870s he was only just setting out on the long road that was to lead to *Effie Briest* and *Der Stechlin*. He would not yet condemn Scheffel for passing over the impact the times had on his characters and concentrating instead on their "timeless" drama of love and rejection.

We can speculate—and it is no more than speculation—that without this timeless quality the novel would not have become a bestseller. *Ekkehard* appeared in the 1850s as the numbers of potential buyers and readers of fiction were climbing rapidly, a by-product of the accelerating growth of the middle and lower middle classes and the expansion of school systems throughout Germany in the second half of the century. Improved methods of book production and distribution enabled publishers to exploit this market with print runs that would have been unimaginable a generation earlier. Even in Goethe's and Schiller's day, light literature made up the larger part of fiction published in Germany; now interest in this type of book increased significantly, and readers found it an added attraction if the romantic plot could also be regarded as intellectually uplifting. Few works responded to their twin demands for entertainment and education as well as did *Ekkehard*. Its author, as Fontane noted, clearly knew a great deal about the German Middle Ages, which, however, did not prevent him from writing a modern love story. Its hero and heroine were familiar types—the seductive but domineering woman and the uncertain young intellectual and poet—their personality traits symbolized by the positions they occupy in the medieval world: duchess and monk. The settings of the story—monastery, castle, the German countryside—were interesting and

attractive, drama alternated with comedy, and the language in which all this was set down could be read without difficulty by anyone who had attended a secondary school. The few relatively complex passages—especially the *Walthari Lied*—could be skipped without losing the thread of the story.

No doubt these are not the only reasons for *Ekkehard*'s popularity: they may not even be the most important ones, nor do they explain why the book made little impression for fifteen years only to shoot up in the sales charts after 1870. But an elevated number of editions of works of fiction is a phenomenon that does not begin until the early years of the Wilhelmine empire. Most of the historical novels that share in it were written between 1870 and 1880; only one besides *Ekkehard* and the *Trompeter von Säkkingen* was already in print earlier—Georg Eber's *The Daughter of an Egyptian King*, which achieved eighteen printings between 1864 and the end of the century, a very respectable success but not comparable to *Ekkehard*'s two hundred editions.[18]

It has been suggested that what lies behind these sales, and what makes *Ekkehard*'s success significant to us, is the book's appeal to a bourgeois readership that had surrendered its political ambitions to the Bismarckian system of national unity under an authoritarian Prussia, and that now sought to withdraw to the solace of historical fiction. Some Marxist critics today echo radical poets of the 1830s and 1840s in complaining that historical novels serve to divert "the people" from the task at hand. The historical bestseller is regarded as emblematic of bourgeois passivity and even impotence. In the case of *Ekkehard* this hypothesis is strengthened for some by their view of its author's development. After his liberal hopes had been dashed by the failure of the Revolution, Scheffel withdrew from political—indeed even from public—life, and the fiction and poetry he now wrote constituted a further escape from reality.[19] The writer's passage from activism to resignation is thus made to reflect the fate of his class, with the escapist literature he produced responding to and expressing its psychological needs.

This is pushing ideological determinism very far. Whether historical novels are more escapist than other kinds of fiction may be doubted, and it is questionable whether even dedicated revolutionaries can live all their waking hours at the edge of political commitment. Beyond that it would have to be explained why the demand for historical novels should indicate bourgeois feebleness in Germany when at the same time the genre reached similar heights of popularity in France and England among the bourgeoisie triumphant. That during the second half of his life Scheffel did not write political prose is certainly true, but he had not done so before 1848 either. Both as artist and scholar he was always attracted to the past. Whether studying and writing about the past need be—or need be nothing but—a way of escaping from the present is of course not for the historian to say.

The larger historical meaning of *Ekkehard*'s success, its political and social symbolism, remains in question. What cannot be doubted, however, is that the book marks a turning point in the long history of the literary and artistic depiction of the Middle Ages in Germany. At the beginning of the nineteenth century medieval Europe provided themes for a largely apolitical, often deeply religious romanticism. Historical research,

its methods and standards increasingly sophisticated, added substance to the romantic view as did the discovery of the political message the Middle Ages might convey to the post-Napoleonic generation. The recovery of the Middle Ages, a European-wide phenomenon, took an unusually forceful political form in Germany. The dream of German unity found models and inspiration in the Hohenstaufen empire and its Carolingian and Ottonian precursors; for every schoolboy in Germany, Barbarossa—the emperor who had died on a crusade and like an earthly Messiah would one day reappear—became a symbol of what had been and would be again. Rethel enlarged the romantic conception into a monumental vision of political and religious ideals, energies, and conflict, expressed in a vocabulary more realistic and of greater scholarly accuracy than that of any of his predecessors and contemporaries, but one that did not destroy the magical, demonic character of the age. In his illustrations for the *Nibelungenlied* and the frescoes in Aix-la-Chapelle, the Middle Ages become the setting for a struggle of elemental forces, the inspiration for all later Germanies, to which the men and women of the 1840s owed their cultural individuality, whose political promise they must restate in their own modern terms, and whose hoped-for unity and power they must achieve. Finally, in the 1850s Scheffel stripped the period of its mysteries, and took away its power to impose chiliastic demands on the present.

Scheffel's image of the Middle Ages is more accurate historically than Rethel's, not only because Scheffel was nearly as much a scholar as an artist and had over years seriously studied the sources, but also because he no longer posited an exemplary quality to the period. It had its unique characteristics, but so far as its meaning to the present was concerned he regarded it almost like any other part of the past. In *Ekkehard* the tenth century was deprived of its programmatic role and became the historical context, executed with much specialized knowledge, not for ideological conflict with contemporary implications but for a story of thwarted love and a conventional *Bildungsroman*. For the German novel-reading public Scheffel domesticated the Middle Ages.[20]

Ekkehard appeared in the years that lay between the failure of liberalism in the Revolution of 1848 and the marshaling of political and military energies in Prussia that led to national unification. After 1870 the novel's undemonic view of the Middle Ages fit the new political situation; unification achieved, it was no longer necessary to tap medieval sources of inspiration. With the embourgeoisement of the Middle Ages, their mysterious and demanding appeal for heroic action gave way to the familiar and safe. That did not diminish the pervasive presence of the period in the fine and applied arts, in literature and music. On the contrary, medieval and quasi-medieval motifs were used so widely in the last third of the century that they turned into cultural and stylistic clichés. But their ideological charge had been dissipated. From calls for commitment and struggle they became expected devices to suggest ties between the first empire and its successor, badges that attributed ancient Germanic authority to the princes, generals, and lord mayors of Wilhelmine Germany, or simply historicist decorations of aspects of daily life—the façades of public and private buildings, furniture, or such ceremonial types of household goods as beer mugs. It was not until the last years of crisis before

1914 and during the First World War itself that the symbols and labels of the Middle Ages regained a measure of their former demonic significance in the design of war graves and of national monuments that proclaimed the political unity of an embattled people, and in the names given to the succession of retrograde defensive lines on the Western front. In those years, too, Scheffel's praise of the native countryside and his dream of a state embracing all German-speaking peoples were taken up, politicized, and exploited by the enemies of modernism in German culture and the proponents of a new nationalism and a greater Reich.

Before, During, and After
the Triumph

I. FROM REVOLUTION TO EMPIRE

EACH IN HIS OWN WAY, in his life and work, Fontane, Menzel, and the young painter Anton von Werner, Scheffel's friend, represented political attitudes that were widespread in Prussia at the end of the 1860s. The country's politics had shifted repeatedly in the previous twenty years. Since 1848 Prussia possessed a constitution, which after several revisions in the first years of conservative reaction to the Revolution preserved to the crown very far-reaching control over policy and the institutions of government. The liberal opposition nevertheless retained some scope because conservatives were far from united on the major domestic issues and on Prussia's role in Germany. When Frederick William IV's psychological deterioration made it impossible for him to continue to govern, and his younger brother, Prince William became regent and in 1861 succeeded him on the throne, a new era of conservative-liberal compromise seemed to begin. In the first elections for the lower house that were free of government interference, moderate liberals won a majority of the seats. The result reflected the composition of the voting rolls, which gave the tax-payers in the highest brackets—who were less than five percent of the whole—one-third of the votes, and the appeal that liberal opinions enjoyed among the educated and the well-to-do: "Liberalism dominated the city halls and chambers of commerce, the universities and gymnasia, the learned societies and other academically oriented associations and clubs. It dominated the newly created national [i.e. all-German] institutions of the educated and commercial bourgeoisie—the annual meetings of merchant and trade associations, of mayors and municipal administrators, of jurists, and of course the older scholarly congresses . . . That literature and science, university students and youth as such were liberal almost goes without saying."[1] But although some efforts were made to open its organizations to members of the lower middle classes, liberalism politically as well as socially and culturally retained the character of an elite. Its reluctance to share power with the less wealthy and the less well educated prevented it from mobilizing wide public support when a new dispute broke out with the royal executive in 1860.

The overt cause of what soon came to be called the constitutional conflict was serious enough—the strength, character, and political control of the army. These issues stood for another, more basic question: whether the crown would accede to any true sharing of responsibility and power. In the end, spells of uncertainty and even panic among the king and his military advisors notwithstanding, the government, led since September 1862 by Bismarck, reorganized the army even though the lower house had refused to vote the necessary funds. The liberals could neither prevent this clear violation of the constitution nor exact a political price in return, and no amount of face-

151

saving hid the linked facts that parliament had been deprived of any say over the country's military institutions and that the independence and authority of the executive, not only in military and foreign affairs, had been significantly enlarged. This proved to be a crucial development not only for Prussia, but for the other German states. After Prussia's victories of 1864 over Denmark and of 1866 over Austria and her German allies, the unification of Germany under Prussian leadership was assured. The exact form the new state would assume was not yet apparent, but whatever liberal alternatives might once have existed had narrowed very considerably. Most Prussian liberals now accepted Bismarck's conduct of foreign policy, and scaled down their proposals for domestic change. In his exemplary analysis of the constitutional conflict, Gordon Craig quotes a liberal leader after Prussia had driven Austria out of Germany in the Seven Weeks War: "The time of ideals is past . . . Politicians must today ask themselves less what is desirable than what is attainable." This, Craig adds, "was burying the past with a vengeance; and it may well be taken as the epitaph of middle class liberalism in Prussia."[2]

At the time, many political observers—not only on the left—would have rejected the finality of this judgment. Liberalism remained an active, vigorous force in Prussian and German affairs. In 1867 the National Liberal Party was founded, which together with liberal factions on the left and right won over 45 percent of the seats in the Prussian lower house, a proportion that in the first elections after 1870 was to rise to 50 percent, as did liberal representation in the nationwide Reichstag after unification. In the chambers of such states as Baden and Hesse liberals even held three-fourths or more of the seats. Many of Germany's most authoritative and influential newspapers, the *Vossische Zeitung* in Berlin and the *Frankfurter Zeitung* among them, expressed liberal points of view or could even be regarded as party organs. But the various factions into which liberalism was split only rarely presented a united front on major issues and proved unable to develop a coherent program as an alternative to Bismarck's firm monarchical control of Prussia's advance toward a united Germany. The desired goal of unification was to be achieved at last, but in thoroughly illiberal form, and an undertone of confusion, shifting fronts, and resignation marks liberalism in the parliamentary debates and the political literature of the last years before the Franco-Prussian War.

Fontane and Menzel, as we know, had held liberal views in earlier years, as did Werner, who belonged to the following generation. Menzel had long ago shed any real interest in how the country was governed; he was now submerged in his work to the exclusion of almost everything else. Fontane continued to be deeply concerned with Prussian politics and their impact on society, but he expected nothing from the liberal factions in parliament, and for a time gave the appearance of having moved close to the conservative camp. Werner knew from the very beginning of his career how to bring his moderate liberal views in accord with those of the powers that be. Indifference and withdrawal, resignation and accommodation—these were common phenomena of German liberalism in retreat; but in the case of the three artists they were less the results of deliberate political decisions than reflections of each man's personal and artistic devel-

opment as it proceeded through the shifting pressures of their immediate and broader environment.

The outbreak of war with France in July 1870 altered the setting in which each man was to work for the rest of his life. Characteristically, Menzel was the least affected of the three. Since his collaboration with Kugler nearly thirty years earlier, Frederician Prussia had continued to be a major theme of his art. After his usual intensive studies in archives, armories, and private collections he produced 453 colored lithographs of the uniforms of the Prussian army under Frederick—he aimed for a serious scholarly work, Karl Scheffler writes, but the results often combine accuracy with great artistic elegance.[3] He painted nearly a dozen pictures on episodes in Frederick's life, for some of which his illustrations to *Frederick the Great* served as early studies. And between 1843 and 1849 he drew sketches for two hundred wood engravings for the Prussian Academy's edition of the writings of Frederick the Great, which we can now recognize as his most important historical interpretations of the Frederician period. Many are not so much illustrations as separate, short essays on the king's text or on one of his themes, which the artist may interpret differently than does the author. An example is the vignette to Frederick's *Anti-Machiavel* (Fig. 79), the third of Menzel's interpretations of this subject. Machiavelli's portrait, signed by the king and dated 1740, is shown nailed

79. Adolph Menzel: Illustration to Frederick's
Anti-Machiavel.

80. Adolph Menzel: *Self-Portrait in the 1860s.*

to the pillory. But Menzel makes it clear that time has passed since the portrait was nailed to the stake. In the intervening years the wooden board on which the portrait is painted has become weather-beaten, and the king's condemnation, too, is now out-dated: at the top of the stake the date 1840, indicating a new age and a new appreciation of Machiavelli's achievement, is surrounded by the oak leaves and laurel of fame.[4]

These and other works signify an unusual immersion in the past by an artist whose imagination does not merely reflect the evidence but analyzes it and reacts to it in a highly personal manner. To many members of his public, nevertheless, Menzel's inde-pendent and even critical mind was obscured by his choice of subjects from Prussia's heroic past, and one consequence of his preoccupation with Frederick was a commis-sion by the Prussian government to paint a contemporary event: the coronation in 1861 of William I. For several years Menzel worked on the gigantic canvas, approaching his task in the same spirit of detailed research that marked his paintings and graphics of the eighteenth century—as we know, he regarded interpretations both of previous ages and of public events in the present as "historical art." His ability to bring the great number of participants in the ceremony together in a firm composition, his reportorial accuracy (although the need to create a strong diagonal led him to paint William raising the sword of state in a theatrical gesture alien to the king's sober nature), and the many fine touches in the more than one hundred portraits that filled the canvas were greatly ad-mired. But the painting as a whole—though superior to anything that other German historical artists at the time could have produced—was not persuasive, and the four years of concentrated effort Menzel devoted to it might have been better spent on other things. Throughout his life Menzel painted pictures "for himself" which he refused to exhibit, paintings like *The March Casualties Lying in State*. Many of these works re-mained unknown until after his death. Among them are examples of an engaged real-ism, in later years executed with an impressionistic breakup of line, in which a firm understanding of the objects depicted miraculously releases an atmosphere of great emotional as well as historical truth—a row of Berlin houses in the snow, a young woman reading by the light of a lamp, the corner of a room with two chairs, a standing mirror, and open, curtained French windows. Today it is not unusual to regard these oils and gouaches as the best things Menzel ever did—the opening measure of what might have become a tradition with a powerful influence on German art had they not remained hidden in his studio.

By the time he celebrated his fiftieth birthday, in 1865, Menzel had become the best-known North German historical painter. As professor and member of the Royal Academy, repeatedly decorated by the Prussian government, his economic position and his place in Berlin society were now secure. Despite his *Coronation of William I*, how-ever, he was far from being a court painter. He eschewed the official portraits and cer-emonial presentation pieces that in increasing numbers accompanied Prussia's path by way of three wars to imperial grandeur. But he took the wars as a new opportunity to plumb reality. When the campaign against Austria began in the summer of 1866 he

followed the army into Bohemia, not as a privileged guest of higher headquarters but with a reserve regiment and in field hospitals. "My sense of duty," he wrote to his brother-in-law, "my thirst still to learn this and that, were more or less satisfied, given that the *fresh* battlefield remained out of the question." To his old friend the army surgeon Dr. Puhlmann he wrote: "For fourteen days I pushed my nose into horror, sadness, and stench." Now he also knew, he added, where Andreas Schlüter, the seventeenth-century sculptor and architect of the Berlin armory, had found the models for his masks of dying warriors.[5] Among the results of this expedition are studies in pencil and watercolor of the naked corpses of soldiers, which in their merciless objectivity are unequaled in the art of the nineteenth century.

Four years later he remained in Berlin rather than follow the troops to France. The war did, however, provide him with a theme, an event he witnessed and later painted from memory: the departure on July 31 of King William from the capital to his headquarters in Mainz (Plate III). The painting, 63 × 78 centimeters, is another of Menzel's not infrequent treatments of large numbers of people coming together for a common purpose. The viewer seems to be in the midst or at the edge of a crowd on the broad sidewalk of the avenue Unter den Linden, under a lowering sky, watching the king and his wife passing in an open carriage that is followed by an escort of four mounted policemen. The road runs in a shallow diagonal from left to center right, its path marked by the heads of the crowd, the linden trees that gave it its name painted with robust virtuosity, and a double row of cast-iron and glass street lamps. In the distance, beyond the last tree, the perspective is brought to a halt by the new redbrick city hall of Berlin— a symbol of the expanding economic and social power that lay behind Prussia's military might. The right third of the canvas is filled with the ornate façades of the new buildings that were transforming the military-bureaucratic capital of a simpler age into an imperial metropolis. From balconies among billowing or twisted flags, ladies and gentlemen watch and wave. The crowd on the steps and sidewalk below is made up largely of well-dressed citizens, some with their children; officers salute, a few men—a worker among them—wave hats and caps. All eyes are on the royal couple, except for two children, and, in the lower left corner, two men who are walking out of the picture, reading the special edition of a newspaper. In the center foreground a gentleman, top hat in his left hand bows to the passing coach; with his unseen right he holds a mastiff on a short leash. The dog, too, faces away from the road, toward a boy who walks through the crowd with a stack of newspapers over his right arm.

Like the dour man walking out of the canvas in *The March Casualties Lying in State*, the paperboy is a strange and disturbing presence in *The Departure of William I to Join the Army*. As a compositional element he is important. In the forest of verticals formed by the members of the crowd, the façades of the buildings, the street lamps and trees, his is a curved shape, round and loose like the flags above his head. But his face (which has an exaggerated masklike quality) staring or smiling at the dog, his odd posture, and the awkward perspective of the placement of his feet draw the viewer's special attention, and weaken if they do not disrupt the unity of the work. The crowd in the

PLATE III. Adolph Menzel: *The Departure of William I to Join the Army.*

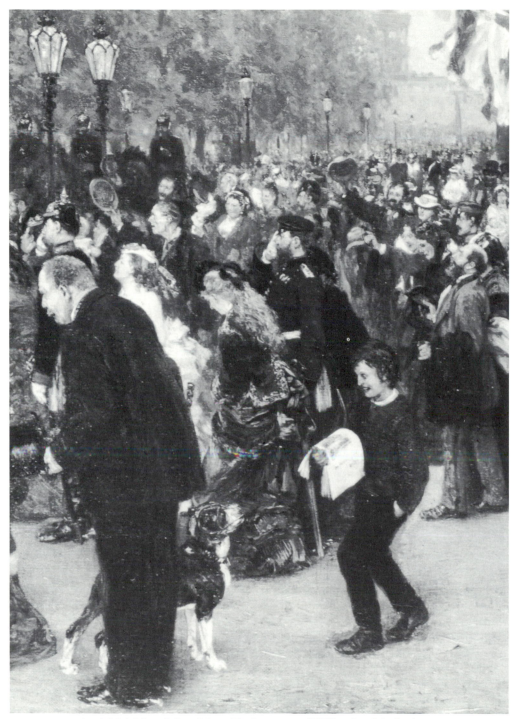

81. Adolph Menzel: Detail from *The Departure of William I to Join the Army*.

painting is far more noticeable than the king; in turn, the boy is the most unusual figure in the crowd.

Whenever many people gather, some are likely to be distracted and to behave differently from the rest. The two men reading the newspaper, a little girl next to them turning her head from the king to look at the mastiff, the paperboy himself—all are truthful components of a crowd as it really is. But Menzel himself demonstrates that in aesthetic interpretations of life, variety must be given some measure of cohesion. He paints the crowd with any number of anecdotal touches without fragmenting it—until he comes to the paperboy. Then his realism—no doubt he had seen a paperboy interrupt his street cries for a moment to play with a dog in just this way—overwhelms his principal theme: the coming together of the military monarchy and its bourgeois substance, a confrontation whose ambiguities the painting hints at. But the boy, a natural element of the crowd, sounds too harsh a note for Menzel's scale of refined dissonance.

After the end of the war, in the summer of 1871, Menzel sent a reproduction of the painting to Fontane, who thanked him in a brief letter addressed to "Dearest Rubens"— Menzel's "Tunnel name." One of the artist's great strengths, Fontane wrote, "showing the imprint of history on everyday life, showing how great events project into ordinary existence (while so many 'historians of the brush' fill major events with their own commonplace traits)—that is what immediately made your picture so dear to me. . . . Permit me to join my most recent *entry*-poem to my thanks for your *departure*-painting."[6] The poem Fontane included in his letter to Menzel had been written for a newspaper on the occasion two weeks earlier of the official return of the victorious German army to Berlin. Though celebrating the third military triumph in seven years, the poem was not without its own ambiguity and even warning: the Prussian guards followed by representatives of every regiment of the German army enter the city through the Brandenburg Gate and almost fly rather than march up Unter den Linden, as though propelled by their flags. But when the troops pass the equestrian statute of Frederick the Great and look up at the king, the old man bends down over the mane of his horse and whispers to them: "Bon soir, Messieurs; *now it is enough* [Fontane's emphasis]."[7]

For much of the twenty years since Fontane had given up pharmacy and, as he put it, bet his life on poetry, his progress had been halting. In 1850, through the influence of a Tunnel friend, he found work in the press office of the Ministry of the Interior, on the strength of which he married, his bride coming from a family of French *réfugiés* not unlike his own. Soon afterwards the office was reorganized and he was let go. An attempt to gain similar employment in the Ministry of Foreign Affairs failed, as did his appeal to the king for a pension to support his writing, in part because his liberal views were known. At last in the fall of 1851 he found a position on the staff of a government newspaper. "Today I sold myself for thirty pieces of silver a month," he wrote a friend. "It is simply impossible to make one's way as a decent human being."[8] He felt disgust with himself for betraying his convictions, but used the newspaper as a means of leaving Prussia and of quitting political journalism, at least for a time. In April 1852 he was sent to London as an occasional correspondent. This time the king granted him a small

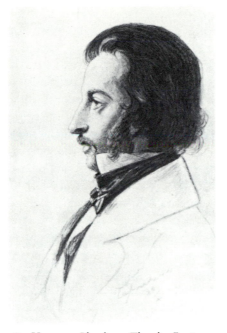

82. Hugo von Blomberg: *Theodor Fontane*,
1857.

travel stipend, and additional help came from his family and from the Tunnel. After six months he was back in Berlin, supplementing his journalism with jobs as a tutor, as a teacher of German, geography, and history in a private school, and once again as a pharmacist. In 1855 he traveled to London for the third time, to report to the Prussian government on politics, the press, and public opinion. But his hopes for permanent employment came to nothing, and after three and a half years he returned to Germany, comparing his feelings to those of a defeated army.[9] The prospect of becoming librarian to King Maximilian of Bavaria proved illusory; other applications for suitable and unsuitable jobs failed. Finally, in June 1860, the editor of the *Kreuzzeitung*, the newspaper of combative Prussian conservatism, to the right even of the government, hired him to take charge of the English desk, a position he held for the next ten years.

Fontane's appointment was the result of his literary productivity, which had continued unabated throughout these years of false starts, humiliations, and economic hardship. During the 1850s he published many dozens of articles, several collections of essays, and a volume of his poems. He edited an anthology of modern verse and with Kugler brought out the literary annual *Argo*. His public lectures on British life and culture confirmed his reputation as an expert on that country. Perhaps especially persuasive to his new employers were his essays on the local history of Brandenburg, which he began to publish in the summer of 1859, a project that soon was supported by an

annual grant from the Kultusministerium and could not fail to appeal to the special patriotic outlook and interests of the *Kreuzzeitung*. When the first volume of the *Wanderings through the Mark Brandenburg* appeared toward the end of 1861, Fontane added to his name as a poet and translator of ballads, and as an authority on England and Scotland, the reputation of an interpreter of the history of Brandenburg, especially of the past and present lives of its noble families in the little garrison towns around Berlin and on their estates. As a regular member of the staff of the *Kreuzzeitung* he at last had a regular if modest income, and enough free time for his own work. "My life has taken a merciful turn," he wrote his mother. "For many years definitely a 'minus,' I now possess a kind of bourgeois position in society, make a decent living, [and] have an occupation that gives me pleasure and satisfaction. . . ."[10]

By joining the staff of the most important conservative newspaper in Prussia, and as the author of historical studies that could be read as emphasizing the qualities of the country's traditional elites, Fontane appeared to have put the liberalism of his youth behind him. His fame as the poet of Prussian heroes reinforced that impression. And it was not wholly inaccurate. It is too much to say that the Revolution had turned him into a conservative, but he now recognized the weaknesses and contradictions in the progressive movements more clearly then he had allowed himself in 1848, when the liberals too readily assumed they represented the interests of the nation and the democrats pretended to speak for a people that failed to give them support. Aesthetic considerations also played a part. He thought that a parliament with real responsibilities and power was appropriate to modern society, but dismissed as tiresome fiction claims that the people were wise and good. His interest was in the country's political and social institutions, which he believed should become more equitable, and in the individual, the man or woman who by force of native qualities and the right kind of circumstances—which might or might not be "favorable" in the usual sense of word—had achieved a degree of psychological independence. His was an essentially aristocratic outlook, aesthetic and psychological rather than political; but for many years it colored his political beliefs.

The independent "originals" that he prized and studied with unflagging interest could be found in every social group, but they were especially concentrated, he thought, in the nobility of Prussia's core provinces. The personalities of these landowners and soldiers were not only interesting in themselves: they had impressed themselves on the country's history and continued to affect it even in a time of growing industrialization and nationalism. A striking example of this type, to whom Fontane devoted a chapter in the second volume of the *Wanderings*, and on whom he modeled a leading character in the historical novel he began to write in the 1860s, was Friedrich August Ludwig von der Marwitz, a member of an old family in the Mark Brandenburg, who played a role in Prussian affairs during and after the era of reform. Marwitz was a man of principle, of moral and physical courage and with a sharp practical intelligence. He was a capable manager of his estate and a tough, resourceful soldier, who although anything but a careerist rose to senior rank. His formal education had ended in his thirteenth year,

when he became an ensign in the *Gensdarmes*, one of the most socially prestigious regiments in the army, but he read widely and was the possessor of a firm, supple prose style—his description of Frederick the Great in old age, drawn from his boyhood recollections, is famous in the literature. He was also a man of towering caste bias, opposed to any reduction in the hierarchic barriers that divided Prussian society, and during the reform period he was one of the leaders of the resistance of the Brandenburg estates to Hardenberg's modernizing policies. In 1811, as a signal that times had changed, he was imprisoned for one month in the Spandau citadel, an experience that only strengthened his resolve to fight for the traditional privileges of his class. His talents, stubborn combativeness, and probity made him one of the spiritual and intellectual founders of Prussian conservatism in the nineteenth century.

Fontane's treatment of this complex figure is marked with admiration for the character traits and quirks that could develop unhindered in an environment of privilege and deference. His analysis also blends historical interpretation with contemporary political concerns, and soon reveals that even in his early years on the *Kreuzzeitung* Fontane's conservatism was of a highly qualified kind. The discussion of Marwitz begins in a manner usual to the *Wanderings* by describing the environment of his subject's estate—in this case farmland some forty-five miles east of Berlin—his manor house, the parish church within the grounds, and its earlier history. Then Fontane turns to the lives of Marwitz's ancestors, and continues with his life and writings. His interpretation is sympathetic to the man, very critical of his ideas. But it is these ideas that help make Marwitz interesting to Fontane. Marwitz did not merely fight the message of the French Revolution with weapons of political and social self-interest: rather, he tried to marshal ideas that would demonstrate the evil of bureaucratic interference in the basic conditions of corporative society, which should be cleansed but not abolished. Fontane regards the memoranda with which Marwitz attacked Hardenburg's reform policies as masterpieces of criticism, not without positive suggestions but ill suited for the immediate political struggle: "Their best part remains the intellectual stimulation that they provide in rich measure."[11] He expresses the hope that now, in the second half of the nineteenth century, the ideologies of both liberalism and conservatism have become accepted means of political discourse: "We wish for a brisk and free breeze in the sails of our ship of state, but we also need the saving anchor, whose iron prong in the sands below holds us firm when the breeze threatens to turn into a storm. Such an anchor was our Marwitz."[12]

Conservatism, then, as the steadying, preserving force. But Marwitz's version, Fontane's analysis continues, suffered from two great weaknesses: it was based on rigid class distinctions; and Marwitz refused to recognize that not all of his peers were as upright as he. He justified the social and political superiority of the nobility not only historically, but also because he considered the bourgeoisie as a whole to be morally inferior—an idea, Fontane adds, that could have the most serious political consequences. He points up its perniciousness by quoting a passage from Marwitz's memoirs that was peculiarly suited to impress the educated German reader: "In 1806, a few days

before the Battle of Jena, our Marwitz encountered Goethe in the ducal palace in Weimar. How does he describe him? 'He was a tall, handsome man, in embroidered court dress, with hair-bag, powder, and dress sword, who always bore himself as the minister of state and well represented the dignity of his rank, although he lacked the natural, free good manners of the well-born.' " Fontane comments: "So even Goethe could not aspire to equality in demeanor and appearance. He was a dignified minister, a great poet, friend of his prince, and the brilliant star of the Weimar court; but as the son of a burgher of Frankfurt he 'lacked the natural, free good manners of the well-born.' An inexpressible something was missing, perhaps the ultimate polish of the *Gensdarmes*."[13]

Even in a period of resignation and compromise, and despite his appreciation of the strong characters and sharply profiled personalities the old elites could produce, Fontane's conservatism had limits, to which a personal trait—sensitivity to arrogance on the one hand, servility on the other—clearly contributed. A telling and characteristically worded expression of his attitude appears in a letter to his wife written some months after the first volume of the *Wanderings* had been published. Fontane was collecting material for the next volume, touring the countryside, working in archives, and interviewing people. He recounts his visit to a manor house: "At three o'clock again to table. In heavy coat and unpolished boots I took my seat next to Countess Schwerin and Countess Finckenstein, incidentally without embarrassment, prepared to face the worst. (Actually it is quite immaterial how one appears before such ladies and gentlemen. An abyss divides us, and no patent pump on earth can fill it. We are not their equals, and because we are not it doesn't matter whether one comes into their presence in homespun or broadcloth . . .)"[14]

Like his *Prussian Songs* before them, Fontane's *Wanderings through the Mark Brandenburg* contain ambiguities and criticisms beneath their patriotic-historical surface, which escaped some readers while for others the tension between positives and negatives was one of the qualities that made the work an impressive interpretation of the Prussian past and, by implication, of the present. Many years later, after Fontane had worked his way through some of his assumptions and sympathies of the 1850s and 1860s, he added an overt condemnation of the Prussian nobility to the *Wanderings*. In 1881, after the first three volumes of the series had been reprinted several times, he completed a fourth and he believed final volume—a fifth did in fact, appear subsequently. In an epilogue to the four volumes he reviews his experiences as itinerant local historian, points out that although not an academic he had uncovered and interpreted some material that was unknown and could "claim the attention even of the professional historian," and discusses his "collaborators"—people whom he had interviewed and who had shown him paintings and documents—in particular country parsons, schoolteachers, and the nobility. The mention of this last group introduces a brief, sharp rejection of its politics. The historical significance of the Prussian nobility, Fontane writes, derives in part from the fact that it had hardly changed in the course of four centuries: "Truly, a naive conviction of its ability to rule and of its right to rule survives in our nobility, a conviction that hurts both the group as a whole and its individual

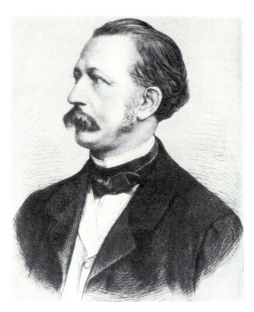

83. Anonymous: *Theodor Fontane*
in the 1870s.

members, and that must for a long time to come prevent the creation of a Tory party based on principles rather than simply on prejudice and self-interest. Such a party is an impossibility without the support of the untitled. But there can't be many 'well-placed' bourgeois—however conservative their temperament and however strict their conservative upbringing—who haven't been thrown into deepest embarrassment and despair by the pseudo-conservatism of our nobility, which in the final analysis cares only for itself and its own benefits. Again and again this pseudo-conservatism breaks to the surface, reveals cherished hopes to be mere delusions, and in the long run renders any genuine cooperation out of the question."[15]

In other words, the attitudes of the social group that dominated Prussian conservatism disqualified conservatism in Prussia as an acceptable political movement. But it is only to be expected that Fontane followed this judgment with an appreciation of the nobility's personal qualities. "All in all," he writes, "they are different from their reputation, these frequently maligned 'Junkers'—different and better, and it is only giving duty and truth their due to affirm that I owe hours of the greatest pleasure to a long series of conversations with them . . ."

The success of the first volume of the *Wanderings* and the need for additional income induced Fontane to embark on further historical writings. In 1865 he published a history of the recent war with Denmark, a work that may have contributed to his being decorated by the Prussian government two years later. He prized this recognition by the state, modest though it was, and hoped it would be followed by others; but while he was adding to his record of achievements that could please official Prussia, an inde-

pendent, even oppositional strain became increasingly apparent, and the Order of the Crown, Fourth Class, was to be the only Prussian honor he received except for a similarly modest decoration two decades later. In 1869 and 1870 he published two volumes on the Prusso-Austrian War, and when war with France broke out that summer Fontane signed a contract for a third work of contemporary military history. In late September he traveled to the theater of operations. A week later he strayed beyond the German lines, and while searching for the historical traces of Joan of Arc in Domrémy was arrested by the French as a German spy. He seems to have been briefly in danger of being executed; but the intervention of influential friends and diplomatic pressure exerted by Bismarck in favor of the harmless scholar "Dr." Fontane, as well as the arrest of three French hostages by the Prussian authorities, led to his release on 24 November. A month later the first installments of the account of his experiences appeared in the newspapers, soon followed by a book, *Prisoner of War*, which scored a considerable success, even if some readers criticized it as too friendly to the French enemy.

This unexpected interlude and its rapid literary exploitation scarcely delayed progress on the larger project, *The War with France, 1870–1871*, which became Fontane's most substantial historical work. The most obvious merit of its 2500 pages is the firm narrative—the sections on combat heavily interspersed with eyewitness accounts—in which political, diplomatic, and military events are unfolded with the same sure touch. Fontane's comments and occasional criticisms lend the text a strong personal note of empathy, realism, and objectivity. He conveys a sense of the confusion and friction that are part of every war, and he is objective not only in his analysis of the German operations, but also in his treatment of the French, whose energy and courage are emphasized throughout even as he condemns as unjust the cause for which they fight. His work is patriotic not chauvinistic. Its scholarship consists mainly in the analysis and integration of a great number of published German and French sources rather than in archival research, although Fontane did visit several battlefields and interviewed participants. Inevitably the mass of specialized studies and memoirs that soon began to appear, the official history published by the German staff from 1872 on, and the volumes of the *section historique* of the French general staff that followed superseded Fontane. But for a time his *War with France* was the most comprehensive and certainly the most balanced history of the war. Midway between a popular account of recent events and the work of a scholar addressing a professional audience, it responded effectively to the demands of the educated general reader.[16]

By the summer of 1871, after the German empire had been proclaimed and the troops were returning home, Fontane's name had gained new weight. Although still not free of financial worries, he was now, in his early fifties, firmly established as a professional man of letters—historian, critic, commentator. A step he had taken just before the war helped right the balance between the external circumstances of his existence and his feelings and convictions. In May 1870 he resigned from the *Kreuzzeitung*—"the position was not worth the freedom I sacrificed for so many years"—and joined the *Vossische Zeitung*, the leading liberal newspaper in Prussia, as its drama critic. The

place had fallen vacant through the death of the previous holder, but Fontane's move was a logical consequence of his journey over the past years toward a new independence from the political and social values that ruled Prussia and were to dominate the new empire.[17]

II. *THE PROCLAMATION OF THE GERMAN EMPIRE* BY WERNER

THE THIRD of the artists whom this discussion singles out as representative of political attitudes that may be termed broadly liberal, and as interpreters of political events and forces in the last phase of German unification, is Anton von Werner.[18] Unlike Menzel and Fontane, Werner was not marked by the experience of 1848; he grew up during the period of reaction and the years of constitutional conflict that followed. He also differed from them in the social standing of his family, which in its antecedents if not in its current condition placed him among Prussia's elites. He was born in 1843 in Frankfurt an der Oder, some fifty miles south-east of Berlin, into a family that had been ennobled in the early eighteenth century but gradually had declined to the artisanal level. His grandfather had still served as an officer, although only in the lowest grades; his father was a carpenter. At the age of fourteen Werner was apprenticed to a housepainter. In 1859 he won a fellowship at the Academic Institute for the Fine Arts in Berlin, where he received the standard—and he thought not very good—academic training. After three years he continued his studies with the historical and genre painter Adolph Schroedter in Karlsruhe, who a decade later was to become his father-in-law. In Karls-ruhe Werner soon formed a close friendship with Joseph Viktor Scheffel, a bond that was to further him socially and professionally. Except for their differing perspectives on the character of the Prussian state, which Scheffel disliked as being aggressive both at home and abroad, Werner's liberal views were at one with his friend's. He was and remained a political moderate, a believer in constitutional, representative government and in a society without rigid distinctions of caste, class, or religion that gave due recognition to the achievements of the educated bourgeoisie, including its Jewish elements. The virulent anti-Semitism that emerged in Germany in the 1870s with such forces as Court Chaplain Stoecker's "Berlin Movement" he castigated as disgusting and cruel.[19] Although a fervent supporter of national unification, he prized the ethnic and cultural diversity of the German territories. Even near the end of his life, as a highly decorated senior official in the Prussian cultural bureaucracy, he recalled with pleasure and some irony the physiognomic variety he encountered among Bavarian officers during the Franco-Prussian War, in contrast to the "uniformity that hair-styles, beard-styles, and even physical features imposed on the faces of our Prussian officers."

Werner rapidly acquired great technical competence and by the end of the 1860s, still in his twenties, was already in demand as an illustrator and a painter of historical subjects. He possessed the impressive gift of quickly capturing the likeness of a person in a sketch or watercolor. But his was an observing not a questioning eye; he recorded rather than interpreted, and his finished portraits in oil even more than his studies are

84. Anton von Werner: *Skaters in Karlsruhe*.

limited to surface accuracy. In his use of color and in his compositions he remained fixed in the academic mold, and his historical paintings and symbolic, allegorical works—the Goddess Germania arming to meet the Gallic foe and similar themes—reveal poverty of imagination and lack energy. Even his illustrations of Scheffel's works, which became very popular, are mostly derivative historical costume pieces without much individuality; only the drawings for Scheffel's student songs show a likable dash and wit. Werner's best works during these years and probably the best he ever did are realistic impressions of upper-middle-class life—elegantly dressed skaters on a frozen lake (Fig. 84), young ladies and university students taking tea on a balcony—which caught the moment, and still convey something of the atmosphere of a solidly established, vigorous society at its ease.

The great opportunity of his life came with the Franco-Prussian War. The Grand-Duke and Duchess of Baden, who had come to know him through Scheffel and liked his work, sent him with letters of introduction to Versailles, since the beginning of October the location of King William's headquarters and the headquarters of the third army, commanded by the Prussian Crown Prince, the Grand-Duchess' brother. Mobile operations had slowed by then, the investment of Paris was under way, and Versailles was as much a center of diplomatic and social as of military activity. Werner joined the entourage of the crown prince, who took a strong liking to him. When after the war the

prince presented the artist to his wife, a daughter of Queen Victoria, she found him equally sympathetic, and he remained on very close terms with the couple until the death of the prince, by then Emperor Frederick, nineteen years later.

In Versailles Werner met and portrayed numerous officers of the two headquarters and of the general staff, who treated him as a welcome guest, an artist who belonged to their own caste, and who was creating an appealing record of their participation in what had turned out to be a triumphant war. His sketches and quick portraits in oil were the equivalent in the military realm of his pleasing depictions of Karlsruhe society a few months earlier—realistic and atmospheric, a few marked by a certain elegant masculinity, others suffering from Werner's inability to delete some of the many details gathered by his unerring eye. A small portrait of Moltke, for example (Fig. 85), shows the thin, seventy-year-old chief of staff of the German forces in plain blue service uniform with the broad carmine trouser stripes of the general staff, a cloth cap with a small visor on his blonde wig, seated in an upholstered armchair, reading a letter or report. At his feet lie an opened envelope and other discarded papers. The calm concentration of the man is well conveyed; but this central theme of the painting is overwhelmed by the sedulously enumerated details of the surroundings—the corner of a salon in the villa that had been requisitioned for the general; ornate wall-paneling with portraits of saints and bishops; the decorated ceiling from which hangs a chandelier, the dominant object in the painting, its curved arms unpleasantly combining Rococo and Victorian motifs; a bronze group of two horses on a chest behind the large table; chairs and drapes; and, seen through the doorway in the background, a second room with *its* furniture, chandelier, and curtained window. Very likely Werner depicted the setting with a high degree of accuracy, but by indiscriminately including everything he leaves us with a sense of confusion.[20] A careful if not judicious photographer could have produced a very similar picture, and indeed Werner's function at Versailles was that of a highly privileged cameraman, who mingled with his subjects on terms of equality or—if they were princes— at least of mutual social respect. Photographs were taken at Versailles, but photography played a noticeably less significant role than it had, for example, during the American Civil War a few years earlier. Possibly the princes and courtiers who set the tone in those activities at Versailles that were subsidiary to diplomacy and war felt that photography was not a medium possessing sufficient dignity, the final product of which did not honor its subject as a painting would. The artists whom they patronized instead, however, were precisely those who worked in a manner that could be characterized with far greater justice than Menzel's twenty years earlier as possessing "daguerreotypical accuracy."

After less than a month Werner returned to Karlsruhe to work up his sketches. Early the following year he received a telegram addressed to "Historical painter v. Werner" and signed by an official of the crown-princely court: "H.R.H. the crown prince asks me to tell you that you will experience something worthy of your brush if you can arrive here by 18 January." Werner reached Versailles on the morning of the 18th, thinking he would witness an attack on Paris, but was told he needed white tie and tails,

which he was able to buy from a local tailor. He was then taken to the palace, crowded with hundreds of officers, and passed into the *Galerie des Glaces* despite the royal Lord Chamberlain's demanding what business "the civilian" had there. Then William I entered, followed by the crown prince, the German reigning princes, the representatives of the Hanseatic cities, the senior commanders, and Bismarck; and after a brief religious service Bismarck read the proclamation founding the second German Reich under the Prussian king, who now became German emperor.[21]

The crown prince and the Grand-Duke of Baden commissioned Werner to paint the proclamation ceremony as a gift of the German princes and Hanseatic cities to the emperor. Six years after the event, in March 1877, the painting was presented to William I as a surprise gift on his eightieth birthday. Aside from the substantial honorarium Werner received, a laurel wreath from the crown princess was delivered to him by two princes, one being the future Emperor William II.

85. Anton von Werner: *Moltke at Versailles*.

Before we discuss the painting—which was reproduced in many thousands of copies, was frequently used as an illustration in history books, and probably became the most familiar work of contemporary art for two generations of Germans—it will be useful to look at Werner's position among German artists of his time and to say something about his ideas on art. By the time *The Proclamation of the German Empire* was unveiled, Werner, although still only thirty-three years old, had become the dean of those Berlin artists who could expect commissions from the court and other clients—city administrations, foreign powers—for official portraits and depictions of scenes from recent and contemporary history. In 1875 he had also been chosen as Director of the Academic Institute for the Fine Arts, the "Berlin Academy" attached to the Royal Academy of Arts, where he had been a student fifteen years earlier. The appointment, which carried with it membership of various government commissions and seats on juries, gave Werner great influence in the Prussian cultural bureaucracy and among artists in Berlin. When Bismarck asked him to take charge of the German art section at the 1878 Paris International Exposition, Werner's standing in the German art world was confirmed.

His official position was strengthened by his associations with the imperial family. He repeatedly painted William I, discussed the correct manner of depicting scenes of Prussian history with him, and was invited to court functions. Of a more personal nature were his links with the crown prince and his wife. He gave advice on art purchases; he accompanied the couple on a trip to Venice, which culminated in a large public demonstration honoring the prince as a champion of liberalism; in 1879 the princess was godmother to Werner's son. During the prince's final illness, from which he died soon after succeeding his father, Werner visited him in Baveno on Lago Maggiore, and then sketched him on his deathbed, as he had sketched the Emperor William ninety-nine days before. The new emperor, William II, had known Werner since adolescence and had received tutorials on art and art history from him. He charged him with the decorations for the first ceremonial openings in his reign of the Reichstag and the Prussian Diet, and from then until Werner's death during the First World War supported him as firmly as his father and grandfather had, but without their discretion and sense of responsibility to all segments of the population. When Impressionism became a force in German art in the 1890s, it encountered in Werner one of its most outspoken and energetic opponents. He and the emperor buttressed each other in their dislike of modernism; but their efforts to turn the cultural agencies of the state into citadels of traditionalism eventually exposed William II to a series of defeats in the area of cultural policy that damaged the integrity of the imperial system itself.

To outsiders Werner might appear as a courtier; but throughout four decades of considerable power, during which he received greater honors than any other artist except Menzel, Werner maintained his independence. He was anything but a man of deference. To his superiors in the government hierarchy he was an assertive, sometimes difficult subordinate, who employed the ultimate weapon of threatening to resign more than once. He did not hesitate to carry on feuds with other officials in public—his dis-

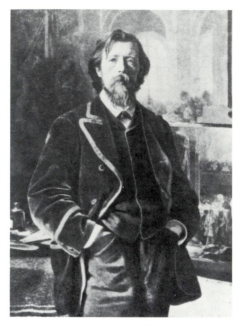

86. Anton von Werner: *Self-Portrait*, 1885.

pute with Wilhelm von Bode over the latter's purchase for the Berlin museums of a possibly spurious Rubens is only one famous example—and could speak plainly to the emperor himself. As a senior official in the Prussian bureaucracy he would not engage in party politics but readily intervened to protect the interests of his constituents. He pressed the government to ameliorate the economic and social condition of the mass of poor artists—the so-called art proletariat; he felt free to tell even Bismarck that high officials who had not worked at a trade as he himself once had could not understand the artisanal classes; and when a group of students in the Academy distributed anti-Semitic propaganda he put a stop to their efforts by threatening them with immediate expulsion. At least until the turn of the century, when the fight over modern art became deeply politicized, he maintained his many social links with liberal circles in Berlin and in southern Germany. Like many others he served and accepted a state that in its centers of power was illiberal with a vengeance; but his private life and at times his official actions as well continued to be marked by the spirit of liberalism in which he had grown up.

Werner's understanding of art did not reach beyond Realism. Manet's *Execution of the Emperor Maximilian* he dismissed as historically inaccurate and without emotional content, a "feeble, botched piece of work." The more linear German Impressionism of Max Liebermann struck him as incomprehensibly misdrawn and poorly executed, with paint laid on in thick, crude strokes that needlessly violated the academic

ideal of a smoothly blended finish. The sexuality of German Expressionism, specimens
of which he saw during the last decade of his life, he could interpret only as pornogra-
phy, which fortunately was deprived of any possible appeal by its extreme ugliness.[22]
Narrow though these views were, his own work might have evolved farther had not his
patrons, with their demand for the accurate, detailed rendering of ceremonies, parades,
and battles, snuffed out the spark that gave life to his early paintings of South German
society.

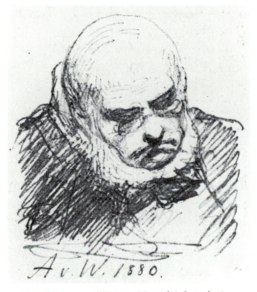

87. Anton von Werner: *Menzel Asleep during
a Senate Meeting of the Royal Academy.*

Werner was not unaware of his limitations. He saw himself as a competent and
experienced craftsman, who had come to specialize in certain types of work, just as his
colleagues and friends might excel in other genres—landscape, for instance, seascape,
or still life. The trouble was that he applied his own artisanal standards to the whole of
contemporary art. Only Menzel he acknowledged as clearly superior to himself and to
all other painters in Berlin. Menzel—we might summarize Werner's attitude—set a
standard for modern historical painting that no other German artist could quite attain
and that only the Russian Vassili Veretschagin and Ernest Meissonier, since Vernet's
death France's leading historical painter, might equal. As a student at the Academy
Werner had copied the illustrations in Kugler's *Frederick the Great* and Menzel's other
wood engravings on Frederician themes, and ever since Menzel had remained "the Mas-
ter." Even the large canvas on the revolutionary theme of workers in a rolling mill that

Menzel painted in 1875 evoked Werner's glowing tribute: "With this creation of genius, the sixty-year-old master, until then admired as the painter of Frederick the Great, launched out in fullest youthful vigor on what seemed totally new paths: the glorification of work, of the iron and machine-tool industries, the true motor of modern life."[23]

Although he recognized its significance, Werner would never have chosen this theme. On the other hand, with a few exceptions Menzel did not paint the ceremonial events and the battles of the Franco-Prussian War that Werner had made peculiarly his own. What was it that kept the "painter of Frederick the Great," who a few years earlier had labored over the giant canvas of William I's coronation, from becoming the preferred painter of the Prussian court? Menzel's lack of interest, even unwillingness, is part of the explanation; another reason must have been the court's silent unease with the unpredictable and uncontrollable pictures of an artist whom it was perhaps safer to honor than to employ. This caution seems justified when we remember the scenes from court life that Menzel painted in the 1870s and 1880s—*The Intermission of the Ball, The "Cercle" of William I*, above all *The Ballsouper* of 1878, which Degas copied when it was exhibited in Paris. The painting shows a crowd of guests in two halls of the royal palace during the supper intermission at a ball. It beautifully catches the crunch and movement of the mass, the color scales created by uniforms and ball-gowns between chandeliers and mirrors; and equally well the social atmosphere—the sum of feelings experienced by individual officers, civilian dignitaries, and ladies—hovering between delight and discomfort. Menzel painted the *Ballsouper* and other court scenes because the theme of crowds in enclosed spaces, the opulence of their dress and of the setting, came to interest him. What is lacking is any hint that by their presence in the palace these happy few partake of, let alone express, a higher state of grace flowing from the crown's majesty and plenitude of power. Werner's many paintings of the imperial family and the court never leave us in doubt that we are face to face with the elect.

After 1871 Werner continued to paint some scenes of upper-middle-class life as well as a few allegories and works on earlier Prussian history; but by far the greater part of his output now dealt with recent and contemporary history: portraits of princes, senior commanders, and ministers; events in the life and work of members of the imperial family and high functionaries at which he was present, such incidents as the christening of the emperor's grandchild, the emperor's visit to a cadet academy, or the final session of the Congress of Berlin; and reconstructions of military actions and other occurrences of the Franco-Prussian War, which he had not himself witnessed. Each of these categories imposed different demands on the artist. Werner distinguished between "ideal" or "monumental" historical painting, on themes that the artist did not know first-hand and which he could therefore interpret with some latitude, and historical painting proper—incidents he had witnessed, which it was his duty to record and interpret as faithfully as possible. Under certain circumstances the record might be altered for the sake of "higher historical truth." Changes of this kind occurred, for example, in seven scenes and portraits related to the Franco-Prussian War that Werner painted for the Saarbrücken city hall. One painting showed the official entry of William I into the

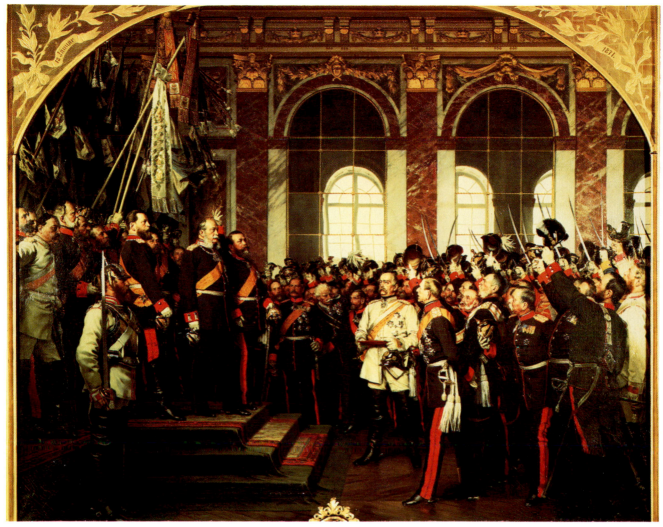

PLATE IV. Anton von Werner: *The Proclamation of the German Empire*. 1885 version.

town as it might—and should—have happened had not the king's schedule been changed. Werner's painting of this non-event nevertheless conveyed, he felt, various historical truths: the king did reach the city eventually, and the inhabitants did express the sentiments of loyalty and patriotism that the painting celebrates. Its verisimilitude was heightened by large infusions of documentary realism: the setting was based on local studies, and numerous portraits of Saarbrücken citizens, done from life, were introduced, including—to the dismay of officials of the state agency overseeing public art commissions—that of an old servant woman who had been decorated for helping German wounded in the battle for the town. Her presence detracted from the dignity of the occasion, the officials felt, who also objected to realistic touches in Werner's preliminary studies for four full-length portraits of Prussian leaders. Prince Frederick Charles, for instance, appears with one hand in the pocket of his uniform, the other holding a cigar. Werner pointed out that the prince, whom he had often sketched, was a heavy smoker; but the pose was condemned as insufficiently monumental, and in the finished painting Werner replaced the cigar with a cane.[24]

When he painted as an eyewitness, Werner's flexibility was reduced. Explaining his approach to painting *The Proclamation of the German Empire*, he said "I had to describe truthfully something I myself had experienced—or to fantasize, which would have been easier but was out of place in a work of historical documentation. Here such difficulties had to be overcome as specific uniforms, the colors of which could not be arbitrarily changed, historical settings of a particular character," and other physical and psychological factors, which Werner invested with great authority.[25] Consequently he tried to capture the reality of the event at Versailles precisely as he himself had seen it— an approach that stretched the potential of art to its very limits (Fig. 88). The dimensions of the canvas, approximately 4.3 × 8 meters, reflect the importance of the subject, but even more the magnitude of the demands it imposed on the artist: to paint a ceremony that whatever its significance and implications was undramatic in itself, and to paint likenesses of many dozens of the hundreds of participants. Werner chose to depict the moment of greatest public participation, the moment when Bismarck had finished reading the statement establishing the empire, and the assembled officers and officials respond to the call of the Grand-Duke of Baden for three cheers for the new emperor. His interpretation places the viewer at the very edge of the long, rectangular *Galerie des Glaces*, somewhat above floor level, a vantage point that did not exist in reality but that permits us to see the principals and much of the large crowd that spreads throughout the hall. No photographer could have captured a similarly comprehensive interior scene.

Much of the picture's background is made up of part of the long rear wall of the *Galerie des Glaces*, its three monumental mirrors reflecting the crowd, the flags, and the windows of the wall opposite, to the rear of the viewer. Well to the left of center it joins the shorter left wall of the gallery, pierced in the center by a portal covered with a red curtain, which leads to the adjoining *Salon de la Guerre*. Portal and wall are largely obscured by the banked flags and battle streamers of the German regiments investing

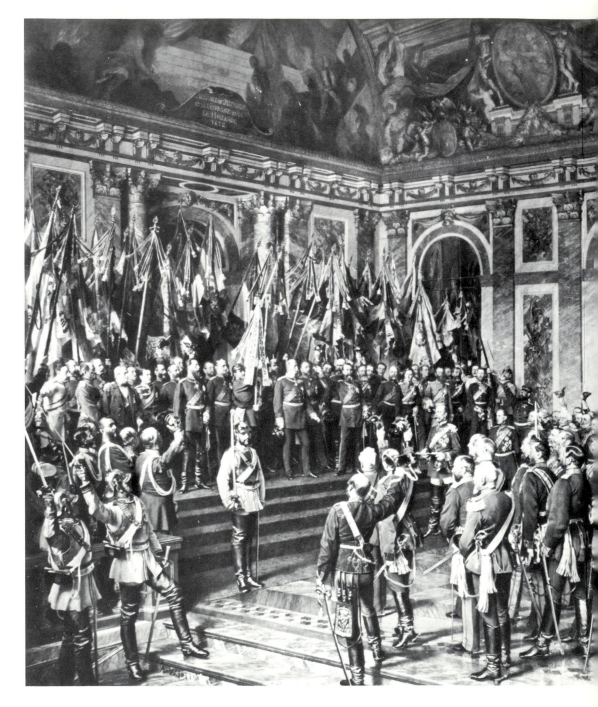

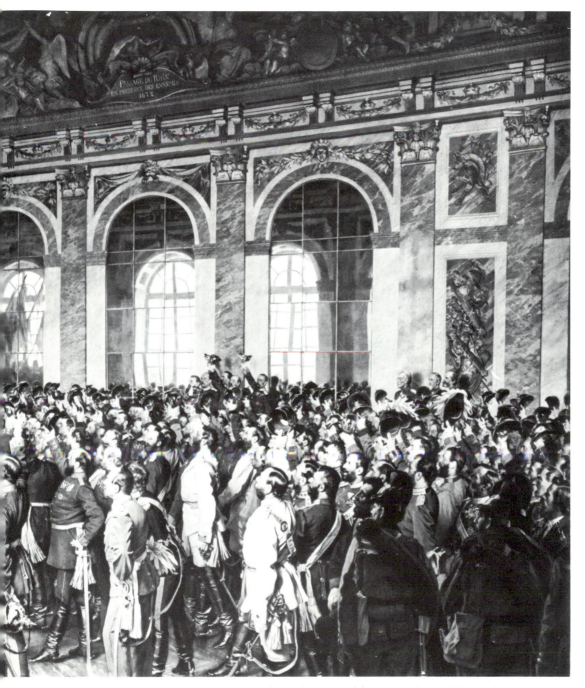

88. Anton von Werner: *The Proclamation of the German Empire*. First version.

Paris. Beneath this busy and brightly colored mass, on a low carpeted platform built for the ceremony, stand the emperor, the Grand-Duke of Baden (his hand still raised), the crown prince, the reigning German princes, and the representatives of the Hanseatic cities. Three steps lead down to the inlaid marble floor of the gallery. At the foot of the steps, two helmeted troopers of the Prussian *Gardes du Corps* with drawn sabers, each marking one end of the platform, stand at attention. Only the head and shoulders of the guard to the rear can be seen above the officers in the foreground; his companion in the left foreground is the most prominent figure in the painting, his immobility contrasting with the ripples of movement that run through the crowd. Between the two troopers, facing half left, stands Bismarck, feet planted apart, his posture one of demonstrative authority, with Moltke a short distance behind him.

The crowd faces Bismarck and the emperor and other dignitaries on the platform in a deep semicircle. Some men raise their helmets or plumed hats as they cheer; others, so Werner recalled, like the "elderly senior officers nearest the platform . . . maintained the dignified, calm attitude appropriate to their age."[26] At the right edge of the painting the artist himself appears, looking over the heads of the crowd; at the opposite extreme two officers of the *Gardes du Corps* wave their sabers. Above the assembled princes and officers arches the ceiling of the gallery decorated with murals glorifying the reign of Louis XIV. Two cartouches with titles of Charles Le Brun's baroque apotheoses of France triumphant over Germany are clearly visible—the one on the right reads "Crossing the Rhine in the Face of the Enemy 1672"—factual segments that strengthen the meaning of the proclamation and complete the symbolism of its pictorial representation.

The impact of the painting depends (or depended—it was destroyed during the Second World War) largely on the viewer's knowledge of and interest in its subject. When the painting was unveiled in 1877, the German public had no difficulty in associating the image with accounts of the proclamation in newspapers and in the first histories of the war, and for some years afterwards could identify not only the principals but also many of the secondary figures in the canvas. Though their fame faded, to the end of the empire the painting was readily understood as depicting a familiar occurrence, which was regarded as the culminating point of one phase of German history and was marking the start of another. But it must have been the title that gave the painting whatever meaning it possessed for most non-Germans. Without an explanatory legend the *Proclamation* became merely another work in that large group of ceremonial paintings produced in every European society, in which loyal subjects render homage to their ruler.

It was also the German public that most cared about the veracity of Werner's account. The likeness of the dozens of portraits and the accuracy of the setting were generally acknowledged, but some commentators were disappointed by an absence of enthusiasm. Werner responded that this deficiency was historically correct: "The externals of the event by no means corresponded to its significance"; the ceremony "proceeded in the most unostentatious manner and with all possible dispatch." After Bismarck had

read the proclamation in an expressionless, "wooden voice," the officers, tightly pressed in the body of the hall, "cheered the emperor by raising their helmets with military precision—that is, if they had enough room to do so." Some then tried to form in column and move past the emperor out of the hall, but this could not be organized on the spur of the moment, and William and his entourage left instead.[27]

Despite the occasion and its splendid surroundings, the ceremony evidently was marked by a certain old-Prussian sobriety, not to say plainness of spirit, which Werner captured, although—much as he hated to stray from observed fact—he did feel compelled to add a few dramatic touches. In particular, the two *Gardes du Corps* officers waving their sabers are scarcely believable. But Werner needed at least some outward signs of feeling, and the composition, too, required a break in the forest of verticals formed by hundreds of standing figures. The diagonals of the two officers' sabers, their raised arms, their trunks, and the bent left leg of the officer in front stop our gaze from gliding out of the lower left corner of the canvas and guide us back and up to the emperor on the platform. But such expedients scarcely do more than accent the painting's invincibly stolid character.

To a British critic writing in the 1880s this was actually the painting's most interesting and appealing feature. In an article on Werner in the *Art Journal*, Alice Meynell pointed to the incredible, almost fictional nature of the fact that the unification of Germany was proclaimed in the palace of Louis XIV. For once it was historical truth that was melodramatic; were it not "for the obstinate fact, one might object to the whole thing, that it was much too complete, rounded, and perfect. . . . But Werner happily is, as has been said, a realist, and has made the necessary apology for this one extravagance of history—this extravagance of truth—by presenting it as modestly as possible in his art. It is really pleasant to find the facts melodramatic and the art so modest. It is a reversal of the old *banal* order of things . . ."[28]

In his subsequent treatments of the theme, the wish for a more engrossing aesthetic solution as well as the demands of higher historical truth led Werner to adopt more imaginative interpretations. Most successful were the two very much reduced versions he painted for the Hall of Honor of the Berlin Armory and for the emperor to give as a present to Bismarck (Plate IV). In these Werner excluded many of the participants and concentrated on the principals, which greatly simplified his task. Many more drawn swords are in evidence; the witnesses closest to the emperor, led by Moltke, have given up their dignified calm and step forward, their faces and postures expressing joy and excitement. The version intended for Bismarck includes the Minister of War, Field Marshal Roon, whom flu had prevented from attending the actual event, but whose presence in the painting as the prime organizer of the victorious Prussian forces seemed desirable. In both versions Bismarck assumes the pose of authority and power familiar to us from the large painting, his legs in thigh-length cuirassier boots planted sturdily apart; but the blue service uniform in the earlier depiction has given way to the white dress coat of the cuirassiers because the artist needed a concentration of bright color in the center of his composition, and around his neck he wears the order *Pour le mérite*,

which he was awarded only subsequently. William I objected that on January 18 Bismarck had worn blue, but when Werner replied that according to regulations he should have worn the white gala uniform but had not taken it with him to France, the emperor agreed: "You are right, he was incorrectly dressed, and it is quite in order for you to have corrected this mistake."[29]

As works of art all versions of the *Proclamation* are insignificant, the first and largest being the least compelling. Werner's solution of the problem of presenting a large enclosed space crowded with people is respectable, especially the way in which he paints the unseen front wall as a reflection in the great mirrors at the rear of the painting—a phenomenon that he had, of course, observed on the spot. But the composition and the color of the largest version—to the extent that color can be judged from reproductions—are mediocre; the architectural details, shown with tedious precision, do not sufficiently link the cheering Prussians with the apotheosis of Louis XIV above them; allowing the trooper standing to attention in the foreground to be the most prominent figure in the painting—a position he also occupies in the later versions—must be counted an inexplicable surrender of the artistic imagination to reality; and even those figures that Werner conceives with some sense of their personality are painted in a plain, prosaic manner. However much or little enthusiasm people expressed on 18 January, Werner's painting is devoid of creative energy.

As a visual document the painting has greater validity. The scene after Bismarck finished reading must have been much as Werner painted it. In the words of an early critic, who wrote approvingly of another of Werner's works *William I Lying in State*, the artist "took a picture" of the scene—"machte . . . eine Aufnahme," using an idiom appropriate for a photograph—the work becoming one in a sequence that forms a "truly monumental historical chronicle" of Prussia in the 1870s and 1880s.[30] If not a work of art, the painting very likely is a reliable document. How deep its interpretation of the event goes is less certain. Is Werner's failure to convey enthusiasm simply a function of his limited ability to rise above what he sees, or does it suggest that the people he painted were of two minds about the proclamation? We know that many of the non-Prussian witnesses in the *Galerie des Glaces* regarded Prussian assumption of central control a regrettable price to pay for unification, and that William I resented the legal objections raised by the Bavarian king and others, which caused Bismarck to agree to the title "German Emperor" rather than the more assertive "Emperor of Germany." But the large Prussian contingent undoubtedly saw the ceremony as a satisfactory conclusion to an inevitable and wished-for political and military reality, and the painting carries no hidden message of disapproval or of unease about the future. Nor is the work particularly charged with nationalistic or chauvinistic feeling. A vindictive interpreter could have made much more of the humiliating aspect of the choice of Versailles for the announcement of German unification. In its celebration of national superiority, Werner's *Proclamation* does not compare with some French paintings that hung in 1871 in another part of the Versailles palace: François Gérard's *Napoleon at the Battle of Austerlitz* or Horace Vernet's *Napoleon at the Battle of Friedland*, with prisoners, captured

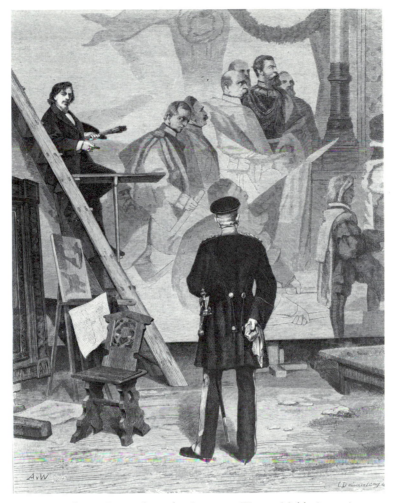

89. Carl Ernst Daumerlang after Anton von Werner: Moltke inspecting
the *Proclamation* in Werner's Studio.

enemy flags, and the emperor glorified as the representative of the invincible French nation.[31]

There is nevertheless one accurate element of the painting that does give one pause, and that enlarges its documentary record into a symbol holding implications for the future. It is frequently—but mistakenly—asserted that Werner's self-portrait at the edge of the canvas constitutes the only civilian in the painting. The representatives of Hamburg, Bremen, and Lübeck on the platform, several ambassadors of foreign powers, Bismarck and other ministers and court officials in the crowd were civilians. Although he held the courtesy rank of major-general, the Chancellor thought of himself, and was considered by the army, as a civilian. On the very day the empire was proclaimed, Bis-

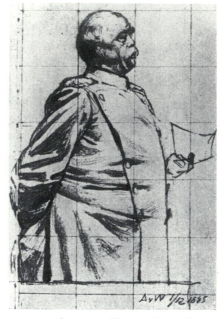

90. Anton von Werner: *Bismarck
in the Reichstag.*

marck sent William I a memorandum objecting to the Chief of the General Staff's control over negotiations with the provisional French government. The relations between the political and military leadership reached a crisis, which the emperor resolved by giving Bismarck ultimate authority in the sovereign's name over German military as well as foreign policy. And yet the military character of the ceremony was more than a surface matter of uniforms. Most of the men present that day in the *Galerie des Glaces* were soldiers, nor was it without significance that the princes and Bismarck appeared in uniform. Had it been thought necessary or desirable, more civilians, at least representatives of German political institutions, could easily have been invited. Instead, unification and the empire were announced in enemy country, with the ceremonial trappings of war. The new state was born on the battlefield, a fact and an image that were to remain powerful in the history of the empire to the day of its dissolution.

III. FONTANE'S APOTHEOSIS OF THE OLD PRUSSIA

IT IS UNUSUAL for a novelist to write his first novel in middle age, in the following ten years to publish eight others, several of which meet the highest standards of the time, and at the end of the decade, now nearly seventy and recognized by his contemporaries as a major writer, to enter his most creative period. People predisposed to writing fiction

tend to be so strongly engaged with the concerns, attitudes, and ideas of their age that their lives rarely include long preparatory periods filled with other kinds of writing or even with silence before they at last express themselves in literary inventions. When it does happen, the results are scarcely ever of lasting consequence. Fontane had begun preliminary studies for a long work of fiction in 1863; but fifteen years of trial and error, during which he wrote his many volumes of local and contemporary history and was busy as a journalist and critic, were needed to complete the manuscript.[32] *Vor dem Sturm* was published in October 1878, two months before the author's fifty-ninth birthday. Among Fontane's models were Scott and Alexis, and in some respects the book bears a close resemblance to the Victorian multi-volume historical novel, with melodramatic incidents, a large cast of secondary figures, and lengthy descriptive interludes and accounts of the characters' background. Conciseness was never the aim of this genre, but Fontane's plot meanders almost too loosely, and the book suffers from other weaknesses. Nevertheless, the care with which he develops the historical and social environment for his narrative and some remarkable conversational episodes—suggestive of a more intellectual North German Trollope without Trollope's occasional prudishness and sentimentality—indicate a powerful talent and point to the future.

The title of the novel—*Before the Storm*—refers to the year 1812, when Prussia was Napoleon's unwilling ally and was used by the emperor as a staging area for his invasion of Russia. French forces garrison the principal towns and intermittently control the highways; but reports of the retreat from Moscow encourage patriots to attack the French garrison of Frankfurt an der Oder without authorization from the Prussian government. They fail; one of the most sympathetic of the secondary characters, a bourgeois law student, is captured by the French and executed, his courageous death demonstrating to the retired noble officers who led the attack that their traditional sense of superiority over the non-noble is no longer justified; and the uprising, though defeated, adds to the turmoil in the country and signals the approaching storm of the Wars of Liberation.

The attack on Frankfurt is a creation of the author's imagination; but Schill, the subject of one of Fontane's *Prussian Songs*, had attempted something like it in 1809, and some officers and landowners certainly considered partisan warfare toward the end of 1812. Fontane inserts his invention into a knowledgeable, sophisticated historical reconstruction of the Mark Brandenburg at the time. Personal relationships and love stories are interwoven with the theme of fighting for liberty, and similarly past and present are intertwined. Turning points in the plot and in the psychological development of some of his characters clearly reveal the author's liberal convictions. Not in programmatic statements but by implication the novel rejects distinctions of social standing and power between the military and landowning nobility and the educated bourgeoisie, and dismisses the claim of authoritarian-monarchical patriotism of the 1870s—which seeks its roots in the earlier history of the Prussian state—to be the only valid, acceptable political position in the new empire. It is true that popular insurrection fails in the novel, and that Prussia will regain freedom from the French by conventional

diplomatic and military measures. But the people's right to take an active part in the affairs of the country is never questioned. Once again Fontane uses historical art to comment on and criticize current conditions in Prussia and Germany.

For Fontane, the writing of *Vor dem Sturm* was a decisive, liberating act. A few days before the book appeared he described it as the "task and content of my life"— words that must have referred less to the novel's theme than to the very act of writing fiction.[33] It was what he wanted to do, and the book, which was moderately well received by reviewers, served as proof to himself and others that his belief in himself as an artist was not misplaced. Throughout his years as a journalist and historian he had never ceased to write verse, and he continued to do so for the rest of his life. Nor did he turn away from journalism when he launched out on the long, intense cycle of novel-writing. But the emphasis changed. Journalism and history lost their former significance; poetry and fiction now dominated. Like a bridge thrown over decades of other work, the novels of his middle and late years link up with the lyrics and ballads that first marked the young man as an artist.

One reason for this late development was economic. To support himself and his family he needed to write incessantly, and even after fiction became his principal concern, journalism continued to serve as a financial crutch. "Put yourself in my position!" he wrote a friend while working on his second novel. "More than three weeks ago I wanted to begin revising the novel, but the entire time I had to write reviews. Today I finally began the revisions, and *must* stay with them."[34] At one point he thought he had found a way out, but the attempted escape from journalism failed, and demonstrated conclusively that Fontane was not made for the discipline and politics of the state bureaucracy.

Early in 1876 the post of first permanent secretary of the Royal Academy of Arts fell vacant, and Fontane, encouraged by influential friends, applied for the appointment, provided he could retain a "safe fallback position" and continue as drama critic of the *Vossische Zeitung* for the time being. The President of the Academy was the architect Friedrich Hitzig, the late Franz Kugler's brother-in-law, well known to Fontane as a member of the Tunnel. His support and the recommendation of senior officials of the Kultusministerium persuaded a somewhat doubtful emperor to sign the appointment in March. Fontane hoped by stepping into "an undemanding, honorific, and well-paid official position to be able to live more comfortably and with less concern for the future."[35] In reality his administrative duties were fairly heavy. Far worse, Hitzig was a domineering individual, at that time engaged in a tenacious conflict over funds and power with Anton von Werner, Director of the Academic Institute for the Fine Arts and an *ex officio* member of the Academy's senate. Fontane was at once drawn into their quarrel. Hitzig suspected him of supporting Werner, and in the presence of the senate accused him of having used ambiguous expressions in the minutes of the previous senate meeting. An experienced bureaucrat could have turned aside this very apparent attempt at intimidation; but Fontane took it as a personal insult, rejected Hitzig's accusation on the spot, and at the end of May asked the emperor to accept his resignation.[36]

The position of permanent secretary of the Royal Academy placed the occupant near the center of the state's cultural policies and administration, not in a leading role certainly, but with influence and assured of an honorable place in the upper-middle-class world of the capital. Fontane's successor, another Tunnel member, asked for the rank of privy councillor as a condition of his appointment, and other marks of distinction could be expected in the natural course of events. Fontane, however, "did not care to dance to every privy councillor's tune." Politicking repelled him even more than devoting hours to the routine business of the Academy. "People find happiness in different things," he wrote an old friend in explaining his departure. " 'One man's owl is another's nightingale.' For me, freedom is the nightingale; for other people, a regular salary."[37] He acknowledged a measure of arrogance in his attitude; but his experience as an official of the Academy, which humiliated him and caused a temporary rift with his wife, who found his renunciation of security and status hard to forgive, also deepened his criticism of the bureaucratic machinery of the Prussian state. It is important to be clear about the nature of this criticism. Fontane did not so much object to the cultural policies of the state as to what he had seen of the ways in which the Academy and other cultural agencies fed the self-importance and careerism, "the running after empty honors," of the men who were part of these institutions. Very little would have been different under a more liberal system. In Fontane's view the monarchical authoritarianism that characterized the Prussian government merely added a further turn to the convoluted pretensions and injustices of an aristocratic-bourgeois society that like all societies was marbled with selfishness and corruption.

As a novelist Fontane at first had difficulty integrating his criticisms of society with other concerns: psychological interpretation, the construction of firmly realistic plots that nevertheless carry a heavy load of symbolism, and the analysis of some of the many ways in which society actually functions—a task of observation and understanding of which social criticism is merely one component. In two short novels that he wrote immediately after completing *Vor dem Sturm*, social issues are scarcely raised. They are conventional works of fiction, set in the seventeenth and eighteenth centuries, but their plots and characterizations are not truly affected by the past. They are extended prose ballads—indeed, the theme of a nobleman's seduction of the heroine's mother in Fontane's ballad "Jung-Emmy," which caused such offense to the Tunnel thirty-five years earlier, reappears in one of the novels, *Ellernklipp*—and with some justice they have been dismissed as finger exercises.[38] In a third novel, *L'Adultera*, printed seriatim in a periodical in 1880 and as a book two years later, Fontane begins the analysis of contemporary Berlin society that he was to pursue through many subsequent works. His account of the young wife of a middle-aged Jewish financier, who falls in love with a young business associate, leaves her husband and child, and with her lover starts a new and happier life, addresses the values and attitudes of middle- and upper-middle-class circles of general-staff officers, commercial councillors, and senior police officials. But the author's paramount interest lies in the psychology of the two leading characters: the young woman who places her instinctual recognition of what is right for her above

social convention, and her husband who fights to keep her but also understands the reasons he cannot. It is not until the fourth novel after *Vor dem Sturm*, also published in 1882, that Fontane for the first time achieves a satisfactory integration of the dramatic and psychological elements of his art with social observation and comment, and combines these with a historical novel—not only of an earlier society but also of the political system that dominated and shaped it: the Prussian monarchy two decades after Frederick the Great's death. Fontane's historical perspective, furthermore, is defined by his view of what is and what is not politically healthy, and his novel of Prussia in the reign of Frederick William III is at the same time a critique of aspects of its successor-state, the Prusso-German empire of the 1880s.

The title of the novel, *Schach von Wuthenow*, is taken from the family name of the principal character, an invention of Fontane, reminiscent of the compound last names of some old noble families in the Mark Brandenburg. Its subtitle—"A Tale from the Days of the *Gensdarmes* Regiment"—indicates the historical nature of the work, and alerts us to the author's critical stance toward his subject. The regiment is the one in which Marwitz served, its officer corps having perfected that degree of social refinement which, according to Fontane's bitter joke, it was beyond Goethe's capacity to attain. The novel describes the self-destruction of its hero, and foretells the collapse of the state that he served. In contrast to *Vor dem Sturm* it is a short, very firmly constructed book—less than 120 pages in a standard modern edition—a miniature on ivory measured against such an enormous canvas as *War and Peace* or *The Charterhouse of Parma*, but comparable to these works in the insight with which it treats individuals and conditions of a former age. Any historian who has done archival research on Prussia in the Napoleonic era will recognize in Fontane's text a familiarity with the sources, which many years of reflection have turned into genuine understanding.[39]

The novel does not, of course, offer a narrative and interpretation of political events. To the extent that *Schach von Wuthenow* may be called history at all, it is cultural history. But in that field it is superior to the writings of many professional historians of the second half of the nineteenth century. Perhaps only Johann Gustav Droysen and Max Lehmann in their biographies of two figures of the Reform Era, Yorck and Scharnhorst, created a similarly accurate and sensitive portrait of Prussia on the eve of collapse. A comparison of the novel with the sections on Prussia before 1806 in Treitschke's *History of Germany in the Nineteenth Century* suggests the measure of Fontane's achievement, for here it is the novelist who seeks to understand his characters and their environment, while the scholar operates with a flurry of ideological rhetoric, patriotic exhortation, and bombast. That the novel's historical element is not a learned superstructure added to an already existing sequence of interactions between individuals is an essential condition of its success as a work of fiction. Fontane links his characters with general conditions, but not in a deterministically causal relationship. Tendencies of the times influence behavior, individual attitudes may reflect and illuminate general social characteristics; but personal strengths and weaknesses always remain de-

cisive. In the long train of German historical fiction, beginning with the Romantic story-tellers and the followers of Scott in the 1820s, acquiring greater historical sophistication in the hands of such authors as Alexis and Scheffel, and flattening out in the professorial constructs of the last decades of the century, Fontane's *Schach von Wuthenow* stands as the supreme achievement.

The novel takes place in the spring and summer of 1806; two brief concluding chapters consist of letters written subsequently, which further illuminate and interpret the action. Schach von Wuthenow, a captain in the elite *Gensdarmes* cavalry regiment stationed in Berlin, is friendly with two ladies of Berlin society, a widow in her late thirties, Josephine von Carayon, and her daughter Victoire. Schach is a man of probity, who holds himself and others to high standards; but although not unintelligent and often showing common sense he cannot rise above the conventional views of his peers, and is strongly influenced by externals—rank, appearance, manners. "He is morbidly dependent," a fellow officer observes, "dependent to the point of feebleness, on other men's judgment . . ." Another officer adds that nevertheless "everything about him is genuine, even his stiff elegance and sense of distinction, boring and insulting though I find them." A third, who is less well disposed to Schach, acknowledges his merits but finds him self-important, pedantic, the very embodiment of a specifically Prussian military arrogance.[40] This critic, a retired officer, Heinrich Dietrich von Bülow, is based on a historical personality. The real Bülow, member of a prominent Prussian family, re-signed from the army at the beginning of the French Revolution, traveled twice to the United States, a country on which he published a book in 1797, and two years later wrote a book on modern war, which immediately placed him in the front rank of German military analysts. Other books on war followed, which tried to explain the reasons for Napoleon's success, criticized Prussia's military institutions for favoring form over substance, and advocated an alliance of Prussia and France. For a time Bülow lived in London and in Paris and Versailles. A history of the War of 1805, which condemned Russian generalship, led to his arrest after the Russian authorities had complained to the Prussian government. During the fall campaign of 1806 he was taken to a Prussian fortress on the Baltic. There he seems to have fallen into Russian hands and, possibly as a result of the treatment he received, died in Riga the following year.[41]

In the novel Bülow and his publisher are also part of the Carayon circle, and much of the first third of the book is taken up with arguments between Bülow and Schach, whose self-assurance and blind confidence in the Prussian army and government are of course no match for the other's criticisms. At the same time, the relationship of Schach and the two ladies is developed. Schach is mildly attracted to both the mother and her daughter, a beautiful girl who at the age of fifteen was disfigured by smallpox. But basically Schach is incapable of sustained, strong affection for anyone, other, perhaps, than his very beautiful mother, recently deceased. A statement in the opening chapter— "One can't very well give or make a present of something one doesn't possess"—dis-creetly introduces this major theme of the novel, although here it refers to diplomatic

negotiations. As the novel progresses, the parallel lines of analysis of Schach's personality and the character of the post-Frederician state come to similar conclusions: both are hollow.

For Schach, the scars on the daughter's face disqualify her as a wife. But Prince Louis Ferdinand—another historical figure, soon to be killed in the opening engagement of the disastrous war with France—makes light of "a few dimples" and refers to Victoire de Carayon's "beauté du diable," calling her a woman "who has passed through purgatory" and who possesses the essential qualities of energy, fire, and passion. Against his will Schach is impressed, and one evening when he and Victoire are alone in the Carayons' apartment he reveals an unexpected depth of feeling. She responds, and both succumb to the atmosphere of the moment—an episode of great emotional force, which Fontane conveys with extreme delicacy. What has passed is indicated only by a break in the text. Victoire then brushes her hair from her forehead and in two brief remarks to her Schach uses the familiar form of address. But his affection is only temporary.

Some days later the two women witness a demonstration by the younger officers of Schach's regiment, protesting or ridiculing a romantic drama currently playing at the Royal Theater, in which the character of Luther appears on stage. This noisy spectacle—a sleighride in July through the streets of Berlin, with officers costumed as Luther and as Catholic nuns leaving the nunnery for a house of prostitution—did in fact occur, and caused minor sensation in Berlin society. In the novel it is the occasion for Victoire to confess her transgression to her mother. Josephine von Carayon demands that Schach marry her daughter. He agrees, but fear of the ridicule and humiliation to which a man with his standards would be subjected were he to marry a disfigured woman makes it impossible for him to acknowledge the engagement. The mother finally appeals to the king, who orders Schach to marry Victoire. Schach obeys, but, Fontane comments, in his heart he was opposed "and so he needed to find a way out that would combine obedience and disobedience, that would conform equally to the king's command and to the command of his own personality . . ."[42] He marries Victoire, and after the wedding rides in his carriage to his rooms to prepare for the wedding trip. On the way he shoots himself. Fontane treats this second physical climax of the novel with almost the same reserve with which he described the first. On the coach box sit Schach's orderly, Baarsch, and his little English groom, who scarcely speaks German. "As the carriage turned from the Behrenstrasse into the Wilhelmstrasse, it was jolted or knocked, although no shock from below could be felt.

" 'Damn,' said the groom. 'What's that?'

" 'What should it be, boy? Its a stone, a "dead soldier." '

" 'Oh no, Baarsch. No stone. 'Twas something . . . dear me . . . like shooting.'

" 'Schuting? Well . . .'

" 'Yes, pistol shooting . . .'

"But the sentence wasn't finished, for the carriage stopped before Schach's house, and the groom anxiously jumped to the ground to help his master from the carriage. He

opened the door, thick smoke poured out, and Schach sat upright in the corner, leaning back only a little. On the rug by his feet lay the pistol. Terrified, the groom threw the door shut and wailed: 'Heavens, he is dead.' "[43]

Fontane relates and describes these events as though he were a member of the Carayons' circle. He gives the facts, suggests explanations, but makes few judgments and does not condemn. Schach—doubly flawed as a man and as a symbol of a doomed society—is nevertheless treated with sympathy and pitied for his inability to rise above himself. The analyses of motives and behavior are concise—sensitive to the psychological dynamic of the characters, but often no longer than a sentence inserted in the narrative. Political issues, on the other hand, are the subject of some of the novel's longest passages. In the conversations that reveal the crisis of the Prussian state, Fontane sought accuracy of content and tone by paraphrasing passages from Bülow's writings, or even employing them almost word for word. At the same time, Bülow, the historical source, gives voice to Fontane's ideas about not only the old but also the new Prussia. In the opening chapter, Fontane has Bülow refer to Mirabeau (and the pockmarked Mirabeau possesses special meaning for Victoire): "Our Prussian system is pitiful, and Mirabeau was right to compare the extolled state of Frederick the Great to a fruit that was already decayed before it had become ripe." Later he tells Schach that Prussia's historical achievements are limited to military show and efficiency—Frederick William I's giant guards and the iron ramroad—and to a moral code that consists of taking care of oneself, legally or not. "I admit I believe Prussia's days are numbered."[44]

What, according to Bülow-Fontane, were Prussia's failings in 1806 that would lead to the state's destruction? There were two: Prussia had preserved the outside forms of the military monarchy that had been developed in the course of the preceding century, but without Frederick the Great's energy and imagination; and the state pretended that the French Revolution had not transformed the political, social, and military world. The highly disciplined, functionally divided society of the Frederician monarchy, its army honed by a single-minded autocrat, had forced its way into the community of major powers. Now the traditional institutions, their old methods, and the hierarchical society on which they rested, had been overtaken by new forces, and the failure to adjust was corrupting both the elites and the larger society they ruled. This was a defensible historical interpretation, although many Prussian conservatives of the 1880s would have rejected it as extreme. But Bülow is made to condemn not only the old elites but also new forces in Prussian society, in words that scarcely apply to 1806 but represent Fontane's judgment of society in the new empire. To the composer Johann Ladislaus Dussek, in the novel as in reality a member of Prince Louis' entourage, Bülow says: "You talk of prejudices in which we are caught, and are stuck in them yourself—you and your entire bourgeoisie, which refuses to create a new free society, but vain and jealous as it is simply wants to enter the ranks of the old privileged classes. But that won't work. The petty jealousies that now consume the heart of our third estate must be replaced by indifference toward all this childishness, which is simply outdated."[45]

The characterization of the "third estate" as subservient to tradition, accepting of

royal authority and hierarchic values if only it too was given leave to climb the ladder, belongs to Fontane's larger censure of German society under the new empire. Bülow's words echo Fontane's displeasure when after years of relative independence as a journalist and freelance historian his appointment to the Royal Academy threw him into the arena of bourgeois careerism. They also form a counterpart to his denunciation—expressed in the epilogue to the *Wanderings* in the same months when he was writing *Schach von Wuthenow*—of the nobility, whose "pseudo-conservatism . . . in the final analysis cares only for itself." Bourgeoisie and nobility, we might summarize Fontane's views, were both inadequate. The old elites perpetuated a system they could justify as generally valid only by pretense and sham historical arguments; too many members of the middle classes lacked the moral and political courage to insist on change. Instead they sought salvation in assimilation. Even very different political systems—notably that of the United Kingdom—with more equitable divisions of responsibility and power, and with reasonable prospects for future change, faltered under the burden of rapid population growth and the often inhuman stresses of industrialization and urbanization; but the German empire, which succeeded in preserving power to small minorities, aggravated most problems by dividing society into antagonistic groups, which the state treated differently. The hypocrisy and one-sidedness that were part of the process infected society, and in time the façade of national and imperial unity could no longer mask the fragmentation of a people that was prevented by its rulers from fully entering the modern world.

The relationship between members of different social groups posed problems to all nineteenth-century societies. But in Prussia the interacting political and social forces were especially rigid, the possibilities of evading the norm within society sharply limited. Categories of privilege that the French Revolution had made obsolete were still not dismissed as outdated in the German empire. On the contrary, a political and social mythology was generated according to which the values of Frederician absolutism survived into the present, provided the basis for Germany's ascendancy, and justified the continuation of privilege and deference today. Fontane found this misuse of history distasteful and politically dangerous. What had once been an absolute, if enlightened, monarchy, he thought, could now very well become a liberal, forward-looking empire. In a characteristic passage in a letter to his daughter, he wrote that the efforts in the eighteenth century to build the state were admirable, but that attitudes that had once been necessary for its growth could no longer apply. Now "a lieutenant should merely be a lieutenant, and though he serves in the Zieten Hussars or even wears a large death's head insignia on his fur cap, he must not want to be a demigod or anything out of the ordinary . . . Titles, . . . decorations, and other attributes of self-importance are simply nonsense, pertain to the past, and have nothing to do with liberty and culture." Fourteen years later, when he was seventy-four, he made the same point with greater vehemence. "I have nothing against the past, if we leave it in its time and judge it in its context. The so-called 'old-Prussian' official, the periwigged scholar of the last century,

91. Borussia, the symbol of Prussia, rears back in horror before bolts of lightning, which trace the date of Prussia's collapse, 1806. Menzel's illustration to Frederick the Great's *Letter on Education*, in which he singles out the king's concern that bad education of the young may lead to the destruction of the state.

Frederick William I, the cuirassier officer whose weight enabled him to squeeze into his wetted-down, skin-tight leather breeches over the course of several hours, the Superior Chamber of Accounts in Potsdam, the Junker believing in his divine right, the orthodox Christian who stands and falls with the Lutheran credo—all these persons and institutions I find splendid in novels and in 'pictures of the times.' I also admit that all did good work, and some even achieved great things. But it is a terrible imposition to have to admire these specters as still setting the tone today, when their decrepitude has been demonstrated for exactly a century now [i.e. since the French Revolution] and becomes more apparent with every year." The same letter describes the Prussian nobility as a group as "unpleasant egotists, with a narrow-mindedness that is incomprehensible to me, whose rottenness is exceeded only by fawning clergymen . . . who want to persuade us that this mix of folly and brutal selfishness represents 'God's Will.' All should be boiled in oil. All are antiquated!"[46]

It is not surprising, consequently, that Fontane's novels never offer Frederician Prussia as a model for the present. None even takes place in the Frederician age. *Vor dem Sturm* and *Schach von Wuthenow* are set in the decades after the king's death, and a major theme of both works is the effort or inability of Prussian society to come to

terms with new conditions to which the institutions, methods, and attitudes of absolutism were no longer suited. Fontane's novels set in contemporary Germany have a related theme—the tension between tradition and the present. That does not, of course, prevent some of their characters as well as the author from finding qualities in the Frederician age that later generations had lost or were in danger of losing: simplicity, hard work, a sense of duty and honor.

In his poetry Fontane's treatment of the Frederician age is somewhat different. Before 1848 and during the Revolution his verse had drawn on Prussian history for criticism and inspiration of the present. Afterwards the poet rarely returned to Frederician themes, but when he did his interest was fully engaged. During his second stay in London in the 1850s he composed five stanzas on a Prussian regimental flag of the Seven Years War, which, exiled like the poet, was kept in a Russian museum. Many years later he wrote four poems with the collective title *Frederician Grenadiers*, the theme of which is the king's relationship with the rank and file of these elite units. The shortest and best of the four repeats a well-known anecdote. At the Battle of Torgau even the grenadiers

92. Adolph Menzel: *Sanssouci.*

would no longer advance. "Like a maniac the king rushed up, raised his cane, and trembling with anger, shouted: 'Rascals, do you want to live forever? Swindlers. . . .' " The grenadiers answered: " 'Don't talk about swindle, Fritz. For fifteen pennies a day we have done enough.' "[47] If the old monarchy was no longer exemplary, its spiritual heirs were disappointing in other ways. In a poem written about his seventy-fifth birthday, Fontane characterizes himself as the historian and poet of the Mark Brandenburg, who celebrated Frederick the Great's Prussia: "You are Old Fritz's man / And the man of those who dine with him, / Some chatting, others silent, / First in Sanssouci, later in Elysium." But, the poet continues, to his amused surprise the well-wishers at his birthday included not the members of the old Prussian families—that the emperor or the government had not sent congratulations goes without saying—but "very, very different names," members of a "nearly prehistoric nobility"—his many Jewish readers.[48]

Fontane had long ago lost favor with the descendants of the men who had fought Frederick's battles and with the political system in which their class continued to play a dominant role. But the rejection of his work by the traditional elites and the manipulation of Prussian history to support Wilhelmine imperialism did nothing to reverse his earlier affectionate interest in Frederician Prussia. His admiration finds its fullest expression in a poem he wrote to mark Menzel's seventieth birthday in December 1885, which once more evokes the years when Menzel illustrated the *History of Frederick the Great* and Fontane wrote the *Prussian Songs*. In the poem the author one evening walks through the park of Sanssouci up the long flight of steps leading to the palace, when the spirit of Frederick the Great stops him and asks who this Menzel is whose birthday everyone is celebrating. Fontane answers by listing the many subjects Menzel has sketched and painted, concluding with his favorite—Frederick's world—and describes one of Menzel's historical paintings, *The Round Table at Sanssouci*. None of this is news to the king, who merely wanted to test Fontane and now asks whether there is a birthday present Menzel might enjoy. Fontane replies that the painter has everything he wants—"reputation, honor, title, decorations," and above all his art—whereupon the king sends Menzel an invitation through Fontane to join him in Sanssouci in Heaven, where he will find the king and his guests as he had painted them, except for Voltaire, whose seat at the round table, vacated since the Franco-Prussian War, is now reserved for the artist. Menzel may choose his own time—the king will gladly wait another ten years.[49]

"On the Steps of Sanssouci," probably the best among Fontane's occasional poems, was published to great acclaim in the *Vossische Zeitung*, although at first Menzel was offended to read that he should not expect to remain in this world beyond another ten years. In fact, he was to live for nearly twice as long, until he was almost ninety. What distinguishes the poem, besides its wit, elegance, and sure sense of place and atmosphere, is its seamless joining of past and present. Once more Frederician Prussia lived in Wilhelmine Germany; but it was an existence in the minds and work of two artists, not in the political and social reality of the empire.

If we retrace the major stages of the path by which Menzel and Fontane had reached this juncture, we find that Frederician Prussia had shaped their family background and that a residue composed of parental reminiscences, pictures, and books still formed part of their childhood. As a political force Frederick no longer touched them directly, but his personality and his times provided material to their creative imagination, and gave a strong impetus to their historicist manner of interpreting the past. That just the eighteenth century should inspire them had any number of psychological, social, even political causes—one being the contemporary implications of two characteristics that could be imputed to Frederick's reign: its political energy, and some enlightened ideas to which was joined a certain irreverence toward such traditional concepts as the divine right of kings. The passivity of Prussia in the years between the French Revolution and the early years of the Napoleonic empire, and the authoritarian somnolence that marked the 1830s, were periods of decline by comparison, and Menzel and Fontane, we know, were not the only ones to elevate the vigor and spirit of Frederician rule into symbols of hoped-for change. In time Germany did regain her political energies, but without those enlightened elements of the past that once had seemed to promise a liberalized social and political order. For the two artists in the 1880s, the Frederician past had become just that: a bundle of historical themes that might still be of occasional interest, but whose earlier political promise had faded.

We have no evidence that in the second half of his life Menzel bothered himself over the political uses of the past or over politics in any guise. Presumably he shrugged his shoulders when he witnessed the emperor or agencies of the state playing with history—William II putting a company of the first regiment of footguards into the uniforms and pointed tin hats of Frederician grenadiers, or holding a court ball at which he and his guests appeared in Frederician uniform, an event Menzel attended in ordinary evening dress. As he grew old he insisted on his independence with increasing brusqueness even toward men in the highest positions, and became what in essence he had always been: nothing but an artist. His surroundings provided apolitical, purely aesthetic grist to his mill. He neither documented the German empire on official occasions, as Anton von Werner had chosen to do, nor studied its political and social forces in Fontane's critical, analytic manner. The political feelings that influenced some of his early work, the *History of Frederick the Great* in particular, no longer played a role. He painted William I's departure for the war, a ball at court, or workers in a rolling mill with the same welcoming interest in the appearance of the real world and with the same indifference to its social and political content that he expressed in other paintings of his late period: visitors at an international exhibition, the corner of a house being built, a Berlin street at dawn with people returning from a party.

Fontane, by contrast, retained the political interests of his youth or, more correctly, fully regained them in middle and old age. Comments on society and politics shoot like flares from the pages of his correspondence, illuminating both the novel or poem on which he was working and his sense of himself, of his environment, and of the direction Germany was taking. Party politics interested him far less than did personalities and

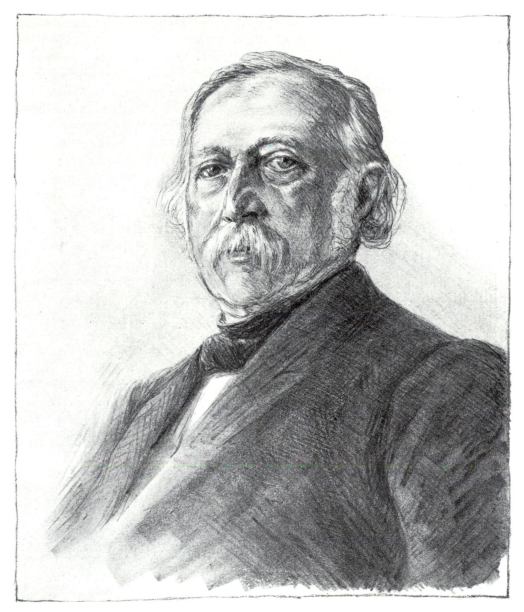

93. Max Liebermann: *Theodor Fontane*, 1896.

general developments—in any case he had long ago lost faith in the political capacity of the writers, editors, and senior government officials who made up his own circle. He admired Bismarck for having achieved the country's unification, but found his egotism and political dishonesty deeply offensive. In the conflict between the Chancellor and

193

William II he took the emperor's side, even though he recognized his autocratic tendencies.[50] Increasingly he feared that the political system that had emerged from the constitutional conflict and from unification repressed people, and corrupted many of them. "Free human beings with natural, unbiased feelings no longer exist," he wrote during the recriminations that followed Emperor Frederick's brief reign and William II's accession. "Everyone is caught—some without being aware of it (and that is the worst)—in the ideology and officiousness of the state."[51] Society, adjusting to the firmly hierarchical values of its rulers, victimized the independent-minded. In the most nearly perfect novel of his middle period as a writer of fiction—*Irrungen, Wirrungen*, which first appeared seriatim in the *Vossische Zeitung* in the summer of 1887—Fontane treats the love affair of an officer and a working-class girl as an episode in human relations in which the full force of society presses people to act in ways that do violence to their own feelings. The officer, a decent and cultured man, recognizes the girl's superior qualities; but he lacks the courage to pay the social costs that marrying her would entail—resigning his commission, giving up his place in society, leaving the country—and marries a woman of his own class. Some readers denounced the novel as pornographic; equally shocking was the spectacle of an author who more than any other had made the Prussian nobility his preferred subject presenting an officer as psychologically weak, and a seamstress as more serious and admirable than an aristocratic heiress. But this distribution of values merely stood for a general conviction the author had reached years earlier.

In December 1889, the young political and cultural commentator Maximilian Harden, in an article that was one of the earliest serious appreciations of Fontane's position in German literature, referred to him as a Frederician grenadier—*Alter Fritz Grenadier.*[52] The characterization, which delighted Fontane, catches some aspects of his old age: a veteran, disciplined, still dangerous, combative as ever, whose calling makes him both a part of ordinary society and an outcast. The battles he fights are not rearguard actions of an antiquated system, but represent new forces in society and literature. Not only his fiction and poetry but also his interest in the new and his strong commitment to temporary, innovative writers make the old man an unusual figure in the literary world. The attribution to the Frederician age also recognizes Fontane's ties to the past, which remains a source of his unique strength but is out of reach to younger generations. In 1895 he began a long manuscript, a psychological and political novel, *Der Stechlin*, which details the last years of a nobleman of the Mark Brandenburg, a man of character and sensitivity, who recognizes that the patriarchal world, the world of deference and duty in which he was brought up, is passing. Fontane completed the final revisions of what is perhaps his greatest work in his eightieth year, during the summer of 1898. In the following weeks he returned to two other manuscripts, one of them a historical novel on which he had worked intermittently since the early 1880s.[53] Its working title, "Die Likedeeler," refers to a group of freebooters who in the last years of the fourteenth century established a community in East Frisia, under rigid central authority but with social and economic equality—hence their name, "equal-dealers."

The Likedeeler constituted an anarchic force that cut across the network of order and controls imposed in the North Sea and the Baltic by the Hanseatic League. Eventually they were destroyed by naval expeditions launched from Hamburg. The medieval maritime world of the subject and, as he said, its "social-democratic modernity" attracted Fontane; but he died before he could do more than review his draft and notes for a work that once again would have conveyed his ideas on social and political freedom through the medium of historical reconstruction.

Epilogue

ONTANE was too good and too self-willed an artist for his life and work to reflect with any degree of accuracy a political development extending over time. Nevertheless we can recognize similarities to the difficulties and eventual political failure of liberalism in nineteenth-century Germany, a development this study has discussed from a variety of perspectives afforded by works of art and literature. The failure of liberalism puzzled Fontane even in old age. His autobiographical study *Von Zwanzig bis Dreissig*, completed two years before his death, includes a passage on the Tunnel over the Spree in the first years after the Revolution, when the "lieutenants and noble Justice officials" who criticized the radicalism of some of his verse still cherished ideals that later were overturned by a rigid monarchism: "The members of the Tunnel, like most educated Prussians, held political views that were essentially in agreement with the national-liberal program [i.e. the ideas of moderate and right-wing liberals]. To this day I find it inexplicable that except for short periods this great political mass did not play a more prominent role and did not succeed in establishing itself as a decisive power in the state." Fontane continues with a psychological explanation of this failure, which for the moment ignores the strength of the conservative opposition and seeks the answer in liberalism iteslf. The "German Whigs," be believes, behaved as arrogant know-alls—another way of saying that they regarded themselves not only as a cultural but also as a political elite; not as allies of the common people but as its rightful leaders.[1]

Although liberalism in its various forms remained a force in the German empire, the rise of mass movements of the left and center, and of powerful pressure groups of the right and far right, assured its decline toward political marginality. A parallel may be traced in Fontane's change from a barricade fighter in 1848 to a highly critical but politically quiescent observer of the empire. But how greatly did he differ from the general run of liberals! He had no confidence in the policies and tactics of the liberal parties; he doubted that economic and cultural achievement predestined the middle classes to political leadership; above all, he abhorred the conventional bourgeois as much as the noble who sought to impose a sham feudalism on the modern industrial world. "I am becoming more and more democratic," he wrote to his daughter in 1894. "At most I [also] accept the genuine nobility; everyone in between—Philistine, bourgeois, official, and above all the 'truly educated'—gives me little pleasure."[2] That was an aesthetic rather than a political judgment, but Fontane made it in full awareness of the political dangers posed by the Wilhelmine system. The history of liberalism in Germany is a tragic history. Eventually liberalism faded elsewhere as well; but in Western Europe it deeply marked society and affected many of the political forces that took its place. The consequences of its decline were therefore not as destructive as they proved to be in Germany, where the conservative elites were assured of a near-monopoly of power in

Prussia, the nation's dominant state, and the national executive remained largely detached from the country's representative institutions. In the short run the dearth of countervailing forces in Germany benefited conservatives; but after the debacle of the First World War they, too, proved defenseless before the new radicalism of the right.

Segments of early stages of this development are marked by the paintings and graphics, verse and prose, that I have discussed in a sequence defined not by elements in their respective disciplines but by events in the larger nineteenth-century world. Each work, its creator, background, and impact, may tell us something about the environment from which it emerged—as might other works that could have been discussed instead, or instances and episodes in fields other than art and literature, ranging from economic affairs and social relationships to political ideas and institutions. All would be useful objects of inquiry, and all might shed light on somewhat different aspects of the rise and decline of German liberalism, itself not an isolated process but entwined with the many identifiable forces of the times, and perhaps also with some as yet unidentified.

The works of art and literature that form the kernels of the cultural and political episodes into which my discussion has been structured have been treated as historical sources. Some are themselves historical interpretations, although the scholarly, objective understanding of their subject need not have been the principal motive in their creation. As artists and writers made statements about the past, they expressed views about their own day. Menzel's illustrations for *Frederick the Great* are a serious attempt to visualize a vanished age but also convey a political message, as, in similarly indirect manner, do Fontane's *Prussian Songs*. Rethel adapts and exploits the medieval dance of death to reveal the evil—as he sees it—of certain social and political developments of 1848. Scheffel's historical novel may lack a contemporary programmatic undertone, but its stress on the accurate reconstruction of the past is a sign of the 1850s and 1860s, as is its demythologizing of the Middle Ages. Fontane's weaving together of the tragedy of an inadequate life and his analysis of a defective social and political system is both good history and a critique of contemporary conditions. Other works—Menzel's paintings of 1848 and 1870 and Werner's account of the symbolic culmination of recent German history in January 1871—address the present directly. Both men witnessed the events they chose as their subjects, and both created historical records and at the same time historical interpretations of these events. Because their statements are couched in aesthetic form, they are perhaps especially revealing of the culture from which they emerged.

To recognize the rich deposits of historical evidence in these images and texts, to treat them as sources, is of course not to assert that their evidentiary potential constitutes their principal value. They are far more than indices of other forces: they exist in and for themselves, and because they are products of the creative imagination it is their aesthetic quality and characteristics that matter most. Through them we understand their environment; in turn the external circumstances to which the painter or writer has

responded will illuminate aspects of their work. But the richer its aesthetic substance, the less likely that historical inquiry will penetrate to its core. Notwithstanding recent claims that the truth rests with the observer not with the observed, respect for the evidence remains a desirable attitude when we explore the past. Works of art, more than other kinds of evidence, demand our recognition that in the end those qualities that make up their essential nature lie beyond the historian's reach.

Notes

INTRODUCTION

1. Leopold von Ranke, *Die römischen Päpste* (Munich and Leipzig, 1923), 1: 225. The work first appeared in 1834.

2. Conversation with Karl Friedrich von Conta, May 1820, in *Goethes Gespräche*, ed. Flodoard von Biedermann (Wiesbaden, 1949), p. 389.

3. Friedrich von Schiller, *Geschichte des Abfalls der Niederlande von der spanischen Regierung*, in *Schillers Werke 17: Historische Schriften*, part 1, ed. Karl-Heinz Hahn (Weimar, 1970), pp. 19f.

4. Arthur Schopenhauer, *Die Welt als Wille und Vorstellung* (Leipzig, 1819), 3: 332f.

CHAPTER ONE. ART AS HISTORY; HISTORY AS POLITICS

1. Hans-Ulrich Wehler, *Deutsche Gesellschaftsgeschichte* (Munich, 1987–ᅠ), 2: 174.

2. James J. Sheehan, *German Liberalism in the Nineteenth Century* (Chicago, 1978), p. 43.

3. Laurent had published an earlier study of Napoleon, as well as books and pamphlets on local history, on the history of philosophy, and on the Saint-Simonians. His best-known work apart from the history of Napoleon is a long critique of the political role of the Orleans family in French public life.

4. The main sources for the genesis of the book are *Adolph von Menzels Briefe*, ed. Hans Wolff (Berlin, 1914); Franz Kugler, "Briefe über die Geschichte Friedrichs des Grossen," *Neue Rundschau*, December 1911; and two articles: Elfried Bock, "Die Geschichte eines Volksbuches," *Kunst und Künstler* 13 (1915); and Françoise Forster-Hahn, "Adolph Menzel's 'Daguerreotypical' Image of Frederick the Great: A Liberal Bourgeois Interpretation of German History." *Art Bulletin* 59, no. 1 (1977), a fine reconstruction from the art-historical perspective to which I am particularly indebted.

5. Theodor Fontane, *Von Zwanzig bis Dreissig*, in *Sämtliche Werke* (Munich, 1959–75), 15: 173. I cannot agree with Wilhelm Treue's statement in his rather thin article "Franz Theodor Kugler—Kulturhistoriker und Kulturpolitiker," *Historische Zeitschrift* 175 (1953): 483, that Fontane's judgment of Kugler is "deeply false, unjust." The affectionate if not uncritical reminiscences of Kugler in Fontane's autobiography seem to me on the same high level as the rest of this masterpiece of psychological and historical reconstruction.

6. Jacob Burckhardt to Paul Heyse (the novelist, and Kugler's son-in-law), 16 November 1860, in Jacob Burckhardt, *Briefe*, ed. Max Burckhardt, Vol. 4 (Munich, 1960), p. 75; Jacob Burckhardt, "Kugler," in *Brockhaus Conversations-Lexikon*, 9th ed. (1843–48), vol. 8. Burckhardt revised the second editions of Kugler's two *Handbooks*, and he dedicated his *Cicerone* to Kugler, who in turn dedicated his collected essays on art to Burckhardt. See also Friedrich Eggers, "Franz Theodor Kugler: Eine Lebensskizze," in Franz Kugler, *Handbuch der Geschichte der Malerei*, 3rd ed. (Leipzig, 1867), vol. 1; Wilhelm Waetzoldt, *Deutsche Kunsthistoriker* (Leipzig, 1921–24), vol. 2; and Walter Rehm, "Jacob Burckhardt und Franz Kugler," *Basler Zeitschrift für Geschichte und Altertumskunde* 41 (1942). A comprehensive biography of Kugler does not exist, but see the thorough study by Leonore Koschnick, "Franz Kugler (1808–1858) als Kunstkritiker und Kulturpolitiker" (Ph.D. diss., Berlin, 1983).

7. Peter Brieger, *Die deutsche Geschichtsmalerei des 19. Jahrhunderts* (Berlin, 1930), p. 1. For a more recent discussion of this incident see Götz Pochat, "Friedrich Theodor Vischer und die Zeitgenössische Kunst," in *Ideengeschichte und Kunstwissenschaft im Kaiserreich*, ed. Ekkehard Mai, Stephan Waetzoldt, and Gerd Wolandt (Berlin, 1983), pp. 101f. Despite the voluminous literature on the sub-

ject of historical painting in Germany that has appeared in recent decades, Brieger's modest but sophisticated study remains unsurpassed as an analytic introduction.

8. Franz Kugler, "Fragmentarisches über die Berliner Kunstausstellung vom Jahr 1836," *Museum*, 1836; reprinted in Franz Kugler, *Kleine Schriften und Studien zur Kunstgeschichte* (Stuttgart, 1854), 3: 169–72.

9. Kugler initially praised Lessing but gradually began to have doubts. By 1843 he criticized one of the paintings about Hus as "lacking the stuff of life," and condemned another as weak and too intellectual. Kugler, *Kleine Schriften*, 3: 187f, 405, and 509.

10. The relationship between the historicism of the historian and that of the painter has received fragmentary rather than comprehensive analysis. Among the most valuable studies on the subject are Wolfgang Hardtwig's articles, for instance "Kunst im Revolutionszeitalter: Historismus in der Kunst und der Historismusbegriff der Kunstwissenschaft," *Archiv für Kulturgeschichte* 61 (1979), and "Geschichtsinteresse, Geschichtsbilder und politische Symbole," in *Kunstverwaltung, Bau- und Denkmal-Politik im Kaiserreich*, ed. Ekkehard Mai and Stephan Waetzoldt (Berlin, 1981).

11. Despite his studies, Leutze got most things wrong. The boats are not of the type that was used, the ice on the river was thinner than the dramatic blocks he painted, some of the uniforms are incorrect, and the flag was of a design not adopted until 1777.

12. Franz Kugler, "Über geschichtliche Compositionen," *Museum*, 1837: reprinted in *Kleine Schriften*, 3: 234.

13. Franz Kugler, "Vorlesung über das historische Museum in Versailles . . . ," first published 1846; reprinted in *Kleine Schriften*, 3: 477.

14. Franz Kugler, review of Hermann Weiss, *Geschichte des Kostüms, Deutsches Kunstblatt*, 1853; reprinted in *Kleine Schriften*, 2: 713.

15. Kugler, *Kleine Schriften*, 2: 234.

16. Ibid., 2: 713.

17. Jacob Burckhardt, "Bericht über die Kunstausstellung zu Berlin im Herbste 1842," *Kunstblatt*, 3 January 1843, pp. 1f. See also Wilhelm Schlink, *Jacob Burckhardt und die Kunsterwartung im Vormärz*, Frankfurter Historische Vorträge, no. 8 (Wiesbaden, 1982).

18. Franz Kugler, "Sendschreiben an Herrn Dr. Ernst Förster . . . ," *Kunstblatt*, 1843; reprinted in *Kleine Schriften*, 3: 406. See also pp. 91–92, below.

19. Adolph Menzel to Dr. Puhlmann, 5 November 1836, in *Menzels Briefe*, p. 15. An interesting discussion of the subject is Peter H. Feist's essay "Adolph Menzel und der Realismus," in *Adolph Menzel*, Exhibition catalogue of the Nationalgalerie (East Berlin, 1980).

20. Franz Kugler and Adolph Menzel, *Geschichte Friedrichs des Grossen* (Leipzig, 1842). Including designs for the announcement and cover, and supplementary illustrations and replacements for the second edition, the total number of Menzel's drawings for the book is 413; Menzel to J. J. Weber, 2 June 1844, in *Menzels Briefe*, p. 81.

21. Charles Rosen and Henri Zerner, *Romanticism and Realism* (New York, 1984), p. 74.

22. Paul-Mathieu Laurent de l'Ardèche, *L'Histoire de L'Empereur Napoléon* (Paris, 1839), pp. 8, 487, 614, 616, etc.

23. Kugler and Menzel, *Geschichte Friedrichs des Grossen*, reprint of the text of the second edition with the illustrations of the first edition (Berlin, 1922), p. iv.

24. Ibid., p. 574.

25. Ibid., pp. 576f.

26. Menzel's statement is too convoluted to translate with absolute precision: ". . . dass Friedrich mehr als Vater für sein Volk lebte, und daher sein Andenken vorzugsweise dem Bürgerstande heilig ist, in welchem die Saat seiner Institutionen am meisten ins Leben eingreifend fortwirkt." To J. J. Weber, 24 February 1839, in *Menzels Briefe*, p. 21.

27. In 1839 Louis Daguerre invented the daguerreotype: though it was not capable of freezing movement, what impressed contemporaries was the accuracy with which it transposed three-dimensional reality to the page. Since Menzel's drawings, many of which have an incomplete, suggestive quality, emphasize

movement and expression rather than surface precision, their repeated comparison in the 1840s with daguerreotypes is odd; but perhaps people sensed the underlying accuracy of his rapid line. Menzel's friend the painter Paul Meyerheim notes in his recollections of the artist, *Adolph von Menzel* (Berlin, 1906), that Menzel opposed drawing from photographs, a practice that he thought interfered with the intense realization of nature.

28. A drawing in which the coming generation of the military elite confronts its role models depicts a detachment of adolescent cadets marching, bibles in hand, from the Potsdam garrison church past a group of posturing guards officers in resplendent uniforms.

29. Kugler's German version is rather free. The original goes:

Pour moi, menacé du naufrage,
Je dois, en affrontant l'orage,
Penser, vivre et mourir en roi.

"Réponse au Sieur Voltaire," 9 October 1757, in *Oeuvres de Frédéric le Grand*, ed. J.D.E. Preuss (Berlin, 1846–56), 14: 116.

30. Laurent de l'Ardèche, *Histoire*, p. 692, refers to the resistance the Allies met at the Barriére de Clichy, and mentions Vernet among the defenders. Vernet illustrated the episode with a large engraving. His painting on the same subject is well known.

31. But we should take care not to exaggerate the bourgeois, pacific aspects. In her article "Adolph Menzel's 'Daguerreotypical' Image . . . ," Françoise Forster-Hahn writes (p. 257): "There can be no doubt which side of Frederick's personality and politics Menzel favored. All liberal authors of 1840 credited Frederick with the creation of a powerful Prussian state . . . but they favored the philosopher and enlightened monarch rather than the hero of great military victories. Menzel was even more deliberate in his interpretation of the philosopher-king." This may possibly apply to Menzel's later interpretations of Frederick, but does not hold true of his illustrations in Kugler's history. Excluding initials, symbolic images, depictions of foreign rulers, diplomats, and soldiers, etc., the book contains some fifty-five images of the king's non-military activities and

of Prussian society during his reign. By contrast, nearly one hundred and thirty images are devoted to Frederick the soldier and commander, to the Prussian army, and to war. Of the nine full-page illustrations, excluding the two frontispieces with symbolic themes and the title pages of the four main parts of the book, two are of scenes at court but four of scenes from the wars, two show the king's triumphant return from victorious campaigns, and the last shows Frederick's death. The overwhelming presence of the military motif in Menzel's illustrations can hardly be denied. As I have noted, they do not glorify war, but they certainly present the king as a passionate and inspired warrior. That German liberalism in the 1840s was anything but peace-loving is another point worth recalling.

32. Two unsigned reviews, *Blätter für literarische Unterhaltung*, 1840, no. 131: 527f; and 1842, no. 49: 195f. In 1841, incidentally, the *Blätter* published a favorable review of a collection of Kugler's poems.

33. Kugler to the firm of J. J. Weber, February 1840, in Kugler, "Briefe," *Neue Rundschau*, December 1911, p. 1734.

34. Kugler to the firm of J. J. Weber, 26 March 1840, ibid., pp. 1737f.

35. Johann Gottfried Schadow, "Zu Ehren Friedrich des Grossen," *Berlinische Nachrichten*, 26 March 1840.

36. Kugler to the firm of J. J. Weber, 26 March 1840, in Kugler, "Briefe," *Neue Rundschau*, December 1911, p. 1738; [Menzel], "An den Herrn Verfasser des Artikels 'zu Ehren Friedrich's des Grossen'," *Berlinische Nachrichten* 28 March 1840.

37. G. P., "Die nationale Bedeutung Friedrichs des Grossen," *Deutsche Viertel-Jahrsschrift*, 1841, part 1: 169, 173f, 177–81, 185, and 240.

38. Karl August Varnhagen von Ense, review of Karl Friedrich Köppen, *Friedrich der Grosse und seine Widersacher, Jahrbücher für wissenschaftliche Kritik*, June 1840, pp. 822–23.

39. Karl Friedrich Köppen, *Friedrich der Grosse und seine Widersacher* (Leipzig, 1840), p. 172.

40. Karl Friedrich Köppen, "Zur Feier der

Thronbesteigung Friedrich's II," *Hallische Jahr-bücher für Deutsche Wissenschaft und Kunst* 3 (1840): 1169f, 1186ff, 1193, and 1197.

41. "Das Andenken Friedrich's II . . . ," *Rheinische Zeitung* no. 325 (21 November 1842).

42. "Einiges von Friedrich dem Grossen," ibid., nos. 85–87 (26–30 March 1843); "Die liberalen Zeitungen Deutschlands," ibid., no. 90 (31 March 1843).

43. R[uge], review of *Geschichte Friedrich's des Grossen, Hallische Jahrbücher für Wissen-schaft und Kunst*, 3, no. 168 (1840), cols. 1343f; A. Ruge, review of *Geschichte Fried-rich's des Grossen, Deutsche Jahrbücher für Wissenschaft und Kunst*, 5 (1842): 891f.

44. Ruge, review of *Geschichte Friedrich's des Grossen. Deutsche Jahrbücher für Wissen-schaft und Kunst*, 5 (1842): 891.

CHAPTER TWO. FONTANE'S PRUSSIAN SONGS

1. Quoted in Theodor Fontane, "Willibald Alexis," in *Sämtliche Werke* (Munich, 59–67), 21, part 1: 200.

2. Two particularly interesting analyses of Fontane's early life, which supplement and interpret his autobiographical writings, are the fine monograph by Helmuth Nürnberger, *Der junge Fontane* (Hamburg, 1967), and the first chapters of Hans-Heinrich Reuter's Marxist-cocooned *Fontane* (Munich, 1968). Two examples of Fontane's continuing attachment to his seventeenth-century origins: he chose his wife from another *réfugié* family; and in private he and his family pronounced their name not in the German manner—Fon-táh-nuh—but in the French—Fón-tain.

3. Fontane to Moritz Lazarus, 5 January 1897, Theodor Fontane, *Briefe*, ed. Walter Keitel and Helmuth Nürnberger (Munich, 1982), 4: 626. Fontane's condensed account probably caught the essence of the group, but was not entirely accurate. For a more detailed recollection, see his autobiographical volume *Von Zwanzig bis Dreissig*, in *Werke*, 15: 89–99.

4. Fontane, *Werke*, 20: 415, 418, 423, and 428.

5. Doch die Wände haben Ohren,
 Und kaum weiss ich, wer du bist,
 Und ich wäre schier verloren,
 Hörte mich ein Polizist.
"Zwei Liberale," ibid., p. 441.

6. Fontane, *Von Zwanzig bis Dreissig*, ibid., 15: 161.

7. Excerpts of the minutes are printed in Ernst Kohler, *Die Balladendichtung im Ber-liner "Tunnel über der Spree"* (Berlin, 1940). The Tunnel was founded by a Jewish journal-ist, and over the years some Jews and—as Koh-ler points out—"half-Jews" (the novelist Paul Heyse) were members. The value of Kohler's intelligent study is not diminished by a few anti-Semitic remarks, but they are disagreeable reminders of the ethical deficiencies of too many German academics during the Third Reich. A similar comment must be made about Hermann Fricke's important study of Fon-tane's last manuscript, *Die Likedeeler*, cited in chapter 5, note 3, below.

8. Fontane, *Von Zwanzig bis Dreissig*, in *Werke*, 15: 140.

9. Kohler lists all the poems and prose works Fontane presented in the Tunnel, and the grades they were given, in an appendix (*Ballad-endichtung*, pp. 414–19). In the same year that the *Prussian Songs* appeared, Fontane pub-lished another ballad cycle, this one on an old-English motif, *Of the Beautiful Rosamunde*, with which he scored his third great success in the Tunnel.

10. Auch *du*, für heil'ge Rechte
 Ficht weiter, sonder Scheu:
 Treulos sind alle Knechte,
 Der Freie nur ist treu!
Fontane, *Werke*, 20: 225.

11. In his essay on Alexis, ibid., 21, part 1: 161.

12. Since so many of Fontane's ballads were written to be read aloud in the Tunnel, a prac-tice which, of course, reflected the widespread social custom of singing or reciting poems in company, it is difficult to understand Gilliam Rodger's assertion that "Fontane, like his con-temporaries, was pleased to overlook the per-formance aspect of the folk-ballad." "Fon-

tane's Conception of the Folk-Ballad," *Modern Language Review* 53 (1958): 52.

13. Fontane, "Der alte Derffling[er]," *Werke*, 20: 204f.

14. Er sprach: "Als alter Schneider
Weiss ich seit langer Zeit,
Man wechselt seine Kleider—
Auch hab' ich des nicht Leid.
Es fehlt der alten Hülle
In Breite schon und Läng',
Der Geist tritt in die Fülle,
Der Leib wird ihm zu eng; . . ."

15. Es haben alle Stände
So ihren Degenwert,
Und selbst in Schneiderhände
Kam einst das Heldenschwert.

16. Fontane, "Der alte Zieten," in *Werke*, 20: 207f.

17. Sie kamen nie alleine,
Der Zieten und der Fritz,
Der Donner war der eine,
Der andre war der Blitz.

18. Lasst schlafen mir den Alten,
Er hat in mancher Nacht
Für uns sich wach gehalten,
Der hat genug gewacht.

19. Kohler, *Balladendichtung*, pp. 217f.

20. I believe Kohler is mistaken in holding that the *Prussian Songs* show that "Fontane is for the old-Prussian tradition" (ibid., p. 232), while Nürnberger seems to me to go too far in concluding that "what ultimately dominates in these poems are Democracy and Anecdote" (*Der junge Fontane*, pp. 126 and 378n). But both authors have made valuable analyses of the ballads, to which I am indebted. Reuter asserts that he is subjecting "the historical-ideological aspect of Fontane's Prussian ballads" to a thorough scholarly investigation for the first time (*Fontane*, 1: 190); but his brief discussion is derived entirely from Kohler, whom he does not cite.

21. Wir haben viel von Nöten,
Trotz allem guten Rat,
Und sollten schier erröten
Vor solchem Mann der Tat.

22. Kohler, *Balladendichtung*, pp. 194f.

23. Fontane, "Unser Friede," *Werke*, 20: 254f. The poem, originally published in a newspaper in 1844, was included by Fontane in the first edition of his selected poems, published in 1851.

24. Die Donnerwolke blitzt und wettert
Und nimmt der Luft den gift'gen Hauch,
Und wird auch mancher Baum zerschmettert,
In faule Sümpfe schlägt es auch.

CHAPTER THREE. THE REVOLUTION OF 1848

1. For a good concise account of Rethel's life and work, see William Vaughan's comprehensive *German Romantic Painting* (New Haven, 1983), pp. 225–38.

2. Wolfgang Müller von Königswinter, *Düsseldorfer Künstler aus den letzten fünfundzwanzig Jahren* (Leipzig, 1854), p. 64; and the same author's *Alfred Rethel: Blätter der Erinnerung* (Leipzig, 1861), p. 6.

3. The literature on the Düsseldorf Academy is extensive. Apart from the two works by Müller von Königswinter cited above, see, for instance, another contemporary account, Friedrich von Uechtritz, *Blicke in das Düsseldorfer Kunst- und Künstlerleben* (Düsseldorf, 1840); the informative anniversary volume edited by Eduard Trier, *Zweihundert Jahre Kunstakademie Düsseldorf* (Düsseldorf, 1973); and the stimulating Marxist-oriented work by Wolfgang Hütt, *Die Düsseldorfer Malerschule, 1819–1869* (Leipzig, 1964).

4. Franz Kugler, "Über die gegenwärtige Lage der Düsseldorfer Schule," in Franz Kugler, *Kleine Schriften und Studien zur Kunstgeschichte* (Stuttgart, 1854), 3: 501f.

5. Müller von Königswinter, *Düsseldorfer Künstler*, p. 65. See also ibid., p. 72, and Robert Reinick, *Aus Biedermeiertagen*, ed. Johannes Höffner (Bielefeld and Leipzig, 1910), p. 82.

6. Rethel's woodcuts for the *Nibelungenlied* are discussed with great insight in Karl Koetschau, *Alfred Rethels Kunst* (Düsseldorf, 1929), pp. 153–56. The author's occasionally elegiac-patriotic tone does not detract from his

profound understanding of nineteenth-century art in the Rhineland.

7. Rethel to his parents, 4 November 1844, in *Alfred Rethels Briefe*, ed. Josef Ponten (Berlin, 1912), pp. 88f. See also a similar earlier statement, ibid., p. 46.

8. Among the many studies of the frescoes, see especially the book by Koetschau cited in note 6 above; the comprehensive monograph by Heinrich Schmidt, *Alfred Rethel, 1816–1859* (Neuss, 1959); and the admirable dissertation by Detlef Hoffmann, *Die Karlsfresken Alfred Rethels* (Freiburg i. B., 1968).

9. Rethel's memorandum is reprinted in Joseph Ponten, *Alfred Rethel* (Stuttgart and Leipzig, 1911), pp. 184–87; the quotation is from p. 184. Even if, as is likely, much of the learned material in the memorandum comes from Rethel's friend Hechtel, the very personal style of the whole indicates that Rethel had familiarized himself with the medieval texts cited and had thought through the incidents they relate.

10. Fontane to Friedrich Eggers, 9 April 1852, in Theodore Fontane, *Briefe*, ed. Walter Keitel and Helmuth Nürnberger (Munich, 1979–82), 1: 217.

11. Ponten, *Alfred Rethel*, p. 187.

12. Hoffmann, *Die Karlsfresken Alfred Rethels*, p. 64, shows, on the basis of Rethel's preliminary sketches, that he made very detailed studies of Carolingian architecture, furniture, and artifacts. Once he had mastered their appearance, he felt free to simplify and adapt his final treatment.

13. For the following I am indebted to the relevant chapter in Peter Brieger, *Die deutsche Geschichtsmalerei des 19. Jahrhunderts* (Berlin, 1930); and to Christoph Heilmann's essay "Zur französisch-belgischen Historienmalerei und ihre Abgrenzung zur Münchner Schule," in *Die Münchner Schule*, Exhibition catalogue (Munich, 1979).

14. For Burckhardt's discussion of the Belgian paintings, see the first and fourth parts of his "Bericht über die Kunstausstellung zu Berlin im Herbste 1842," *Kunstblatt*, 3 and 12 January 1843, pp. 1 and 14f.

15. Kugler, "Sendschreiben an Herrn Dr. Ernst Förster . . . ," in Kugler, *Kleine Schriften*, 3: 403.

16. Franz Kugler, "Kunstreise im Jahr 1845," in *Kleine Schriften*, 3: 487.

17. Theodor Fontane, *Von Zwanzig bis Dreissig, Sämliche Werke* (Munich, 1963), 15: 335. The five chapters in his autobiographical writings in which Fontane describes and reflects on his activities and experiences during the Revolution express his strong commitment to far-reaching change. As might be expected from someone who was incapable of not seeing the other side of a dispute, his political convictions do not prevent Fontane from being critical of unsavory elements among the civilian population and sympathizing with the troops, which had to carry out an unpleasant as well as dangerous task. On Fontane's politics in 1848 and later, see also Joachim Remak, *The Gentle Critic: Theodor Fontane and German Politics* (Syracuse, 1964), a valuable introduction to the subject, even if I would question how gentle Fontane's criticism was.

18. Among the 303 fatalities were 29 masters of workshops, 115 journeymen, 13 apprentices, 52 skilled and unskilled workers, 34 servants and small shopkeepers, and 15 members of "the educated classes" (officials, an artist, a merchant, two university students, etc.). R. Hoppe and Jürgen Kuczynski, "Eine Berufs bzw. auch Klassen- und Schichtenanalyse der Märzgefallenen 1848 in Berlin," *Jahrbuch für Wirtschaftsgeschichte* 4 (1964): 200–76.

19. Report of the *Vossische Zeitung*, reprinted in Adolf Wolff, *Berliner Revolutions-Chronik* (Berlin, 1851), 1: 320. Additional newspaper articles on the ceremony and funeral are printed ibid., pp. 321–27.

20. Menzel to Carl Arnold, 23 March 1848, in *Adolph von Menzels Briefe*, ed. Hans Wolff (Berlin, 1914), pp. 126–32. Menzel's sketches for the painting have been repeatedly reproduced; see, for instance, the catalogue of an exhibition of Menzel's works in the Hamburg Kunsthalle, *Menzel—der Beobachter*, ed. Werner Hofmann (Munich, 1982), pp. 85f. In 1842 Menzel had made a very detailed sketch of the façade of the New Church, one of a

group of architectural sketches for a new edition of *Frederick the Great*. It was later decided not to use the drawings.

21. Karl Scheffler's *Menzel* has been frequently reprinted; I cite from the second edition (Berlin, 1915), p. 165. A more recent representative of the objective interpretation is Jens Christian Jensen, "Adolph Menzel: Realist—Historist—Maler des Hofes," in Jens Christian Jensen, ed., *Adolph Menzel*, Exhibition catalogue of the Kiel Kunsthalle (Schweinfurt, 1981), p. 9.

22. *Menzel—der Beobachter*, p. 83. Another exponent of the political view is Christopher With, "Adolph Menzel and the German Revolution of 1848," *Zeitschrift für Kunstgeschichte* 42 (1979): 195–214. The essay, laudable for its interdisciplinary approach, ultimately fails because the author operates with one-dimensional political concepts and misconstrues major cultural and intellectual forces of the period, associating, for example, the individualizing historicism of the 1840s with Hegelian speculative and programmatic patterns.

23. Elke von Radziewsky, "Menzel—ein Realist?," in *Menzel—der Beobachter*, pp. 17–30.

24. Menzel to Carl Arnold, 23 April 1847, in *Menzels Briefe*, p. 103.

25. Menzel to Dr. Puhlmann, 7 April 1848, and to Carl Arnold, 3 May and 15 September 1848 and 16 January 1849, ibid., pp. 132f, 136, 137.

26. Alfred Lichtwark, *Briefe an die Kommission für die Verwaltung der Kunsthalle*, ed. Gustav Pauli (Hamburg, 1924), 2: 31ff.

27. Wolfgang Hütt, *Adolph Menzel* (Leipzig, 1965), p. 21. See also the greatly expanded second edition of this work published in 1981.

28. See, for example, Günter Busch, "Menzels Grenzen," in Jensen, *Adolph Menzel*, Exhibition catalogue, pp. 11f.

29. Richard Wagner, *My Life*, transl. Andrew Gray, ed. Mary Whittall (Cambridge, 1983), p. 362.

30. Georg Wigand, the publisher of the *Dance of Death*, to Reinick, 14 July 1849, in Reinick, *Aus Biedermeiertagen*, pp. 268f.

31. Rethel to Reinick, 22 April 1849, in *Rethels Briefe*, pp. 116f.

32. Letter of 14 June 1849, in Reinick, *Aus Biedermeiertagen*, p. 256.

33. The work was reprinted three times in 1849 and also came out in a French edition. It has been reissued periodically ever since, for a total of about thirty printings by the 1980s.

34. Ihr Menschen, ja, nun kommt der Mann, Der frei und gleich euch machen kann.

35. Rethel may have borrowed this motif (Fig. 94) from an illustration of an episode in *Frederick the Great*, in which the king interfered with the judicial process because he believed a noble plaintiff was being favored over his tenant, a miller. Menzel's vignette (Fig. 95)

94. Alfred Rethel: Detail from Plate 3 of *Another Dance of Death* .

95. Adolph Menzel: Frederick's Hand Keeps the Scales of Justice in Balance.

96. Horace Vernet: Napoleon's Sword Outweighs British Gold.

shows a hand, identified as Frederick's by the ermine cloak, grasping the indicator of a balance to make the pan holding the miller's case level with the pan holding a noble's escutcheon. In *The Life of Napoleon* Vernet also draws a balance, its proper working not interfered with, to illustrate that Napoleon's sword outweighs bags of British gold (Fig. 96).

36. Du blindes Weib, was schleichst du fort?
Siehst mehr du als die andern dort?

37. Eugène Delacroix, entry of 5 March 1849, in *Journal de Eugène Delacroix*, ed. André Joubin (Paris, 1932), 1: 182. On Meissonier's *The Barricade*, see T. J. Clark, *The Absolute Bourgeois* (Princeton, 1982), pp. 27ff.

38. Der sie geführt, es war der Tod,
Er hat gehalten, was er bot,
Die ihm gefolgt, sie liegen bleich
Als Brüder alle, frei und gleich.
Seht hin, die Maske that er fort,
Als Sieger hoch zu Rosse dort
Zieht der Verwesung Hohn im Blick,
Der Held der roten Republik.

39. Ernst Förster, Review of Alfred Rethel, *Auch ein Todtentanz, Kunstblatt,* 28 June 1849, p. 96; Müller von Königswinter, *Alfred Rethel*, p. 153; article "Alfred Rethel," in *Allgemeine Deutsche Biographie* (Leipzig, 1889),

vol. 28; Josef Ponten, *Studien über Alfred Rethel* (Stuttgart, 1922), p. 54; Clark, *The Absolute Bourgeois*, pp. 26f. For a characteristic Marxist interpretation see Helmut Hartwig and Karl Riha's study of West German responses to the memory of the Revolution of 1848, *Politische Ästhetik und Öffentlichkeit* (Steinbach, 1974), p. 16. I first developed my contrary view in "The German Revolution of 1848 and Rethel's Dance of Death," *Journal of Interdisciplinary History* 17, no. 1 (Summer 1986); see also Karl-Ludwig Hofmann and Christmut Präger, "Revolution als Totentanz—Alfred Rethel, 'Ein Totentanz,' 1849," in *Thema Totentanz*, Exhibition catalogue of the Mannheim Kunstverein, 5 October – 9 November 1986 (Mannheim, 1986). The continuing hold of Rethel's images on the historical imagination is exemplified by the jacket design for a history of the Revolution published in 1905. The right-of-center author was the son

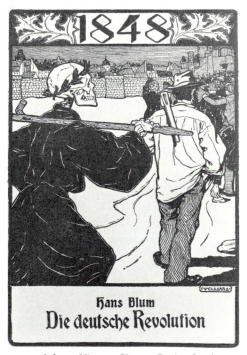

97. Johann Vincent Cissarz: Design for the announcement of a book on the Revolution of 1848.

of Robert Blum, a moderate democrat whom the Austrian army had executed in 1848. For the jacket, Johann Cissarz drew a variation of Rethel's second plate: Death, crowned with a laurel wreath and carrying a scythe, follows a crowd of armed civilians that is advancing on a peaceful town.

40. Müller von Königswinter, *Alfred Rethel*, p. 156.

41. Letter of 9 or 10 May 1849, in *Rethels Briefe*, pp. 119f.

42. Rethel to his parents, 21 October 1833, ibid., pp. 16–31. Among the songs and poems Rethel mentions are works by Reinick and Kugler.

43. Rethel to Reinick, 22 April 1849, ibid., p. 117.

44. *Death as Friend* conveys an idyllic, apolitical aura of the sort often encountered in the woodcuts of Ludwig Richter, Rethel's Dresden contemporary, who incidentally also illustrated verses by Robert Reinick: a burgher's contented dream of rural and small-town Germany—wrapped in sunshine and spider webs—existing almost unchanged from the Middle Ages to the last halcyon years before 1789. A few decades later, Wilhelm Busch, in the pen-and-ink illustrations to his stories in rhyme, provided an ironic gloss to this vision of timeless middle-class comfort and passivity. In our century, Theodor Heuss, in his edition of Rethel's *Auch ein Totentanz* (Stuttgart, 1957), p. 12, has likened *Death as Friend* to a folksong; but it would be more accurate to compare the woodcut to an *art*-song of the 1830s and 1840s, in which the sophisticated and nervous sensibility of its creator employs an archaic vocabulary to develop a theme of sentimental appeal in unspoken opposition to the modern, industrializing world.

45. T. J. Clark identifies "certain violent, cynical episodes in Holbein's *Dance of Death*" as Rethel's "point of reference" (*The Absolute Bourgeois*, pp. 26f). But the Holbein prints he mentions can be relevant at most to one or another segment of one of Rethel's plates, never to the entire image.

46. Wilhelm Waetzold, *Dürer und seine Zeit* (Vienna, 1935), p. 71.

47. Another contemporary political reference is worth noting: twice Reinick's verses refer to Death as "Sensenmann"—man with the scythe. *Sensenmänner* was also a common term for rural revolutionaries, for example the Polish insurgents of 1831.

48. By contrast, the newspaper illustrations of the fighting in Berlin in March 1848 (Fig. 71) and in Dresden in May 1849 (Fig. 72) accurately show members of several social groups on the barricades.

49. A concept of death that seems somewhat analogous, and may even have influenced Rethel, is expressed in Freiligrath's revolutionary poem, "A Song of Death," written in April 1848. The poem was published later that year, and it is likely that Rethel knew it by the time he was working on *Another Dance of Death*, the more so since in the fall of 1848 Freiligrath, in a highly publicized trial, was accused of having insulted Frederick William IV. In the poem an apparition at dawn, sword in hand, asks: "Who am I?", and answers:

> I am liberatordeath
> Am death for mankind, for the fatherland!

Combining the two nouns "liberator" and "death" into one word—*Befreiertot*—was Freiligrath's invention. The poem concludes:

> I shall stride forward and kill,
> Until the sun follows the dawn!
> Oh, sacred spring, full of joy and pain!
> Forward! I am liberatordeath!

50. Albert Soboul, *The Sans-Culottes: The Popular Movement and Revolutionary Government, 1793–1794*, trans. Remy Inglis Hall (Princeton, 1980).

CHAPTER FOUR. SCHEFFEL AND THE GERMAN MIDDLE AGES

1. Scheffel's life and work gave rise to an extensive biographical and critical literature before the First World War. During the 1920s and 1930s the German society devoted to the study of Scheffel's works, the Scheffelbund, sponsored the publication of important parts of his correspondence. After several decades of neglect, a certain revival of interest in Scheffel is evident. Note, for example, Hartmut Eggert,

Studien zur Wirkungsgeschichte des deutschen historischen Romans, 1850–1875 (Frankfurt a.M., 1971), with useful statistical information on the sale of works by Scheffel and other writers of his time. Unfortunately Eggert, relying on a single secondary source, misinterprets Scheffel's politics, which badly confuses his literary analysis. A very critical sociological study is Rolf Selbmann's *Dichterberuf im bürgerlichen Zeitalter: Joseph Viktor von Scheffel und seine Literatur* (Heidelberg, 1982). Selbmann's work is dismisssed as fashionably ahistorical by Günther Mahal in his comprehensive and balanced monograph, *Joseph Viktor von Scheffel: Versuch einer Revision* (Karlsruhe, 1986).

2. Behüt uns Gott
 vor Rassenhass
 Und Klassenhass
 Und derlei Teufelswerken!

Cited in the memoirs of his friend the painter Anton von Werner, *Erlebnisse und Eindrücke, 1870–1890* (Berlin, 1913), p. 271.

3. Scheffel to his father, 8 June 1848, in Josef Viktor von Scheffel, *Briefe ins Elternhaus, 1843–1849*, ed. Wilhelm Zentner (Karlsruhe, 1926), p. 187. See also Scheffel's letter to Friedrich Eggers, 27 January 1849, in Gerda Ruge, ed., *Eine Studienfreundschaft: Scheffels Briefe an Friedrich Eggers, 1844–1849* (Karlsruhe, 1936), p. 70.

4. Letter of 5 April 1848, in Scheffel, *Briefe ins Elternhaus*, p. 177.

5. Scheffel to Eggers, 17 October 1849, in Ruge, ed., *Eine Studienfreundschaft*, pp. 74f.

6. At least one artist, Anton von Werner, disagreed. In a talk commemorating the first anniversary of Scheffel's death, Werner said: "The obituaries that appeared after the poet's death frequently emphasized that Scheffel lacked talent or aptitude to be a painter, and that he was already too old to study art. Nevertheless . . . on the basis of many years' experience as the head of an art academy I would assert that today we could undoubtedly make something of a twenty-five- or twenty-six-year old art neophyte with the gift, enthusiasm, and energy Scheffel possessed at the time. But it seems to me that Scheffel, with his sound, naturalistic eye, with his tendency to see and depict nature as it is, not as one wanted it to be at that time, came into conflict with the views on art of that period. He couldn't understand the sources of this conflict then or later . . . but in later years he told me how much he regretted not having become a painter . . ." Address to the Berlin Society of Artists, 9 April 1887, Nachlass Anton von Werner, Zentrales Staatsarchiv, Merseburg (ZStA), Rep. 92, IVb, p. 42.

7. Scheffel to Werner, 17 July 1870, in *Briefe von Josef Viktor von Scheffel an Anton von Werner*, ed. Anton von Werner (Stuttgart, 1915), p. 111. See also Werner's comment in *Erlebnisse und Eindrücke*, p. 5.

8. Werner, Address to the Berlin Society of Artists, ZStA, Rep. 92, IVb, p. 69 verso; Scheffel to Adolf Erismann, 15 September 1870, *Briefe J. V. v. Scheffels an Schweizer Freunde*, ed. Adolf Frey (Zurich, 1898), p. 189.

9. In his memorial address, Werner notes that Scheffel always remained loyal to the ideal of a greater Germany, "which did not diminish his respect for the revered German emperor and his admiration for our Iron Chancellor, which whom he became personally acquainted in 1877; but these feelings were always accompanied by a sense of pain and regret that the empire could not include all of Germany" (ZStA, Rep. 92, IVb, p. 51).

10. A striking case of celebrating Scheffel as a poet of German values is the collection of essays and verse in commemoration of his hundredth birthday, *Joseph Viktor von Scheffel im Lichte seines hundertsten Geburtstages* (Stuttgart, 1926). Among the contributors are Gerhard Hauptmann, Hugo von Hoffmannsthal, and Stefan Zweig.

11. Fahr wohl, du hoher Säntis, der treu um
 mich gewacht,
 Fahr wohl, du grüne Alpe, die mich
 gesund gemacht!
 Hab Dank für deine Spenden, du heil'ge
 Einsamkeit,
 Vorbei der alte Kummer—vorbei das
 alte Leid.
 Geläutert war das Herze, und Blumen
 wuchsen drin:
 Zu neuem Kampf gelustigt steht nach

der Welt mein Sinn.
Der Jüngling lag in Träumen, dann kam
 die dunkle Nacht;
In scharfer Luft der Berge ist jetzt der
 Mann erwacht!

Ekkehard, in *Scheffels Werke*, ed. Friedrich Panzer (Leipzig and Vienna, n.d.), 3: 453.

12. "Ermesset nun, ehrwürdige Brüder, welch ein Mass von Unrecht man mir angetan, und was der für ein Mensch sein muss, der seinem Nebenmenschen den Irrtum eines Ablativus vorhält!" *Scheffels Werke*, 3: 286.

13. The first two volumes of *Die Ahnen* were published in 1872 and 1873, and achieved twenty-seven and twenty-three printings respectively by 1900. *Ein Kampf um Rom* appeared in 1876 and reached its thirtieth printing in 1900. By the 1920s about 950,000 copies of *Die Ahnen* had been sold.

14. Specialists are not in full agreement on the developmental phases of the *Professorenroman*. Some regard the first volumes of Freytag's *Ahnen* as mere forerunners of prototypes of the genre—e.g. Claus Holz, *Flucht aus der Wirklichkeit* (Frankfurt a.M., 1983), p. 14. The technical distinctions on which these arguments are based, and whether or not the author at the time of writing actually was an academic, seem less important than the attitudes and intentions with which the author proceeded.

15. *Scheffels Werke*, 3: 19–26.

16. S. G. Mulert, *Scheffels Ekkehard als historischer Roman* (Münster i.W., 1909).

17. Theodor Fontane, "Ekkehard," in *Sämtliche Werke* (Munich, 1959–67), 21, part 1: 250ff. The essay, which was not published during Fontane's lifetime, is undated. The editor, Kurt Schreinert (ibid., p. 501), believes it was written in 1865 or a little later, but Fontane's reference to Emperor William suggests that it must have been written after 1870, most probably in the first years of the empire. See Hans-Heinrich Reuter, *Fontane* (Munich, 1968), 2: 963. In later years Fontane seems to have changed his high opinion of *Ekkehard*. In 1889, responding to a question about the books he liked most or that influenced his development as a writer, he listed seventy-one au-

thors, some with several works, but not Scheffel (ibid., pp. 497ff). Among the authors and works mentioned are the radical political poets Herwegh and Freiligrath, especially the poem that led to Freiligrath's trial for *lèse majesté*; *Percy's Reliques of Ancient English Poetry*; Scott's *Ministrelsy of the Scottish Borders*; and Kugler's *History of Frederick the Great*.

18. Eggert, *Studien*, pp. 205–12.

19. This is one of the main themes of Selbmann's 1982 study of Scheffel (cited in note 1, above).

20. Despite the political messages often attributed to them, the operas that Wagner set in the Middle Ages treat the period not in the way Rethel did, as a time of political conflict and achievement that should inspire us today, but, like Scheffel, as a stage for human passions.

CHAPTER FIVE. BEFORE, DURING, AND AFTER THE TRIUMPH

1. Thomas Nipperdey, *Deutsche Geschichte, 1800–1866* (Munich, 1984), pp. 721ff. The discussions of society are one of the strongest aspects of this notable work.

2. Gordon A. Craig, *The Politics of the Prussian Army, 1640–1945* (Oxford, 1955), p. 177.

3. Karl Scheffler, *Menzel* (Berlin, 1915), p. 134.

4. Menzel's illustrations have frequently been reprinted, sometimes without Frederick's texts. Paul Ortwin Rave's edition of ninety-nine of the two hundred wood engravings. *Holzschnitte zu den Werken Friedrichs des Grossen von Adolph Menzel* (Berlin, 1955), offers an admirable analytic introduction to the entire work.

5. Menzel to Herman Krigar, 24 July 1866, and to Dr. Puhlmann, 2 August 1866, in *Adolph von Menzels Briefe*, ed. Hans Wolff (Berlin, 1914), pp. 203 and 205.

6. Fontane to Menzel, 2 July 1871, in Theodor Fontane, *Briefe*, ed. Walter Keitel and Helmuth Nürnberger (Munich, 1979–82), 2: 382.

7. "Einzug," 16 June 1871, in Theodor Fontane, *Sämtliche Werke* (Munich, 1959–67), 20: 239ff. The concluding stanza of the poem goes:

Bei dem Fritzen-Denkmal stehen sie
 wieder,
Sie blicken hinauf, der Alte blickt nieder;
Er neigt sich leise über den Bug:
'Bon soir, Messieurs, *nun ist es genug.*'

8. Fontane to Bernard von Lepel, 30 October 1851, in Fontane, *Briefe*, 1: 194.

9. Fontane to Wilhelm Hertz, 24 November 1861, ibid., 2: 51.

10. Fontane to Emilie Fontane, 3 March 1864, ibid., p. 121.

11. Fontane, "Friedrich August Ludwig von der Marwitz," in *Werke*, 10: 213.

12. Ibid., p. 203.

13. Ibid., p. 221.

14. Fontane to Emilie Fontane (his wife and his mother had the same first name), 30 June 1862, in Fontane, *Briefe*, 2: 76.

15. Fontane, "Schlusswort," in *Werke*, 12: 401f. The following quotation is from p. 403.

16. In his introduction to a new edition of *Der Krieg gegen Frankreich, 1870–1871* (Zurich, 1985), 1: xviii and xxxi, Gordon Craig writes that Fontane deals more accurately with his sources than such a professional historian as Treitschke, and that "the most rigorous historian would have every reason to be proud of a book like *The War with France.*"

17. Fontane to his wife, 28 May 1870, in *Briefe*, 2: 320.

18. On Werner, see above all his memoirs, *Erlebnisse und Eindrücke, 1870–1890* (Berlin, 1913), which reveal his personality and his views on art far better than does the informative but somewhat colorless early biography by Adolph Rosenberg, *A. von Werner* (Bielefeld and Leipzig, 1895). I discuss Werner's role in the art politics of the period in my *Berlin Secession* (Cambridge, Mass., 1980), and in two articles: "The Tschudi Affair," *Journal of Modern History* 53, no. 4 (1981), and "The Artist as *Staatsbürger,*" *German Studies Review* 6 (October 1983). The recent monograph by Dominik Bartmann, *Anton von Werner* (Berlin, 1985), is essentially a useful collection of material, which the author interprets in a superficial and unduly derivative manner.

19. Werner, *Erlebnisse und Eindrücke*, pp. 270f. The following quotation, ibid., p. 42.

20. The conventional taste of the time saw it differently. Rosenberg's 1895 monograph on Werner singles out the profusion of detail in Moltke's portrait as especially deserving of praise (*A. von Werner*, pp. 16–17).

21. Werner, *Erlebnisse und Eindrücke*, pp. 31–34.

22. For Werner's rejection of Manet and other negative comments on modern French and German art, see his memoirs (ibid., pp. 319, 373, 410, 565f). The Werner papers (Merseburg, ZStA, Rep. 92, VIII) contain a newspaper clipping with Max Pechstein's poster for the 1910 exhibition of the New Secession in Berlin. In the margin Werner drastically expresses his dislike of the poster's centerpiece, an aggressively unacademic naked woman with bow and arrow.

23. Werner, *Erlebnisse und Eindrücke*, p. 129.

24. Ibid., pp. 54f, 197–203.

25. Ibid., p. 54.

26. Ibid.

27. Ibid., pp. 33f, 54. Fontane, who was not present, gives a far more festive account of the ceremony in his history of the Franco-Prussian War, *Der Krieg gegen Frankreich*, 4: 447–54.

28. Alice Meynell, "A German Military Painter," *The Art Journal*, January 1887, p. 9.

29. Werner, *Erlebnisse und Eindrücke*, pp. 356f. In preparation for his second major painting of an event in contemporary history, the Congress of Berlin of 1878, Werner actually intervened to change the reality he was to depict. He asked Bismarck whether at the final session the representatives of the various powers could appear in uniform and whether the peace treaties could be signed in better natural light than was available at the conference table (ibid., p. 234). The London *Times* of 12 July 1878 carried a long account of Werner's preliminary sketches. Commenting on the work's centerpiece—Bismarck, the Austro-Hungarian foreign minister at his side, shaking hands with the second Russian representative—the correspondent, Opper de Blowitz, wrote: "I do not know . . . whether Professor von Werner has courageously undertaken to solve the problem suggesting itself to the polit-

98. Anton von Werner: Bismarck at
the Congress of Berlin.

ical heads of modern Europe by hinting that
the alliance of the three Empires, of which the
Congress of Berlin is a consequence, unques-
tionably survives the Treaty which has just
been signed. This reproduction on canvas of
the so-called triple alliance is perhaps more due
to the fancy of the painter than to the observed
facts of the politician . . . and I think that pub-
lic opinion in Europe will see in the bold pen-
cilling of Professor von Werner a memory, and
not a hope." When the painting was completed
three years later, a critic noted that Werner had
the good fortune that his main figure was a
man of "gigantic proportions," and asked
what effect a statesman of small bodily stature
like Cavour would have made—an observation
Werner confirmed in the margin of a clipping
of the article with an "Indeed!" Anton v. Wer-
ner's Congressbild im Berliner Rathhause,"
Allgemeine Kunst-Chronik 5, no. 27 (1881), p.
232; and Nachlass Anton von Werner, ZStA,
Rep. 92, VIII.

30. Rosenberg, *A. von Werner*, pp. 104f.

31. In his fine monograph *Versailles als Na-
tionaldenkmal* (Berlin, 1985), p. 243, Thomas
W. Gaehtgens refers to some French critics of
the 1830s, among them Alfred de Musset, who
objected to the glorification of the emperor in
Vernet's paintings at the expense of the grim
truth of war.

32. The exact date when Fontane started
work on the novel has not been established; the
earliest outlines may go back to the 1850s.
Fontane's turning toward fiction has been ana-
lyzed with great care in the opening chapters of
the second volume of Hans-Heinrich Reuter's
Fontane (Munich, 1968).

33. Fontane to Paul Lindau, 23 October
1878, in Fontane, *Briefe*, 2: 626.

34. Fontane to Ludwig Pietsch, 16 Novem-
ber 1878, ibid., p. 633.

35. Fontane to Mathilde von Rohr, 30 No-
vember 1876, ibid., 3: 548.

36. Documents relating to Fontane's ap-
pointment and resignation are published in
Walter Huder, ed., *Theodor Fontane und die
preussische Akademie der Künste* (Berlin,
1971). Anton von Werner includes an account
of the episode in his memoirs, *Erlebnisse und
Eindrücke*, pp. 171f, which reads in part:
"From the beginning of March on, Fontane
studied the files in order to acquaint himself
with his duties. Occasionally I had to deal with
him on some official business, but I tried as far
as possible not to trouble him with such things.
Naturally he knew as little as I did about offi-
cial correspondence, registry matters, and of-
fice routine. One day I encountered him, per-
plexed before a vast stack of files, in a situation
that did not lack a comic note. Wearing a red
fez, he stood pensively before a long wooden
table, on which he had drawn a fair number of
digits and circles in white chalk, into which
and from which he placed files and took them
out again, apparently attempting to organize
them according to some system. Although he
seemed to find this situation very odd, he did
not take it too seriously; but I had the impres-
sion that considering the demands he was fac-
ing he was even less suited to be an official than
I. Councillor Hitzig, whose social behavior was
marked by an undeniably pleasant bonhomie,
regarded the newly created post of President as
akin to the position of a Pasha in an oriental
despotism, which enabled him to wield abso-
lute executive power. He may also have already
been suffering from the painful illness that
killed him several years later. In any case, he
adopted a remarkably inconsiderate tone, even
toward his old Tunnel friend, and it was not
long before his brusque, actually insulting be-
havior toward the good Fontane during a
meeting of the senate caused the sensitive man

to ask to be relieved of an official position that neither suited him, nor he it.

37. Fontane to Mathilde von Rohr, 17 June and 1 July 1876, in Fontane, *Briefe*, 2: 527, 534.

38. Reuter, *Fontane*, 2: 587.

39. The historical background and Fontane's sources are carefully analyzed by Pierre-Paul Sagave in his edition of *Schach von Wuthenow* in the series "Dichtung und Wirklichkeit" (Berlin, 1966). Sagave's work is very helpful, even if in correcting Fontane he himself occasionally errs (e.g. p. 109, note to p. 69), and his social analysis is too schematic to catch the reality of the times.

40. Fontane, *Schach von Wuthenow*, in *Werke*, 2: 288f.

41. On Bülow, see R. R. Palmer, "Frederick the Great, Guibert, Bülow: From Dynastic to National War," in *Makers of Modern Strategy*, ed. Peter Paret (Princeton, 1985); and Peter Paret, *Clausewitz and the State*, 2nd ed. rev. (Princeton, 1985), esp. pp. 91–94; and the same author's "Napoleon as Enemy," *Proceedings of the Consortium on Revolutionary Europe* (Athens, Ga., 1985).

42. Fontane, *Werke*, 2: 373.

43. Ibid., p. 382.

44. Ibid., pp. 274, 281f.

45. Ibid., p. 316.

46. Fontane to Martha Fontane, 8 August 1880, in Fontane, *Briefe*, 3: 97; and to Georg Friedlaender, 12 April 1894, ibid., 4: 342–43.

47. Auch die Grenadiere wollen nicht mehr.
 Wie ein Rasender jagt der König daher
 Und hebt den Stock und ruft unter
 Beben:
 "Racker, wollt ihr denn ewig leben?
 Bedrüger . . ."
 "Fritze, nichts von Bedrug;
 Für fünfzehn Pfennig ist's heute genug."
"Bei Torgau," in Fontane, *Werke*, 20: 217.

48. "An meinem Fünfundsiebzigsten," ibid., pp. 409f. After his seventieth birthday Fontane had written in similar vein to an acquaintance: "Modern Berlin made an idol of me, but the old *Prussia*, which I glorified for more than forty years in books about war, biographies, accounts of land and people, and popular poems, this 'old Prussia' scarcely budged and left everything (as so often) to the Jews." Fontane to Heinrich Jacobi, 23 January 1890, in Fontane, *Briefe*, 4: 18.

49. "Auf der Treppe von Sanssouci," in Fontane, *Werke*, 20: 273–76.

50. Fontane to Georg Friedlaender, 16 November 1891, and to Martha Fontane, 29 January 1894, in Fontane, *Briefe*, 4: 162, 325f. See also the enlightening discussion of Fontane's opinions of Bismarck in Kenneth Attwood, *Fontane und das Preussentum* (Berlin, 1970), pp. 192–200.

51. Fontane to Georg Friedlaender, 5 October 1888, in Fontane, *Briefe*, 3: 646.

52. Maximilian Harden, "Fontane," *Nation* 1, no. 13 (1889): 189–92; Fontane to Harden, 17 December 1889, in Fontane, *Briefe*, 3: 742. The version of the essay included in Maximilian Harden, *Literatur und Theater* (Berlin, 1896), pp. 89–106, does not contain the expression, "Frederician grenadier."

53. The surviving draft and notes are published in Hermann Fricke, *Die Likedeeler* (Rathenow, 1938).

EPILOGUE.

1. Theodor Fontane, *Von Zwanzig bis Dreissig*, in *Sämtliche Werke* (Munich, 1959–67), 15: 252.

2. To Martha Fontane, 16 February 1894, in Theodor Fontane, *Briefe*, ed. Walter Keitel and Helmuth Nürnberger (Munich, 1982), 4: 335.

Notes on the Illustrations

Original dimensions, where known, are given in centimeters.

Wounded Soldier and Corpses, ibid., p. 510. Wood engraving. 5.4 × 11.2.

FIG. 21 (page 41). Adolph Menzel: *A Battlefield Covered with Corpses*, ibid., p. 231. Wood engraving. 6.1 × 10.2.

FIG. 22 (page 42). Adolph Menzel: *Frederick on a Night March*, ibid., p. 365. Wood engraving. 3.2 × 10.

FIG. 23 (page 42). Adolph Menzel: *Field Marshal Keith Mortally Wounded*, ibid., p. 401. Wood engraving. 6.3 × 7.6.

FIG. 24 (page 43). Adolph Menzel: *Battle at Night*, ibid., p. 402. Wood engraving. 7.6 × 8.9.

FIG. 25 (page 44). Adolph Menzel: *Frederick by a Campfire*, ibid., p. 449. Wood engraving. 10.1 × 10.4.

FIG. 26 (page 44). Adolph Menzel: *A Hand Supports a Wall*, ibid., p. 572. Wood engraving. 7.3 × 4.2.

FIG. 27 (page 45). Adolph Menzel: *Frederick on the Banks of a Stream*, ibid., p. 577. Wood engraving. 7.5 × 11.2.

FIG. 28 (page 45). Adolph Menzel: *Landscape*. Pencil.

FIG. 29 (page 46). Adolph Menzel: *The Polish Crown*, in *Geschichte*, p. 553. Wood engraving. 3.4 × 5.9.

FIG. 30 (page 46). Adolph Menzel: *Frederick Reading at His Desk*, ibid., p. 604. Wood engraving. 9.6 × 9.

FIG. 31 (page 47). Adolph Menzel: *Frederick Working at His Desk*, ibid., p. 262. Wood engraving. 10.9 × 8.5.

FIG. 32 (page 48). Adolph Menzel: *Frederick among Tombstones*, ibid., p. 607. Wood engraving. 5 × 7.6.

FIG. 33 (page 48). Adolph Menzel: *Frederick on Maneuvers in the Rain*, ibid., p. 613. Wood engraving. 5.5 × 12.7.

FIG. 34 (page 49). Adolph Menzel: *Frederick Sitting before the Potsdam Palace*, ibid., p. 615. Wood engraving. 12.1 × 6.

FIG. 35 (page 53). Eberhard Henne after Daniel Chodowiecki: *Frederick Sitting on the Terrace of Sanssouci*. Engraving.

FIG. 36 (page 53). Adolph Menzel: *Frederick Sitting before the Potsdam Palace*, in *Ge-*

schichte, 1st ed., 1842, p. 615. Wood engraving. 12.1 × 6.

FIG. 37 (page 58). Adolph Menzel: *Prussian Infantry at Rest*, ibid., p. 564. Wood engraving. 8.1 × 11.2.

FIG. 38 (page 59). Adolph Menzel: *Prussian Infantry Awaiting the Enemy*, ibid., p. 565. Wood engraving. 7.9 × 11.1. Figs. 37 and 38 were drawn as a pair and printed on facing pages.

FIG. 39 (page 65). J. W. Burford. *Theodor Fontane*, 1844. Crayon. 11 × 9.

FIG. 40 (page 66). Adolph Menzel: *A Meeting of the Tunnel*. Pen and ink.

FIG. 41 (page 70). Adolph Menzel: *Field Marshal Schwerin Returning to the Attack*, in *Geschichte*, p. 317. Wood engraving. 10.5 × 9.3.

FIG. 42 (page 72). Adolph Menzel: *General Seydlitz*, ibid., p. 348. Wood engraving. 10.6 × 9.7.

FIG. 43 (page 73). Adolph Menzel: *Prince Leopold Praying before Battle*, ibid., p. 238. Wood engraving. 11.4 × 7.6.

FIG. 44 (page 80). Alfred Rethel: *Self-Portrait*, 1839. Pencil. 15.7 × 12.6.

FIG. 45 (page 84). Alfred Rethel: *How They Threw out the Corpses*, illustration to the *Nibelungenlied*. Woodcut. 16 × 12.3.

FIG. 46 (page 85). Alfred Rethel: *How Iring was Slain*, illustration to the *Nibelungenlied*. Woodcut. 16 × 12.3.

FIG. 47 (page 86). Alfred Rethel: *Harkort's Factory in Castle Wetter on the Ruhr River*. Oil. 43.5 × 57.5.

FIG. 48 (page 88). Alfred Rethel: Frontispiece of the *Hannibal* cycle. Pencil and wash. 32 × 35.

FIG. 49 (page 89). Alfred Rethel: Study for the fresco *Otto Descending into the Crypt of Charlemagne*. Pencil and wash.

FIG. 50 (page 95). Anonymous. *Attack on the Barricade on the Alexanderplatz on the Afternoon of 18 March*. Contemporary wood engraving. 16.2 × 23.

FIG. 51 (page 99). Adolph Menzel: Detail from *The March Casualties Lying in State* (Plate II).

FIG. 52 (page 100). Adolph Menzel: Sketch at the head of a letter. Pen and ink.

FIG. 53 (page 106). Alfred Rethel: *Another Dance of Death*, Plate 1. Woodcut. 22.9 × 32.9.

FIG. 54 (page 107). Alfred Rethel: *Another Dance of Death*, Plate 2. Woodcut. 22.9 × 32.9.

FIG. 55 (page 108). Alfred Rethel: *Another Dance of Death*, Plate 3. Woodcut. 22.9 × 32.9.

FIG. 56 (page 109). Alfred Rethel: *Another Dance of Death*, Plate 4. Woodcut. 22.9 × 32.9.

FIG. 57 (page 109). Alfred Rethel: *Another Dance of Death*, Plate 5. Woodcut. 22.9 × 32.9.

FIG. 58 (page 110). Alfred Rethel: *Another Dance of Death*, Plate 6. Woodcut. 22.9 × 32.9.

FIG. 59 (page 111). Ernest Meissonier: *The Barricade*. Oil. 29 × 22.

FIG. 60 (page 115). Alfred Rethel: *Death as Servant*, Pencil and chalk. 30.7 × 27.1.

FIG. 61 (page 116). Alfred Rethel: *Death as Enemy*. Woodcut. 30 × 27.

FIG. 62 (page 117). Alfred Rethel: *Death as Friend*. Woodcut. 30 × 27.

FIG. 63 (page 118). Alfred Rethel: Illustration to a poem by his wife. Pen and ink. 15.8 × 10.4.

FIG. 64 (page 120). Hans Holbein the Younger: *Death and the Empress*, from *The Dance of Death*. Woodcut. 6.5 × 5.

FIG. 65 (page 120). Hans Holbein the Younger: *Death and the Knight*, from *The Dance of Death*. Woodcut. 6.5 × 5.

FIG. 66 (page 120). Hans Holbein the Younger: *Death and the Physician*, from *The Dance of Death*. Woodcut. 6.5 × 5.

FIG. 67 (page 120). Hans Holbein the Younger: *Death and the Attorney*, from *The Dance of Death*. Woodcut. 6.5 × 5.

FIG. 68 (page 120). Hans Holbein the Younger: *Death and the Small Child*, from *The Dance of Death*. Woodcut. 6.5 × 5.

FIG. 69 (page 120). Hans Holbein the Younger: *Death and the Old Woman*, from *The Dance of Death*. Woodcut. 6.5 × 5.

FIG. 70 (page 122). Albrecht Dürer: Detail from *The Four Horsemen*, Plate 3 of *The Revelation to John (The Apocalypse)*. Woodcut.

FIG. 71 (page 123). Johann Kirchhoff: *Combat on the "Great Barricade,"* Berlin, March 1848. Contemporary wood engraving. 23 × 16.2.

FIG. 72 (page 124). Anonymous: *The Defenders of the Barricade in the Grosse Frauengasse*, Dresden, May 1849. Contemporary lithograph.

FIG. 73 (page 125). Anonymous. *Friedrich Hecker as Leader of the Baden Insurrection*. Contemporary woodcut.

FIG. 74 (page 127). Anonymous: *Pardoned to Powder and Lead, 1849*. Contemporary wood engraving. 27 × 33.6.

FIG. 75 (page 135). Anton von Werner: Title page of *Gaudeamus* by Scheffel. Pen and ink.

FIG. 76 (page 136). Anton von Werner: *Bismarck Reading "Gaudeamus."* Crayon.

FIG. 77 (page 138). Anton von Werner: *Scheffel on a Walking Tour by the Hohentwiel*. Pen and ink.

FIG. 78 (page 143). Anton von Werner: *Joseph Viktor Scheffel, 1867*. Pencil and wash.

FIG. 79 (page 153). Adolph Menzel: Illustration to *L'Antimachiavel* and *Réfutation du Prince de Machiavel* by Frederick the Great, Plate 66 of *Oeuvres de Frédéric le Grand*, Berlin, 1846–56. Wood engraving. 9.3 × 6.1.

FIG. 80 (page 154). Adolph Menzel: *Self-Portrait in the 1860s*. Crayon. 22.2 × 10.

FIG. 81 (page 157). Adolph Menzel: Detail from *The Departure of William I to Join the Army* (Plate III).

FIG. 82 (page 159). Hugo von Blomberg: *Theodor Fontane, 1857*. Crayon.

FIG. 83 (page 163). Anonymous: *Theodor Fontane in the 1870s*. Wood engraving. 14.7 × 12. The portrait first appeared in the periodical *Über Land und Meer*, vol. 21 (1878).

FIG. 84 (page 166). Anton von Werner: *Skaters in Karlsruhe (Auf der Schiesswiese in Karlsruhe)*. Watercolor.

FIG. 85 (page 168). Anton von Werner: *Moltke at Versailles, 1870*. Oil.

FIG. 86 (page 170). Anton von Werner: *Self-Portrait*, 1885. Oil.

FIG. 87 (page 171). Anton von Werner: *Menzel Asleep during a Senate Meeting of the Royal Academy*, 1880. Pencil.

FIG. 88 (pages 174-75). Anton von Werner: *The Proclamation of the German Empire*. Oil. Approximately 430 × 800.

FIG. 89 (page 179). Carl Ernst Daumerlang after Anton von Werner, *Moltke and Werner* (depicted in Werner's studio before one version of the *Proclamation of the German Empire*). Published in the journal *Daheim*, May 1875. Woodcut. 22.5 × 16.9.

FIG. 90 (page 180). Anton von Werner: *Bismarck in the Reichstag*. Pencil.

FIG. 91 (page 189). Adolph Menzel: Illustration to *Lettre sur l'éducation* by Frederick the Great, Plate 76 of *Oeuvres de Frédéric le Grand*, Berlin, 1846–56. Wood engraving. 9.4 × 11.5.

FIG. 92 (page 190). Adolph Menzel: *Sans-souci* in *Geschichte*, p. 266. Wood engraving. 8.7 × 11.4.

FIG. 93 (page 193). Max Liebermann: *Theodor Fontane*, 1896. Lithograph. 26.5 × 21.6.

FIG. 94 (page 209). Alfred Rethel: Detail from Plate 3 of *Another Dance of Death* (Fig. 55).

FIG. 95 (page 209). Adolph Menzel: *Frederick's Hand Keeps the Scales of Justice in Balance*, in *Geschichte*, p. 587. Wood engraving. 4.4 × 5.6.

FIG. 96 (page 210). Horace Vernet: *Napoleon's Sword Outweighs British Gold*, in *Histoire*, p. 171. Wood engraving. 7 × 6.8.

FIG. 97 (page 210). Johann Vincent Cissarz: Design for the announcement of *Die deutsche Revolution* by Hans Blum. Pen and ink. 22.1 × 14.8.

FIG. 98 (page 215). Anton von Werner: Study for the central group of the painting *The Congress of Berlin*. Pencil.

Bibliography

MANUSCRIPTS

Nachlass Anton von Werner. Zentrales Staatsarchiv (ZStA), Merseburg, Rep. 92, IVb and VIII.

PUBLISHED SOURCES

"Alfred Rethel." In *Allgemeine Deutsche Biographie*, vol. 28. Leipzig, 1889.

"Anton v. Werner's Congressbild im Berliner Rathhause." *Allgemeine Kunst-Chronik* 5, no. 27 (1881).

Attwood, Kenneth. *Fontane und das Preussentum.* Berlin, 1970.

Bartmann, Dominik. *Anton von Werner.* Berlin, 1985.

Bock, Elfried. "Die Geschichte eines Volksbuches." *Kunst und Künstler* 13 (1915).

Brieger, Peter. *Die deutsche Geschichtsmalerei des 19. Jahrhunderts.* Berlin, 1930.

Burckhardt, Jacob. "Kugler." In *Brockhaus Conversations-Lexikon.* 9th ed. Leipzig, 1843–48.

———. *Briefe.* 10 vols. Edited by Max Burckhardt. Munich, 1949–86.

———. "Bericht über die Kunstausstellung zu Berlin im Herbste 1842." *Kunstblatt*, 3–12 January and 9–21 March 1843.

Busch, Günter. "Menzels Grenzen." In Jens Christian Jensen, ed. *Adolph Menzel*, Exhibition catalogue of the Kiel Kunsthalle. Schweinfurt, 1981.

Clark, T. J. *The Absolute Bourgeois.* Princeton, 1982.

Craig, Gordon A. *The Politics of the Prussian Army, 1640–1945.* Oxford, 1955.

———. Introduction to Theodor Fontane, *Der Krieg gegen Frankreich 1870–1871.* 4 vols. Zurich, 1985.

"Das Andenken Friedrich's II . . ." *Rheinische Zeitung*, no. 325, 21 November 1842.

Delacroix, Eugène. *Journal de Eugène Delacroix.* 2 vols. Edited by André Joubin. Paris, 1932.

"Die liberalen Zeitungen Deutschlands." *Rheinische Zeitung*, no. 90, 31 March 1843.

Eggers, Friedrich. "Franz Theodor Kugler. Eine Lebensskizze." In Franz Kugler, *Handbuch der Geschichte der Malerei*, 3rd ed., vol. 1. Leipzig, 1867.

Eggert, Hartmut. *Studien zur Wirkungsgeschichte des deutschen historischen Romans, 1850–1875.* Frankfurt a.M., 1971.

"Einiges von Friedrich dem Grossen." *Rheinische Zeitung*, nos. 85–87, 26–30 March 1843.

Feist, Peter H. "Adolph Menzel und der Realismus." In *Adolph Menzel*, Exhibition catalogue of the Nationalgalerie. East Berlin, 1980.

Fontane, Theodor. *Briefe.* 4 vols. Edited by Walter Keitel and Helmuth Nürnberger. Munich, 1976–82.

———. *Der Krieg gegen Frankreich 1870–1871.* 4 vols. Zurich, 1985.

———. *Schach von Wuthenow.* Edited by Pierre-Paul Sagave. Berlin, 1966.

———. *Sämtliche Werke.* 24 vols. in 30. Munich, 1959–75.

Förster, Ernst. Review of Alfred Rethel, *Auch ein Todtentanz. Kunstblatt*, 28 June 1849.

Forster-Hahn, Françoise. "Adolph Menzel's 'Daguerreotypical' Image of Frederick the Great: A Liberal Bourgeois Interpretation of German History." *Art Bulletin* 59, no. 1 (1977).

Frederick II. *Oeuvres de Frédéric le Grand.* Edited by J.D.E. Preuss. 31 vols. in 27. Berlin, 1846–56.

Fricke, Hermann. *Die Likedeeler.* Rathenow, 1938.

Gaehtgens, Thomas W. *Versailles als Nationaldenkmal.* Berlin, 1985.

G.P. "Die nationale Bedeutung Friedrichs des Grossen." *Deutsche Viertel-Jahrsschrift*, 1841, part 1.

Goethe, Johann Wolfgang von. *Goethes Ge-*

spräche. Edited by Flodoard von Bieder-mann. Wiesbaden, 1949.

Harden, Maximilian. *Literatur und Theater.* Berlin. 1896.

Hardtwig, Wolfgang. "Geschichtsinteresse, Geschichtsbilder und politische Symbole." In *Kulturverwaltung, Bau- und Denkmal-Politik im Kaiserreich*, edited by Ekkehard Mai and Stephan Waetzold. Berlin, 1981.

——. "Kunst im Revolutionszeitalter: Historismus in der Kunst und der Historismusbegriff der Kunstwissenschaft." *Archiv für Kulturgeschichte* 61 (1979).

Hartwig, Helmut, and Riha, Karl. *Politische Ästhetik und Öffentlichkeit.* Steinbach, 1974.

Heilmann, Christoph. "Zur französisch-belgischen Historienmalerei und ihre Abgrenzung zur Münchner Schule." In *Die Münchner Schule*, Exhibition catalogue. Munich, 1979.

Hoffmann, Detlef. *Die Karlsfresken Alfred Rethels.* Freiburg i. B., 1968.

Hofmann, Karl-Ludwig, and Präger, Christmut. "Revolution als Totentanz—Alfred Rethel, 'Ein Totentanz,' 1849." In *Thema Totentanz*, Exhibition catalogue of the Mannheim Kunstverein, 5 October – 9 November 1986. Mannheim, 1986.

Hofmann, Werner, ed. *Menzel—der Beobachter*, Exhibition catalogue of the Hamburg Kunsthalle. Munich, 1982.

Holz, Claus. *Flucht aus der Wirklichkeit.* Frankfurt a.M., 1983.

Hoppe, R., and Kuczynski, Jürgen. "Eine Berufs bzw. auch Klassen- und Schichtenanalyse der Märzgefallenen 1848 in Berlin." *Jahrbuch für Wirtschaftsgeschichte* 4 (1964).

Huder, Walther, ed. *Theodor Fontane und die preussische Akademie der Künste.* Berlin, 1971.

Hütt, Wolfgang. *Adolph Menzel.* Leipzig, 1965; rev. ed. Leipzig, 1981.

——. *Die Düsseldorfer Malerschule, 1819–1869.* 2nd ed., rev. Leipzig, 1984.

Jensen, Jens Christian, ed. *Adolph Menzel*, Exhibition catalogue of the Kiel Kunsthalle. Schweinfurt, 1981.

Joseph Viktor von Scheffel im Lichte seines hundertsten Geburtstages. Stuttgart, 1926.

Koetschau, Karl. *Alfred Rethels Kunst.* Düsseldorf, 1929.

Kohler, Ernst. *Die Balladendichtung im Berliner "Tunnel über der Spree."* Berlin, 1940.

Köppen, Karl Friedrich. "Zur Feier der Thronbesteigung Friedrich's II." *Hallische Jahrbücher für Deutsche Wissenschaft und Kunst* 3, nos. 147, 149, and 150 (19–23 June 1840).

——. *Friedrich der Grosse und seine Widersacher.* Leipzig, 1840.

Koschnick, Leonore. "Franz Kugler (1808–1858) als Kunstkritiker und Kulturpolitiker." Ph.D. dissertation, Berlin, 1983.

Kugler, Franz. "Briefe über die Geschichte Friedrichs des Grossen." *Neue Rundschau*, December 1911.

——. *Kleine Schriften und Studien zur Kunstgeschichte.* 3 vols. Stuttgart, 1854.

——, and Menzel, Adolph. *Geschichte Friedrichs des Grossen.* Leipzig, 1842; rev. ed. 1846; reprint of the rev. ed. with the illustrations of the 1st ed., Leipzig, 1922.

Laurent de l'Ardèche, Paul-Mathieu. *L'Histoire de l'Empereur Napoléon.* Paris, 1839.

Lichtwark, Alfred. *Briefe an die Kommission für die Verwaltung der Kunsthalle.* 2 vols. Edited by Gustav Pauli. Hamburg, 1924.

Mahal, Günther. *Joseph Viktor von Scheffel: Versuch einer Revision.* Karlsruhe, 1986.

Menzel, Adolph von. *Adolph von Menzels Briefe.* Edited by Hans Wolff. Berlin, 1914.

[Menzel, Adolph von]. "An den Herrn Verfasser des Artikels 'zu Ehren Friedrich's des Grossen,'" *Berlinische Nachrichten*, 28 March 1840.

Meyerheim, Paul. *Adolph von Menzel.* Berlin, 1906.

Meynell, Alice. "A German Military Painter." *The Art Journal*, January 1887.

Mulert, S. G. *Scheffels Ekkehard als historischer Roman.* Münster i.W., 1909.

Müller von Königswinter, Wolfgang. *Alfred Rethel: Blätter der Erinnerung.* Leipzig, 1861.

——. *Düsseldorfer Künstler aus den letzten fünfundzwanzig Jahren.* Leipzig, 1854.

Nipperdey, Thomas. *Deutsche Geschichte, 1800–1866.* Munich, 1984.

Nürnberger, Helmuth. *Der junge Fontane.* Hamburg, 1967.

Palmer, R. R. "Frederick the Great, Guibert, Bülow: From Dynastic to National War." In *Makers of Modern Strategy*, edited by Peter Paret. Princeton, 1985.

Paret, Peter. "Napoleon as Enemy." *Proceedings of the Consortium on Revolutionary Europe.* Athens, Ga., 1985.

———. "The Artist as *Staatsbürger*." *German Studies Review* 6 (October 1983).

———. "The German Revolution of 1848 and Rethel's Dance of Death." *Journal of Interdisciplinary History* 17, no. 1 (Summer 1986).

———. "The Tschudi Affair." *Journal of Modern History* 53, no. 4 (December 1981).

———. *Clausewitz and the State.* 2nd ed., rev. Princeton, 1985.

———. *The Berlin Secession.* Cambridge, Mass., 1980.

Pochat, Götz. "Friedrich Theodor Vischer und die Zeitgenössische Kunst." In *Ideengeschichte und Kunstwissenschaft im Kaiserreich*, edited by Ekkehard Mai, Stephan Waetzoldt, and Gerd Wolandt. Berlin, 1983.

Ponten, Josef. *Alfred Rethel.* Stuttgart and Leipzig, 1911.

———. *Studien über Alfred Rethel.* Stuttgart, 1922.

Radziewsky, Elke von. "Menzel—ein Realist?" In Werner Hofmann, ed., *Menzel—der Beobachter*, Exhibition catalogue of the Hamburger Kunsthalle. Munich, 1982.

Ranke, Leopold von. *Die römischen Päpste.* 2 vols. Munich and Leipzig, 1923.

Rave, Paul Ortwin, ed. *Holzschnitte zu den Werken Friedrichs des Grossen von Adolph Menzel.* Berlin, 1955.

Rehm, Walter. "Jacob Burckhardt und Franz Kugler." *Basler Zeitschrift für Geschichte und Altertumskunde* 41 (1942).

Reinick, Robert. *Aus Biedermeiertagen.* Edited by Johannes Höffner. Bielefeld and Leipzig, 1910.

Remak, Joachim. *The Gentle Critic: Theodor Fontane and German Politics.* Syracuse, 1964.

Rethel, Alfred. *Alfred Rethels Briefe.* Edited by Josef Ponten. Berlin, 1912.

———. *Auch ein Totentanz.* Edited by Theodor Heuss. Stuttgart, 1957.

Reuter, Hans-Heinrich. *Fontane.* 2 vols. Munich, 1968.

Review of Franz Kugler and Adolph Menzel, *Geschichte Friedrich's des Grossen* [signed "11"]. *Blätter für literarische Unterhaltung*, 1840, no. 131.

Review of Franz Kugler and Adolph Menzel, *Geschichte Friedrich's des Grossen* [signed "19"]. *Blätter für literarische Unterhaltung*, 1842, no. 49.

Rodger, Gilliam. "Fontane's Conception of the Folk-Ballad." *Modern Language Review* 53 (1958).

Rosen, Charles, and Zerner, Henri. *Romanticism and Realism.* New York, 1984.

Rosenberg, Adolph. *A. von Werner.* Bielefeld and Leipzig, 1895.

R[uge, Arnold]. Review of Franz Kugler and Adolph Menzel, *Geschichte Friedrich's des Grossen. Hallische Jahrbücher für Wissenschaft und Kunst*, 3, no. 168 (1840).

Ruge, Arnold. Review of Franz Kugler and Adolph Menzel, *Geschichte Friedrich's des Grossen. Deutsche Jahrbücher für Wissenschaft und Kunst*, 5 (1842).

Schadow, Johann Gottfried. "Zu Ehren Friedrich des Grossen von einem Veteranen." *Berlinische Nachrichten*, 26 March 1840.

Scheffel, Josef Viktor von. *Briefe ins Elternhaus, 1843–1849.* Edited by Wilhelm Zentner. Karlsruhe, 1926.

———. *Briefe J. V. v. Scheffels an Schweizer Freunde.* Edited by Adolph Frey. Zurich, 1898.

———. *Briefe von Joseph Viktor Scheffel an Anton von Werner.* Edited by Anton von Werner. Stuttgart, 1915.

———. *Eine Studienfreundschaft: Scheffels Briefe an Friedrich Eggers, 1844–1849.* Edited by Gerda Ruge. Karlsruhe, 1936.

———. *Scheffels Werke.* 4 vols. Edited by Friedrich Panzer. Leipzig and Vienna, n.d.

Scheffler, Karl. *Menzel*, 2nd ed. Berlin, 1915.

Schiller, Friedrich von. *Geschichte des Abfalls der Niederlande von der spanischen Regierung.* In *Schillers Werke,* vol. 17: *Historische Schriften,* part 1, edited by Karl-Heinz Hahn. Weimar, 1970.

Schlink, Wilhelm. *Jacob Burckhardt und die Kunsterwartung im Vormärz.* Frankfurter Historische Vorträge, no. 8. Wiesbaden, 1982.

Schmidt, Heinrich. *Alfred Rethel, 1816–1859.* Neuss, 1959.

Schopenhauer, Arthur. *Die Welt als Wille und Vorstellung.* 4 vols. Leipzig, 1819.

Selbmann, Rolf. *Dichterberuf im bürgerlichen Zeitalter: Joseph Viktor von Scheffel und seine Literatur.* Heidelberg, 1982.

Sheehan, James J. *German Liberalism in the Nineteenth Century.* Chicago, 1978.

Soboul, Albert. *The Sans-Culottes: The Popular Movement and Revolutionary Government, 1793–1794.* Translated by Remy Inglis Hall. Princeton, 1980.

Treue, Wilhelm. "Franz Theodor Kugler—Kulturhistoriker und Kulturpolitiker." *Historische Zeitschrift* 175 (1953).

Trier, Eduard, ed. *Zweihundert Jahre Kunstakademie Düsseldorf.* Düsseldorf, 1973.

Uechtritz, Friedrich von. *Blicke in das Düsseldorfer Kunst- und Künstlerleben.* Düsseldorf, 1840.

Varnhagen von Ense, Karl August. Review of Karl Friedrich Köppen, *Friedrich der Grosse und seine Widersacher. Jahrbücher für wissenschaftliche Kritik,* June 1840.

Vaughan, William. *German Romantic Painting.* New Haven, 1983.

Waetzoldt, Wilhelm. *Deutsche Kunsthistoriker.* 2 vols. Leipzig, 1921–24.

——. *Dürer und seine Zeit.* Vienna, 1935.

Wagner, Richard. *My Life.* Translated by Andrew Gray, edited by Mary Whittall. Cambridge, 1983.

Wehler, Hans-Ulrich. *Deutsche Gesellschaftsgeschichte.* 2 vols. Munich, 1987– .

Werner, Anton von. *Erlebnisse und Eindrücke, 1870–1890.* Berlin, 1913.

With, Christopher. "Adolph Menzel and the German Revolution of 1848." *Zeitschrift für Kunstgeschichte* 42 (1979).

Wolff, Adolph. *Berliner Revolutions-Chronik.* 3 vols. Berlin, 1851.

Index